WAYS of
DRAWING

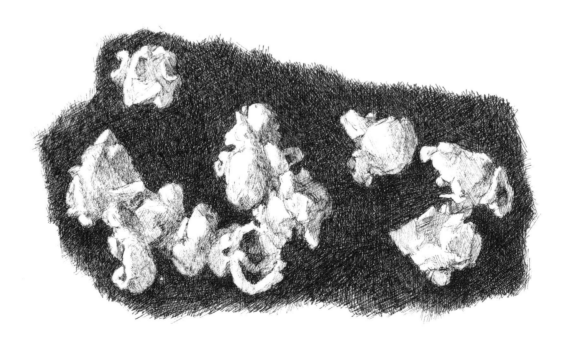

ROYAL DRAWING SCHOOL

WAYS of DRAWING

Artists' Perspectives and Practices

Introduced by Julian Bell

Edited by Julian Bell, Julia Balchin & Claudia Tobin

With over 300 illustrations

ROYAL DRAWING SCHOOL

Drawing, like music and dance, needs to be taught
and practised throughout an artist's life. It is my firm
belief that drawing is one of the most direct ways
of engaging with the world and that using the most
limited of means can lead to the most beautiful
results. Furthermore, I am certain that drawing from
observation is a central element of success across
a broad scope of practice – from architecture, design,
fashion and engineering, to film, animation and the
wider creative industries.

HRH THE PRINCE OF WALES
Royal Founding Patron of the Royal Drawing School

Contents

STUDIO SPACE

OPEN SPACE

INNER SPACE

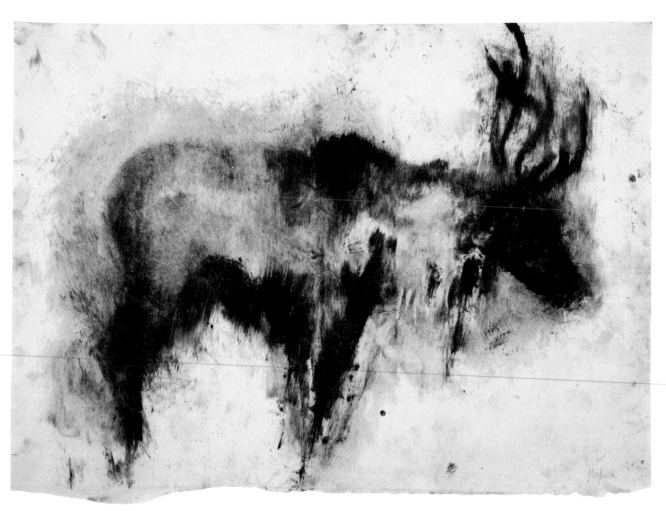

Meg Buick, *Lascaux Deer,* 2013, monotype

Preface *Catherine Goodman*

The Royal Drawing School was founded in 2000 by HRH The Prince of Wales and artist Catherine Goodman in Shoreditch, east London. It began with forty students in one drawing studio and now receives a thousand students across its programmes each week.

The Royal Drawing School began as an emergency measure. There was a peculiar insistence in art education during the 1990s and 2000s that drawing from life was irrelevant, yesterday's game. That only lasted a few years and has now subsided. As we know, every artist draws as a way of visual thinking and feeling, of exploring both their interior and exterior worlds. Most people feel so close to their drawings that they are often embarrassed or ashamed of them. It is as though they offer a direct window onto their interior lives or their dreams – I often think that's why people say 'I can't draw'. Of course we can and do all draw, either literally or in our imagination.

Drawing can be direct, incisive, intimate, surprising, funny or confrontational. Using the most limited of means, both visually and intellectually it offers some of the most demanding opportunities for growth to a contemporary artist, allowing a free transition between mediums. It is one of the simplest and yet most endlessly complex of human activities, encompassing a wide scope of practice and interpretation.

Drawing was part of my own education. I drew every day, and it was part of the warp and weft of life at art school. It is not a specific thing; it is a choice of gesture and movement and precision. I always find drawing to be the element that moves a work on, that opens a window and leads to the next discovery. I can't do without it.

When it came to setting up the Drawing School, I was interested in artists who insisted on the importance of drawing from life. The beginning of the School coincided with the closure of the life rooms at the Slade and Royal Academy Schools, which had been serious places of study for life drawing in London. Drawing had been taught with a strong moral agenda – you made a good or a bad drawing – and people were reacting to that at the time. I saw the School as offering something complementary. It seemed to me that there were students out there who still wanted to access good-quality teaching and drawing practice.

At the same time, the art world was exploding, becoming much more international and globalized. Starting the School was also about bringing students who needed a community together. Through the Drawing Year and now the Foundation Year, we offer that sense of community. The School provides a supportive and lively environment for sustained exploration in drawing, with the belief that practice strengthens hand and eye, and conceptual innovation can be generated by an active engagement with the visual world that surrounds us.

Drawing is at the heart of expression in every medium. It gives people a visual confidence that they may not otherwise find. And it doesn't matter whether you're drawing with wax or paint or clay – what is important is that drawing can access the electric current through which art is made.

Ways of Drawing gathers together a wide spectrum of approaches to drawing at the School, taking in a range of artistic practice. In the following pages, leading contemporary artists explore approaches to drawing as a way of thinking, seeing and understanding.

herman Bass

red ochre

green ocre green

pink

green

pale ... pink
purple manson

pink

(Basohli, India 1660.)
V+A

greens
yellow ochre
red
browns-

yellow ochre

To Start... *Julian Bell*

Drawing could start anywhere. A crayon scuffs paper and the child holding it sees a mark emerge. A brush runs along a batten and look, there is a line. The skid of a swung stick describes fine curves in the sand; the effects of our actions interest us and we make further marks. A zone of attention forms. Within this mental zone, whatever dots, edges or curves we produce seem to gang up and find ways of relating to one another – rhythms, behaviour patterns.

The instinctual actions out of which drawing arises are hard to discuss and they may seem hard to defend. We all know the scenario where some articulate character holds forth, while across the room another person with a pencil merely 'doodles'. That doodling is deemed to indicate inattention. Yet a great many of us feel pulled along by the fascination of mark-making, and covertly we sense that whatever subject the speaker may be pronouncing on, our drawing will in fact be the best form of attention of which we are capable.

What are we attending to? The interplay of pencil tracks parallels a wordless interplay in the drawer's mind, a cluster of concerns inevitably touching on our intuitions and memories and possibly including whatever we happen to be looking at. This cluster guides the drawing hand, and it is in this respect that the collection of marks, the drawing, will always be *about* something.

Drawers might therefore justify their activity by calling it a form of 'thought'. That makes sense in terms of the results it can generate. For behind the built and manufactured objects that surround us stand lines that first have to be drawn, and lines are less material. They may seem sheer ideas, as wholly weightless as the digital displays on our smartphones – but the hands to draw those lines and to work those gadgets will always be involved in human affairs, along with the bodies to which they belong, so that we slide this way and that on the spectrum stretching from thought to object.

Our movements on the touchscreen may start merely from the knuckles. Facing paper, they start more likely from the shoulder. As fleshly beings, we may find that the latter option retains an appeal, and the types of drawing discussed in this book head in that direction. Here we talk of work on firm surfaces, with its push and resist, its scratch, scrub and sweep. The struggle may be sweatier than work on the screen, but the taste might be sweeter.

Rosie Vohra, untitled (sketchbook), 2014, gouache, acrylic and pencil on paper

What need is there to justify this activity at all? Philosophers might claim, pointing for instance to the marvels of prehistoric art, that by drawing, 'humanity' makes known its presence in the world; but the category is too large, since there will always be those for whom drawing has no meaning. Politicians might point to the economic benefits of a flourishing design and creative sector; but while the claim may be just, it upends priorities. We earn money so we can do what we love to do, not vice versa. For in fact, love is the best available argument. A personal devotion to drawing is the factor uniting everyone writing in this book; a warmth of heart about a shared set of overlapping practices that runs through the school at which we work and which we want to communicate beyond its studios.

To set up a school for drawing is to assert that this form of activity deserves nurturing and developing. For that, it may need an enclosed arena – a studio, most obviously. The first section of this book, *Studio Space*, concerns practices that are likely to take shape in such spaces. *Open Space*, the section that follows, focuses on the need to make drawing porous to the wider world – to what, in the broadest sense, we could call 'nature', if we take that to include the built environment and the society we live in. The final section, *Inner Space*, returns to the sources of drawing – to the living, feeling person and the energies that power the body and mind.

What *Ways of Drawing* offers you, in sum, is a range of reflections and suggestions. The contributors have brought to it their individual experiences in many different areas of drawing, experiences they may have previously shared when working with students. You will come across fresh cultural frameworks. You will engage with artists giving extended expression to their personal considered wisdom. And you will find, in the 'In Practice' pieces that run through the book, short, stimulating propositions for fresh ways to practise.

Above all, we hope that when you turn from these pages, you will want to reach out and make marks.

Opposite, top: Charlotte Ager, *Kitchen Rush* (sketchbook), 2018, charcoal and pastel on paper

Opposite, bottom: Joana Galego, *Sing you to bed,* 2017, mixed media on paper

STUDIO SPACE

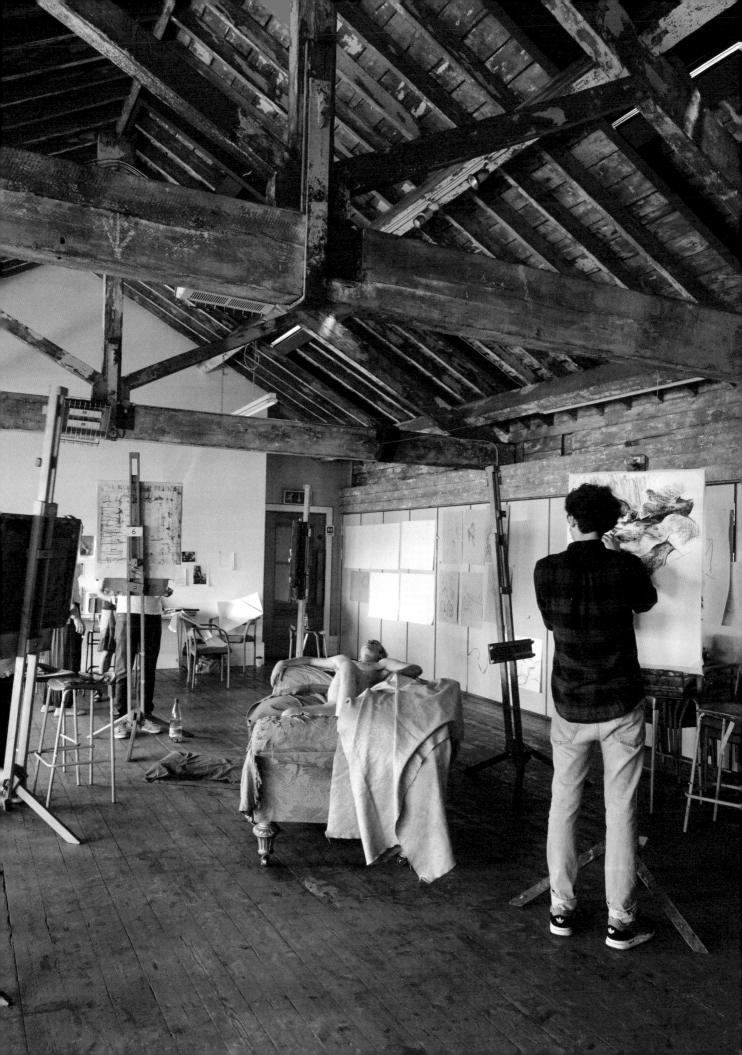

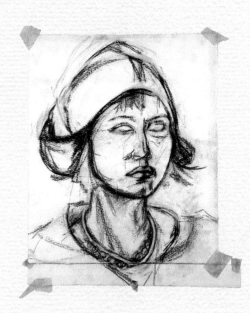

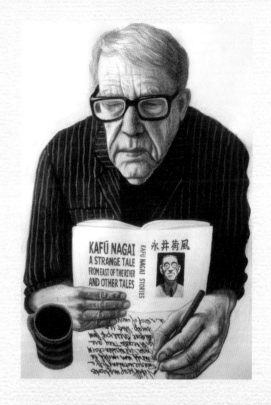

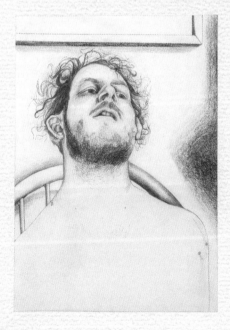

STUDIO SPACE Introduction *Julian Bell*

All around the world, at any given moment, there will be people drawing. There will be many individuals who are quietly, happily busy, focusing their minds and exercising their energies, hopeful that vivid and surprising effects will emerge from the materials they are using. We could find ready images for this broad common ground of drawing by looking at playgroups or primary school art sessions.

We might also turn to the tags on subways, or if we were to think historically, to the cave art of the Palaeolithic. In either case, it is process that rules over product. What one person has left behind encourages another to make marks, and it matters little whether these new marks abut or smother the old: in time, a cluster develops, an irregular impacted sprawl. We notice, however, that some drawings in the cluster are further developed than others. We infer a deeper level of attention in the drawer. They have been taken over by a personal obsession; some dream-demand, whether animal, angel, demon or dance of lines, has driven them along to such an extent that this image sings out louder than its neighbours.

But to rove caves and subways can only be a preamble, if it's drawing we wish to engage with. The Palaeolithic is past and most of us, most of the time, have to work inside well-defined spaces, very likely orthogonal in form. Our images tend to obey the same social requirements. An interior wall, an easel painting, a book and a screen all have confines. In this section's introduction and in the two that follow, I want to consider how these various frames affect contemporary drawing practice and shine light on the three zones with which the book's sections are concerned: the drawing studio, the world beyond its doors and the drawer's own body and mind.

It makes sense to start with the context of a building's interior, because the possibility of images made for that context underlies so much of what we have come to call art. Temples and churches were set up as formal enclosures within which worshippers would confront sacred imagery, whether two- or three-dimensional, and that confrontation carried over into secular spaces such as palaces and our present-day museums and galleries. Think how a Buddha or Shiva or Madonna presides over those who enter a hall to pray, or how a marble frieze or a fresco asks us to gaze and consider. Think of how that alertness, that seriousness, is also asked of us by full-length portraits, or by history paintings made for private clients by Titian or Caravaggio, or

Matthew Cunningham, *Held 3*, 2014, charcoal on paper

by spectaculars aimed at the gallery-going public from the days of Manet to those of Philip Guston. What is at issue in all these cases is that the images have been made for standing before. They assume that you, the viewer, are upright, with your eyes set forward and with time to stop and stare. They provide you with experiences to complement that stationariness: let there be, on the flat and vertical surface confronting you, presences that appear powerfully alive and capable of movement, and which at the same time feel subject to the same constraint of gravity that affects you in three dimensions.

Much drawing is done in relation to this powerful formula for image-making. The observational figure study, that most familiar of drawing exercises, started off historically as a preparation for the sort of painting that confronts us with a body on a wall; and however such a practice is taught, the small-scale image tends to carry certain expectations over from the large-scale. Live bodies are not indeterminate in structure. They all have some strength. They all have some weight. They all constitute variations on a certain common anatomy. To make a body come alive on the surface on which you are drawing, you may try to bring those factors out from that surface – and to do so requires both receptive, attentive observation and active, empathetic imagination. The challenges may well redouble if you move up to that smaller, tighter unit of life, the portrayed head.

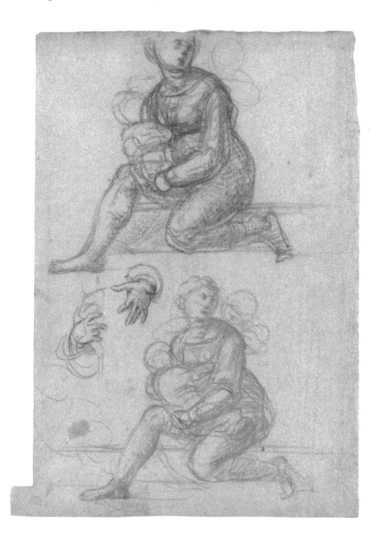

FRA BARTOLOMMEO
Study for Mother and Two Children,
c. 1515, black chalk and two shades of
red chalk, 29.2 x 21.8 cm (11½ x 8⅝ in.)

This study was probably drawn from life,
and is one of several made for a painted
altarpiece; detail and movement have
been built up using coloured chalks.
A carefully scrutinized study of hands,
made for another figure in the same
painting, also appears on the sheet.

NICOLAS POUSSIN
The Holy Family on the Steps, c. 1650, pen, brown ink and wash over black chalk on laid paper, 18.4 x 25.1 cm (7¼ x 10 in.)

Rather than drawing from life, Poussin worked from small wax figures, lit so as to sharply define their form. In this study for his painting *Holy Family on the Steps*, the absence of colour or facial detail emphasizes the pyramidal composition and play of light and shade.

Just as some passages of charcoaled limestone or aerosoled concrete stand out from others, not all figure studies are equal. Some display greater attention and empathy, and maybe we could put this down to temperament, to a happy obsessionality that only certain people share. Moreover, when it comes to plausibly lifelike figures and still more to facial likenesses there is – as everyone who has ever drawn from observation will concede – the possibility of failure. But the same societies that required public figural wall images and teams of artists to produce them have found ways to stabilize these variables. A skill tradition of figure drawing was active in painters' workshops by the early fifteenth century; by the late sixteenth, it had started to take on institutional status in the art academies, with their programmes of working from the naked model. Drawers were supplied with directives as to right and wrong practice, sometimes backed up by theoretical rationale. Distant though we are from those academies, their accumulated wisdom can be rewarding and even provocative to study. Some tutors in present-day 'atelier' art schools would go further, bidding to revive academic definitions of what is 'correct'.

The writers contributing to this book all know that drawings can go wrong – can go wrong again and again, in fact, however much we learn. They all, by differing routes, aim for the wonderful drawing that 'comes right'. They do not, however, provide assertions that such and such a practice is 'correct'. We don't want to solve all your problems. We do want to encourage you to enjoy them.

The reasons for this stance can themselves be traced back through a lengthy history. We might look for instance at the mid-seventeenth-century canvases painted in Rome, by Poussin. The Frenchman paid homage to the city's great wall paintings – by Raphael, among others – but he did so by fashioning items that were self-consciously self-contained, often for export to his native land. It was through these works

that the idea of the 'easel painting' as an exemplary art form came to fruition. Poussin's work asserts that, yes, figures have significance, but equally, so has the entire rectangular entity that those figures find places within. Standing and staring at a wall, we may only be peripherally aware of the boundaries within which large painted figures are situated; but those that seal off an easel painting are insistent. This particular form of fine art aims to make a virtue of its boundaries by harmonizing all elements of the rectangle's surface, as though the figures and the negative spaces between them constitute the plus and minuses of a resolved equation.

Drawings such as Poussin's, made with this harmony in mind, shift from studying figures in their own right to attending to the sheet in its entirety, whether through patterns of light and shade or interplays of line and bare paper. This is 'composition', as we have come to understand the term – a different kind of self-sufficiency to that of the confronting large figure. And the two agendas may be at odds. What the composition wants for the sake of its own coherence may not be what the figure seems to want. It's a tussle we see most famously in the work of a painter who stands between Poussin and the twentieth century: Cézanne. Cézanne's personal way of negotiating the tension between the sheet itself and the body being observed is often to fracture the 'contours' – the latter's outlines – and let unmarked paper stand for unmediated reality. But this is less a prototype to be followed than a salute to a mystery. The conundrum it meditates on – how might a drawing be adequate? – is one that will stay with us for as long as we believe that the practice of drawing is worth nurturing.

It stays with us because the notion of 'a work of art' stays with us, and that notion's most familiar and user-friendly form is a self-contained object that might be affixed to some wall inside a building. To cultivate drawing is to consider that it might have this status. A sheet that is a candidate to be mounted and exhibited on a wall is a sheet that is, so to speak, 'full of itself': whether marked or left bare, every part of its surface comes across as packed with meaning. And yet the route to this form of adequacy may not consist in deliberately packing the sheet with meaning (or marks). As everyone who draws regularly can testify, the happiest instances of their work, the sheets that most marvellously come 'right' or 'alive', may well be the least considered, the devil-may-care quick sketches that seem almost to draw themselves without conscious intention.

There's no certain way out of that paradox. How far you can programme yourself to be spontaneous is a question to which writers here will repeatedly return. Perhaps, however, the problem parallels on a personal level the politics within which drawing is caught. It is good that people draw. Anyone can try to exercise their energies this way, and everyone should be encouraged to do so: whether or not it's a human right, drawing is a happy activity which has fewer deleterious side effects than most. But though we might want to look on school art groups, doodlepads and graffitied hoardings pluralistically, as the seeds of a democracy of self-expression, they rarely come together to generate a conscious viewing community. That, by contrast, is what the commanding figuration in a public space seeks to summon into being. Think of the great mosaics, crucifixes and frescoes in Italian churches; think of the *Oath of the Horatii*

Rachel Hodgson, *Celine Dion – All the tears turn to dust*, 2018, oil pastel on paper

and the *Raft of the Medusa*, the mighty canvases with which David and Géricault challenged Paris; think of Picasso's *Guernica*. Without such large and challenging works of the imagination, whether in visual art or otherwise, it is questionable whether there would be such a thing as a 'public' at all. But work on this scale of ambition demands concerted training, preparation and skill specialism. It entails that within a given context, some drawings shall be better than others. It requires hierarchy. A school in the midst of one of the contemporary world's most important artistic centres has to turn its face to the resulting question of how to recognise excellence. At the same time, this school of drawing fails in its purpose if it does not cherish and nurture in every individual with whom it deals the potential – in all reasonable senses – to 'make a mark'. Between pluralism and hierarchy, it is an interesting position to occupy.

The essays that follow all consider, from differing viewpoints, how drawers might become more conscious of their practice; how they might concentrate and reflect on it, most obviously in the specially designated space of the studio. *Ishbel Myerscough* speaks for innumerable artists and would-be artists in telling of her own journey from freeform childhood enthusiasm to a discovery of what she herself found imaginatively necessary. She goes on to outline the terms of this personal truth, which she expresses in her intensely scrutinized drawings and paintings of individuals. The oil painter and printmaker *Thomas Newbolt*, whose figure compositions are painted without other persons in the studio, looks at the educational exercise that schools such as our own have inherited from the old academies: the 'life room', in which a group of drawers studies a living person who is usually unclothed and unmoving. He considers the limitations that this deliberately 'artificial' scenario imposes and eloquently conveys the discoveries with which it may reward the drawer. *Eileen Hogan*, an artist whose work is largely landscape-based, explores a refreshingly lateral way of approaching personal portrayal: enhancing your acquaintance with the individual by listening to them talk to a third party. She returns to review her past experience of academic methods. *John Lessore*, a veteran of British figurative painting, brings his depth of judgment to reflections on a lifetime's teaching of drawing and a contemplation of the relations between skill – the artisan's remit – and risk-taking – the artist's. Away from her own art of people and the places they inhabit, *Ann Dowker* takes the School's students to draw in London's National Gallery. Here, she describes how such studies of the European tradition can provide the drawer with a 'visual dictionary', offering her own vivid instances and insights. *Ian Jenkins* follows this with a consideration of drawing from sculpture, focusing on the classical sculptures of the Parthenon with which he, as curator of the ancient Greek collections at the British Museum, has a particular affinity. In the section's concluding essay, the artist's gaze is reversed. The playwright *Isley Lynn*, who has worked regularly as a model, explains with bracing wit not what it is like to draw, but what it is like to be drawn.

Kate Kirk, *Josie*, 2015, pencil on paper

Overleaf: Paul Fenner, *Around the Chair*, 2012, charcoal and pencil on paper

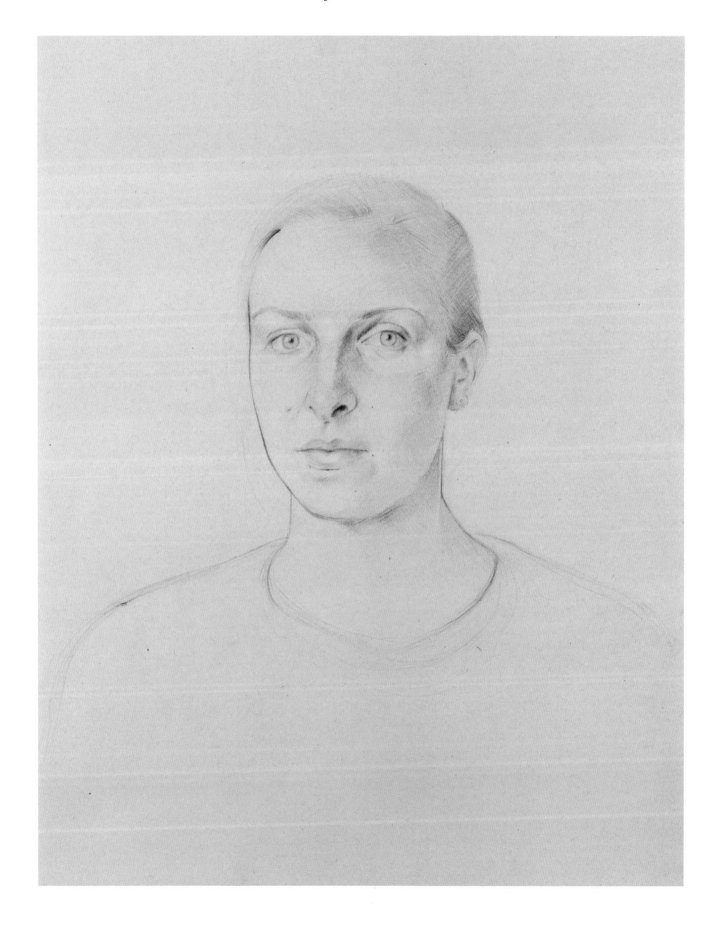

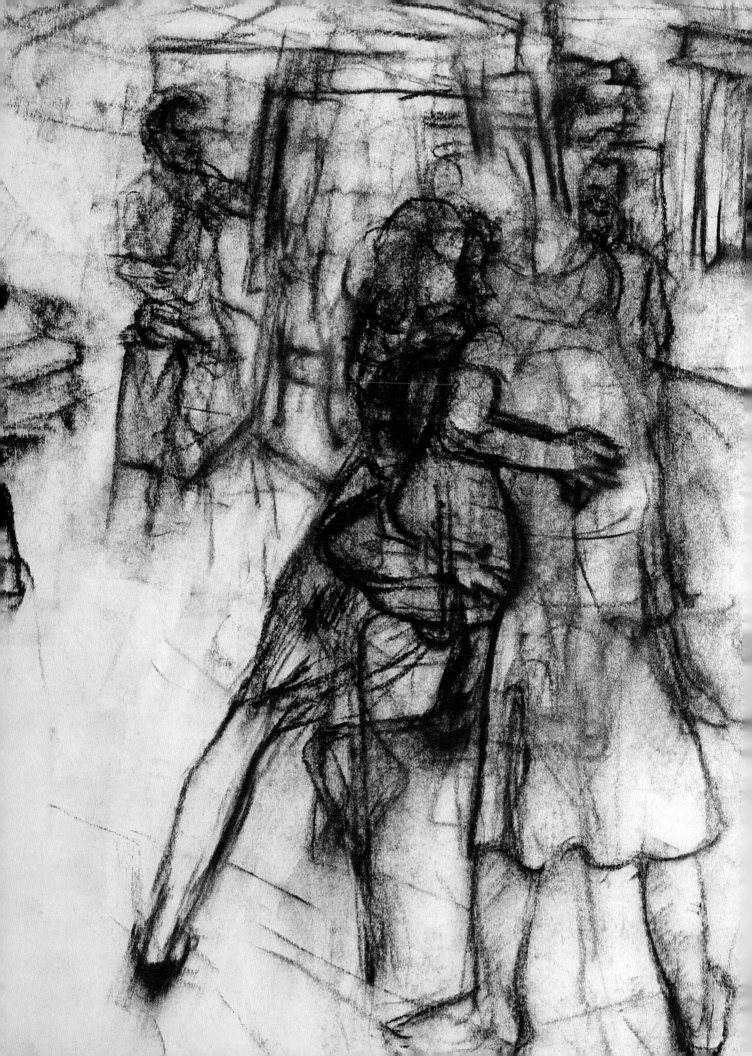

Focusing on the Individual *Ishbel Myerscough*

How a personal practice of drawing might develop,
moving from Expressionism to seek for a keener focus.

Drawing is scary. Will it go wrong? Will it look like them? What will other
people think?

A blank piece of paper creates such excitement, so many possibilities
– images that are held but not seen, more felt or smelt than visualized.
But it can also be crippling. So many people produce their most beautiful
drawings on newsprint. They can't cope with the intimidation of expensive
drawing paper. These feelings never go away, and perhaps that is all part
of the excitement. The reality is that, most often, we feel we have fallen
short of the imagined brilliance we wanted to surprise ourselves with.
This is the artist's burden to carry, and the addictive highs and lows are
a driving force for many.

Growing as a drawer

I don't ever remember not drawing – but then it is a strange child that
doesn't draw. I do remember extreme frustration that my drawings
were not good enough. When I ventured away from imaginative felt-tip
cities, drawn on a huge scale on rolls of lining paper, and tried to draw
my mother or our cat, I couldn't fathom why I couldn't make it look
like them. It took me a long time to reject my felt tips. I could chart my
development by the posters on my bedroom wall. I pinned up a Félix
Vallotton and in time it was joined by Picasso's 1928 *Visage de Marie-
Thérèse* – a poster I took with me to college and back again. As a teenager,
the Viennese Secession became my greatest influence – Egon Schiele
and Gustav Klimt – alongside the loose, fluid drawings of Rodin.

My drawing evolved in a way that was unexpected to my younger
self. In those days, I was brash, broad, strong and bold, but my drawings
looked facile. They showed flair and invention but never quite reached
what I was trying to achieve. That scrabbling around only yielded
glimpses of potential, viewed from a distance. I finally decided to
experiment with extreme concentration. I aimed to forget about the
impression I wanted to make on the world. Rather than the Secession,
I found that my attention was turning towards Holbein and Tudor
portraiture; towards Barbara Hepworth's drawings of surgeons, with
their almost etched quality; towards Helene Schjerfbeck's drawings of
herself. I couldn't fight my sharpness, my hard line, my need to define

Isobel Neviazsky, untitled, 2016, pencil
on paper

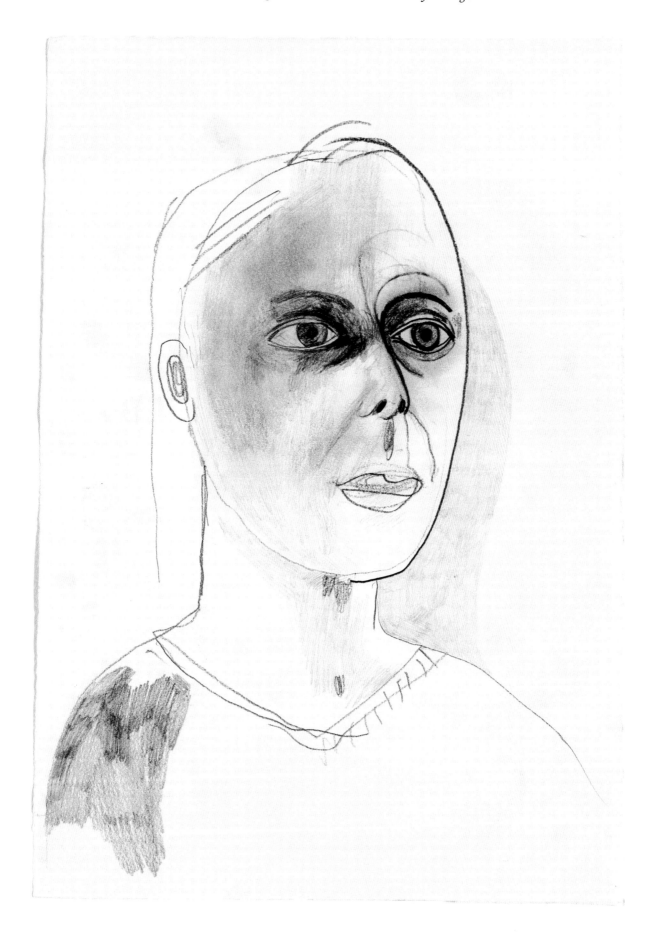

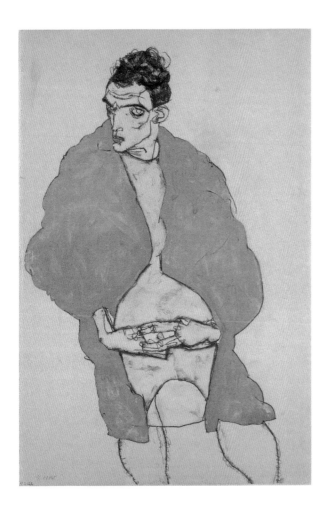

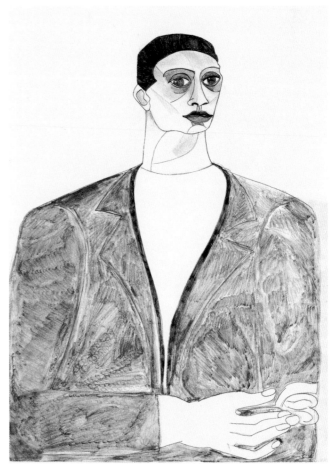

Salma Ali, *Saira*, 2014, ink and pencil on paper

the particular – observing not the general, but the nuances of the individual. I created drawings that on one level I hated for their accuracy and descriptive precision. But I also had to acknowledge that this was the closest I had ever come to the feelings I wanted to capture or inspire. I like to feel that my early exuberance is still all there, but tamed – a well-behaved monster.

Reality and concentration
Drawing is the purest form of art. It is the primary, the start line. For me, it is a means to explain things that cannot be explained with words. In trying to verbalize my work as an artist, I stand in danger of killing it – the flame might die and the spirit disappear. But, as I see it, by drawing I am investigating, compiling evidence. It is my own correlation of statistics, a layering of all I see, think and experience. Life is so complicated, intricate and unknowable. I try to break it down, capture some of that confusion, hoping to simplify but contain all that I have observed. I try very hard to leave out as much as I can, until it screams at me to put it in. I want the viewer's brain to say the unsaid.

I practise a form of drawing in the studio that is an end in itself – most often not a study towards another work. I am drawing in my own

Above, left:
EGON SCHIELE
Standing Male Figure (self-portrait), 1914, gouache and graphite on paper, 46 x 30.5 cm (18⅛ x 12⅛ in.)

Here, Schiele's characteristically precise, defined graphite line is complemented by an extraordinary use of colour. His orange garment vibrates against the blues and greens shadowing his face and torso, and picks up the almost feverishly bright spots on his lips, cheeks and ear.

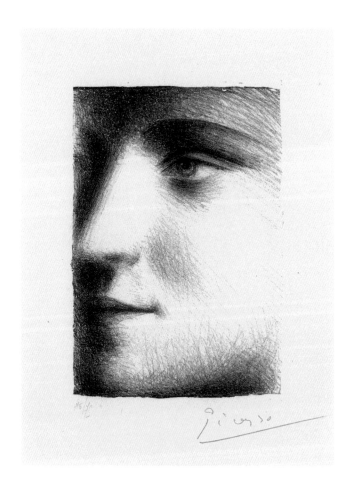

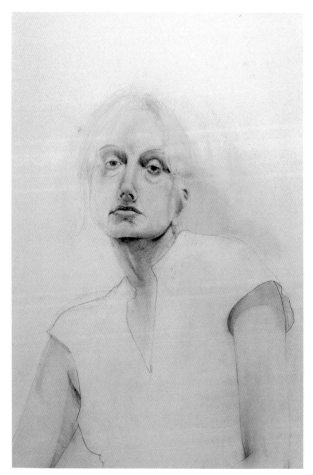

Alexis Soul-Gray, *Jane*, 2007, pencil and charcoal on paper

Above:
PABLO PICASSO
Visage de Marie-Thérèse, 1928,
lithograph on Japan paper, 20 x 14 cm
(10¼ x 8⅜ in.)

Picasso was an accomplished
printmaker, and his early lithographs
show the influence of his work in
drypoint: this image, of his young lover
Marie-Thérèse Walther, is built up from
linear strokes similar to those made by
a drypoint needle.

deliberately arranged conditions, and so approach this work differently
than when I am making quickly rendered sketches, notes to self, diary
entries or narratives retold on the page. I left my imaginary world long
ago. I need the real – models, props, rooms – and it is hours, not minutes,
that are required for this work. I need to observe the particular. More and
more, I like to draw who and what I really know, the things in my life that
I am heavily invested in. The terms of reference have become smaller as
I have grown older. I still pursue the same themes, but they have softened
or sharpened with age.

When I am in a classroom situation, I try not to impose anything on
the students. I aspire to enable them to feel comfortable, that anything
and everything is possible. There are no set ways to use a medium, and
drawing is not all about pencils and charcoal. Drawing is about making
marks with anything that will let you. Each person will have an affinity
of their own with certain media, be it coloured pencils, pen and ink or
indeed felt-tips. As well as an individual feel for materials, in a life studio
each person will see the model differently. Do they see the stubble, the
mole on the ear, or do they see a whole, an aura, a colour? One artist's
view of a model may be of a woman deemed boring because she is middle-
aged; another will see her as a contemporary against whom to judge

HELENE SCHJERFBECK
Self-portrait with a Silver Background, 1915,
watercolour, charcoal, pencil and silver
leaf on paper, 47 x 34.5 cm (18⅝ x 13⅝ in.)

Schjerfbeck completed a number of
self-portraits throughout her career,
simplifying and abstracting her line
as her artistic style developed, becoming
increasingly melancholic in her later work.
Here, her pose is self-assured, chin tilted
upwards and gaze direct. The lines of her
clothing are simple, even provisional;
but the luxurious silver leaf used in the
background elevates the status of the
sitter to that of an icon.

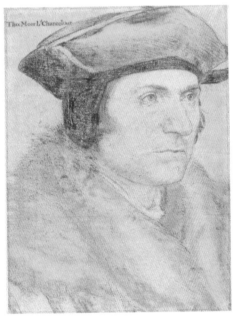

HANS HOLBEIN THE YOUNGER
Sir Thomas More, *c*. 1526–7, black and
coloured chalk on paper, 39.8 x 29.9 cm
(15¾ x 11⅞ in.)

This study was almost certainly drawn from
life. The outlines of the drawing have been
pricked for transfer, indicating that it was
likely a preparatory study for a painting of
More – a number of these studies survive,
but in this case the painting itself does not.

BARBARA HEPWORTH
Concentration of Hands (2), 1948, pencil and
oil on plywood, 26.7 x 34.3 cm (10½ x 13½ in.)

'There is, it seems to me, a close affinity
between the work and approach both of
physicians and surgeons, and painters
and sculptors,' said Hepworth of her time
drawing in the operating theatre. Her
precise, almost rhythmic line here echoes
the movements of the surgeons at work.

Ishbel Myerscough, *Chuck,* 1996, pencil and pastel on paper

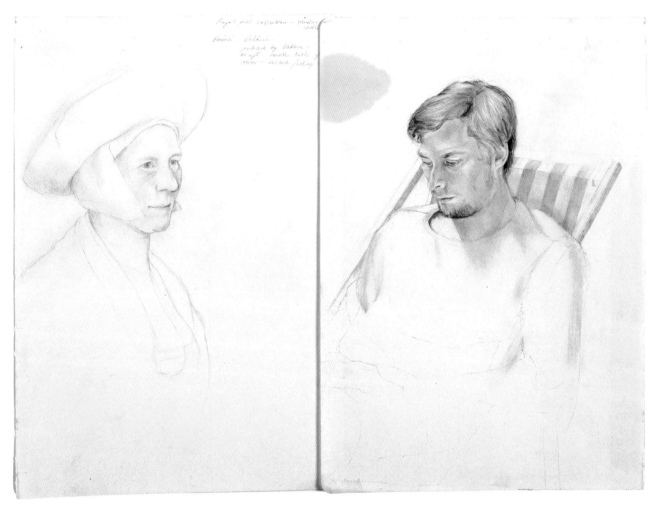

Pollyanna Johnson, *Heads,* 2016, pencil on paper

themselves; a third, a beautiful woman of fascinating depth. We all come at the individual from our personal angles.

I try to encourage the alchemy of concentration. Drawing is like magic. If we allow ourselves to detach from the world around us and form a perfect bubble between ourselves and the object, to shake off feelings of expectation or embarrassment or indeed our own hope for brilliance; if we stay calm, treat the viewed in an almost abstract fashion, focus on the essential; if, at first deliberately and then unconsciously, almost meditatively, we remove the fact that we are looking at a nose or an eye, or even a head or a person; if we watch the way that the line of the inner eyelid lifts at the corner, the improbability of the shape of the shadow under the nose – if we concentrate that hard, not making judgments while we are doing so but forging ahead until the trance is broken, when there will be an opportunity to stand back and assess – if all that is truly achieved, then magic is made. Whether or not the observation is right, in proportion or even has a likeness, an intensity has been achieved, a point of fascination. And that is what a drawing really needs.

Liam Walker, *Self-portrait Thinking of Heroes,* 2016, pencil on paper

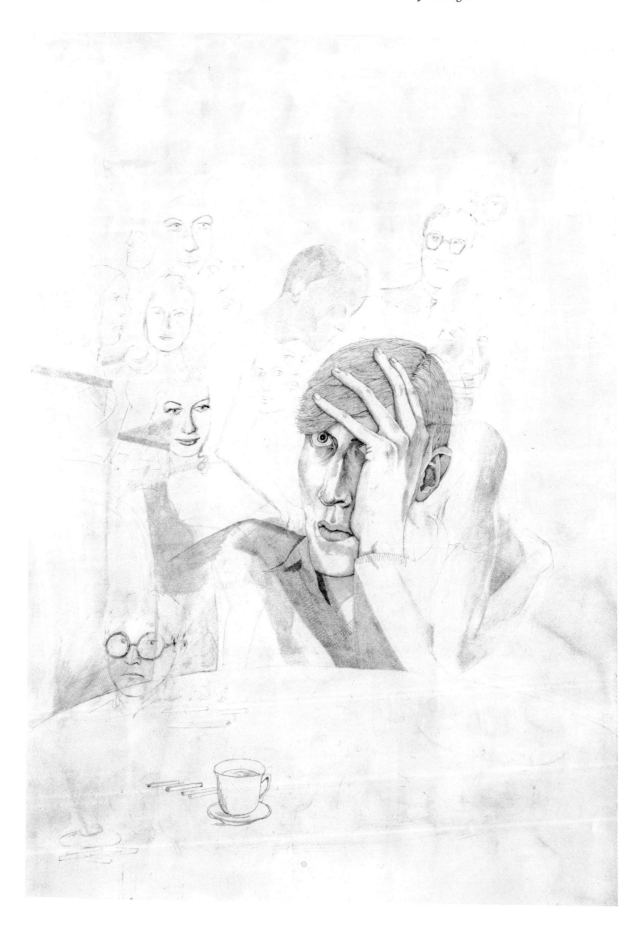

The Impact of Intimacy *Ishbel Myerscough*

WHO: *a group of drawers (preferably) and a sitter*

More often than not, when drawing we impose our world on the model. Life models are mostly unknown to us, a stranger to dissect and analyse. This session involves the class asking the model questions, with the aim of making more personal drawings of them.

If you are working in a group, form a circle and set up the model in the middle. The model should sit for a series of six five-minute poses, turning with each pose so that everyone can draw them from each angle.

Then, ask the model to take a longer pose, perhaps two forty-five-minute sessions of the same pose. This time, the artists should ask the model questions to get to know them better. Don't get too personal. Where did they grow up? Do they have siblings? Have they ever had short hair? How did they choose what they are wearing today?

The experiment in this session is to see whether drawings are altered by having this information, in contrast with the assumptions we might usually make about those we draw.

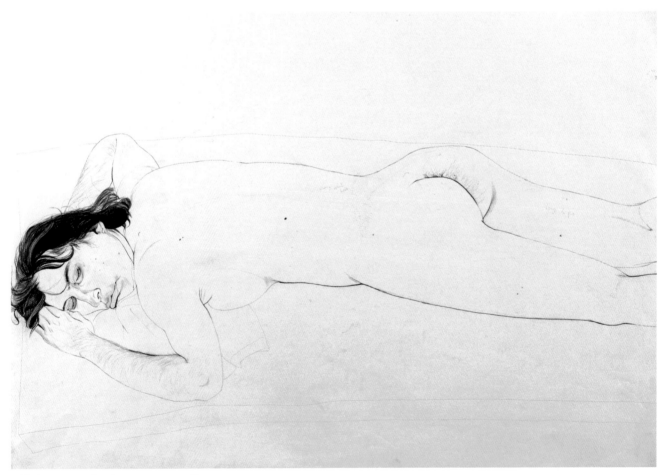

Ishbel Myerscough, *Figure 2*, 1995, pencil on paper

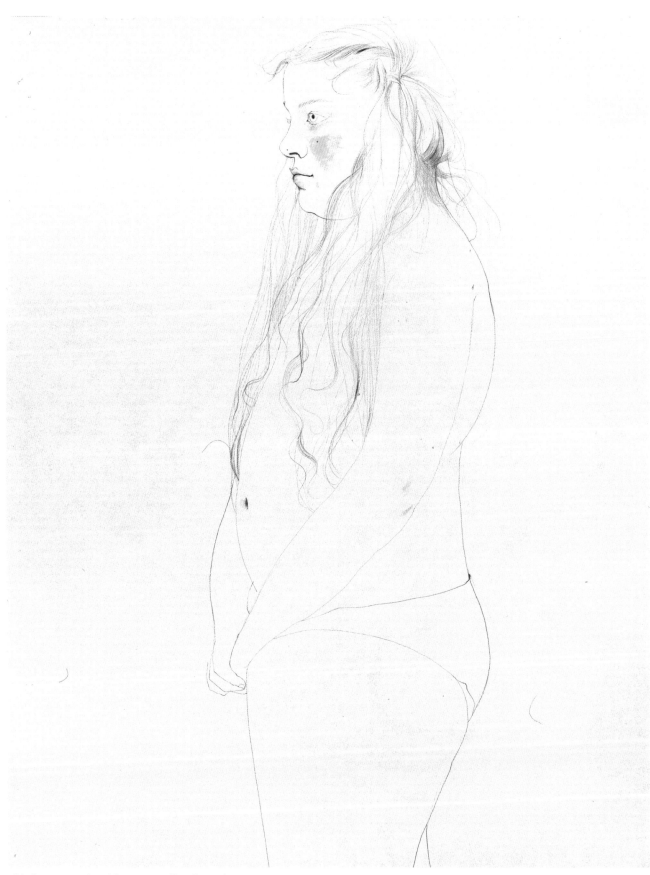

Ishbel Myerscough, *Girl*, 2016, pencil and pastel on paper

The Life Room *Thomas Newbolt*

What kinds of 'life' and 'truth' might be discovered by
working in the artificial space of the 'life room'?

A life drawing studio provides the equipment necessary to make
a drawing of the figure with reduced distraction from the external world.
A life class is an artificial idea requiring that the model be unnaturally
still, that the materials used be simple and to hand and that the light
be sufficient.

For a successful class, it is vital that there be mutual, professional
involvement between tutor, model and student. Each student has to
maintain a high level of concentration in order to work imaginatively and
inventively through what is, at the Royal Drawing School, a six-hour day.
Imaginatively, because while life drawing is a descriptive, documentary
form of study, it is balanced by the student's sense of their own technical
and artistic development; inventively, because the size of the problem forces
the person drawing to invent a visual language which leaves things out.
It is necessary to maintain an imaginative connection between successive
drawings and between the beginning and the end of a long drawing;
drawings have to feel real, even if that reality is clearly constructed.
The student strives to create a world that is vivid, lifelike, convincing.

It is in the nature of drawing that we see the world through the part
of it in front of us. But what happens in the life room is also extraordinarily
to do with memory, with elements that are not in front of us at that
moment. Proportion and anatomy are just two important aspects of
drawing practice that would be hard to learn from looking only, without
reference to diagrams or medical knowledge. Proportions are distorted
if the student is close to the model, anatomy less visible when the model
is far enough away to be seen entirely. A drawing made from seven or
eight feet away is constructed from at least two or three angles of vision.
A drawing made from eighteen feet away – the distance needed to see
a standing figure without moving your head, clearly impractical in most
life rooms – will feel lacking in essential detail. Anatomy, perspective,
proportion, colour, form and composition are usually studied in separate,
specialist classes, and drawing and painting are very rarely taught
together, though each one of these skills has a place in the life room.

The act of drawing articulates feelings about perceived experience;
it is a gesture of approaching and not possessing the world around
us. Acceptance of the world as it is and a yearning to reach a 'truthful'

Constanza Dessain, untitled, 2012,
charcoal on paper

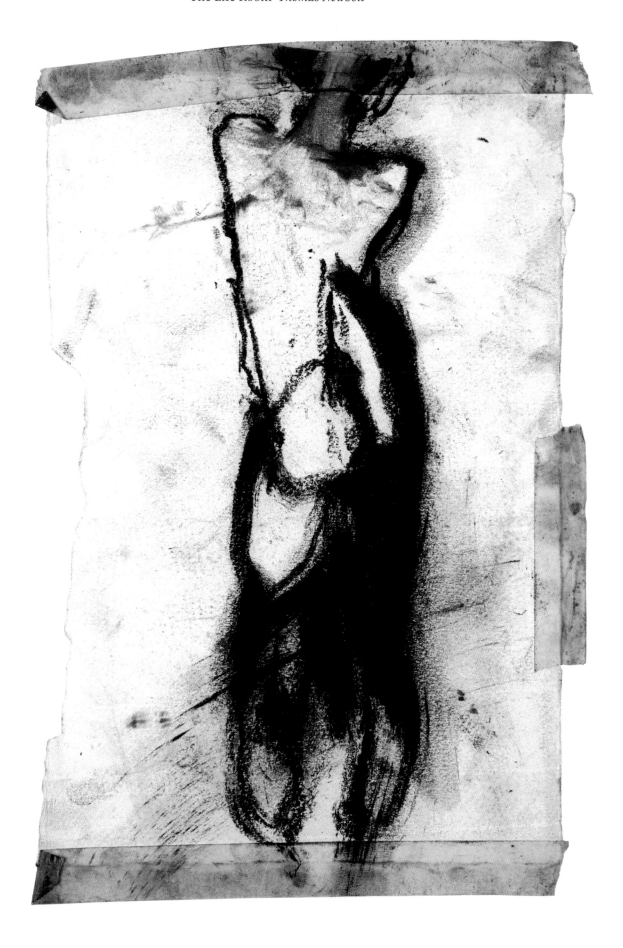

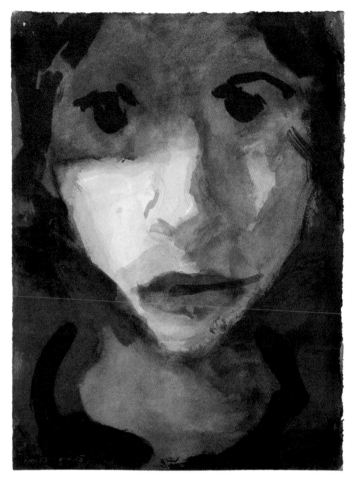

Thomas Newbolt, *Head no. 31*, 2015, watercolour on paper

viewpoint are shown by the individual student's touch, by their placement
of drawn elements and the overall feeling manifest in the finished drawing.
As forms are made and remade, luminosity evoked and controlled,
proportions examined and perspective adjusted, one is often taken
unawares by the newly minted, self-renewing richness of the surrounding
world. Our acts of creation make us more aware of existence.

These endless acts of defining and redefining encourage both
passionate involvement and calm detachment. The same student can
be at one moment engrossed in a blind, ecstatic pushing-through of the
desired idea, the next silently amazed as, stepping back, the irritatingly
unconnected fragments on the page show themselves to have unity of
purpose. A tutor, moving towards the student's easel from across the room,
may affirm this counterintuitive discovery; standing side by side, tutor
and student share the experience of the model before them, and can check
and verify each part against the whole.

Much as knowledge of proportion and anatomy may visibly regulate
the student who is drawing from life, so may the work of other artists.
In the life room, students with art-historical knowledge will rub shoulders
with those who have none. Copying from other artists' life drawings can
be very useful in order to encourage unity of effect and fluent transitions

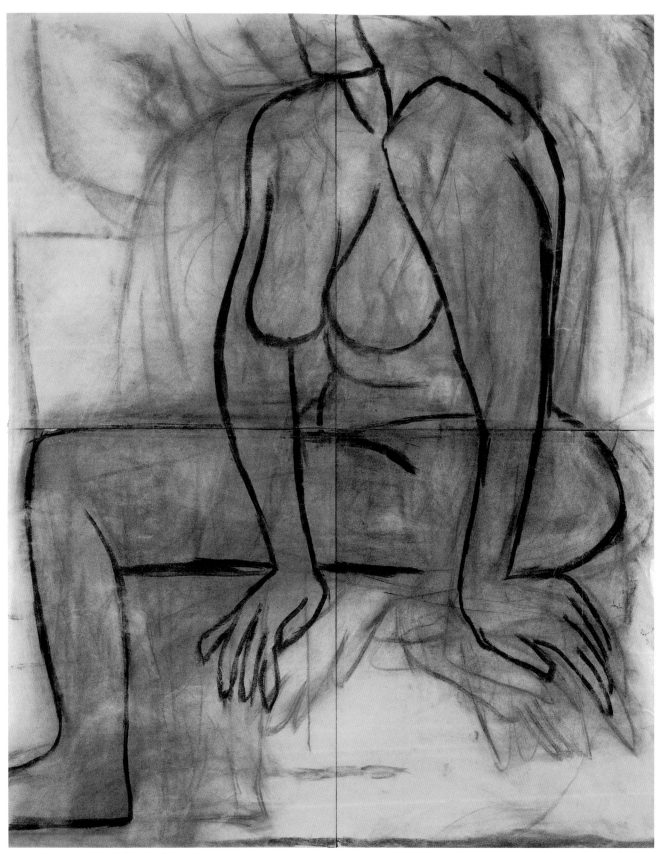

Rose Arbuthnott, untitled, 2010, charcoal on paper

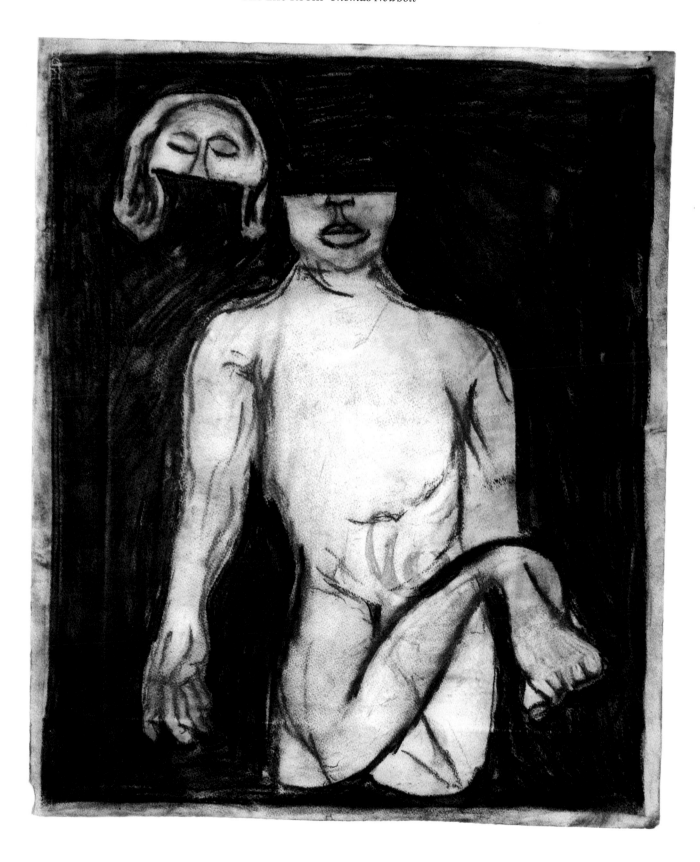

Opposite: Anna Bergin, *Series 2,* 2015, charcoal and pencil on paper

Above: Rosie Vohra, *A Part of Me, Apart From Me*, 2014, charcoal on paper

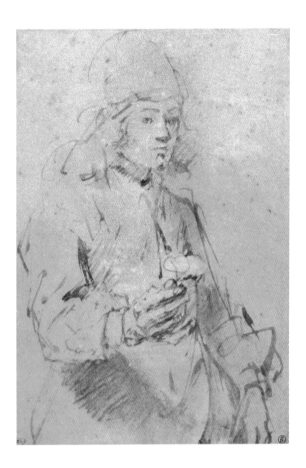

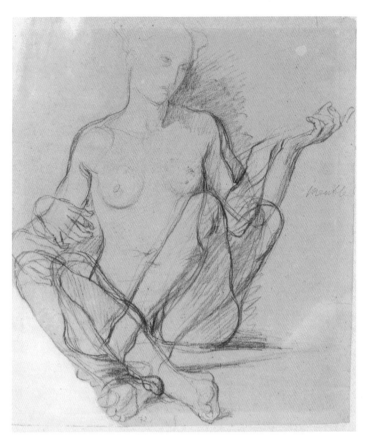

Above, left:
REMBRANDT VAN RIJN
Young Man Holding a Flower,
c. 1665–9, pen and bistre, 17.5 x 11.8 cm
(7 x 4¾ in.)

Here, a three-dimensional figure is
worked from two-dimensional space
using fluid, sparing pen strokes. The
blank areas of Rembrandt's sheet are
as important as the marks in creating
a sense of light and volume.

Above, right:
JEAN-AUGUSTE-DOMINIQUE INGRES
*Nude Study for Odalisque with Slave
(study for figure playing lute)*, 1839–42,
black chalk on paper, 23.3 x 20.3 cm
(9¼ x 8 in.)

In Ingres's finished painting, the
figure playing the lute is clothed;
this nude study was perhaps
completed to understand the way
the pose works more fully. Ingres
was instructed in the studio of
Jacques-Louis David, who stressed
the importance of drawing the nude
model.

in the body – for example, head-neck-shoulder or back-hip-thigh. Copies
are *not* made so as to repeat the original. Far from it: we in the life class
know that Rembrandt, like the model, like live music, cannot be repeated.
They are made to get closer to an image which flows, and to explore the
ways in which things work together. Made regularly, copies encourage
drawings that look for links between disparate features and bring breadth
to the reading of a pose; instead of seeing the musculature of the knee as an
isolated event, we may start to regard it as a ruby in a richly jewelled sword.

A rapid sketch works partly because the chosen observations have
been thought of and seen together; a drawing of a longer pose works
partly because it has developed simple, fluid rhythms and echoes across
the sheet. With practice and experience, the student becomes more aware
of the need to find simple ways to convey the complex, interrelated forms
of the body on flat paper, often reducing them to a coherent tonal pattern
or an elegant reduction in line. Andrei Tarkovsky writes that 'In the end
everything can be reduced to the one simple element which is all a person
can count upon in his existence: the capacity to love. That element can
grow within the soul to become the supreme factor which determines the
meaning of a person's life.'

As the arm moves over a sheet of paper, it makes marks that celebrate
aspects of that sheet: its size and shape, its capacity to be luminous and
to allow projecting, shallow, swirling, rounded and angular forms to be
worked from its surface – always in relation to each other and in harmony

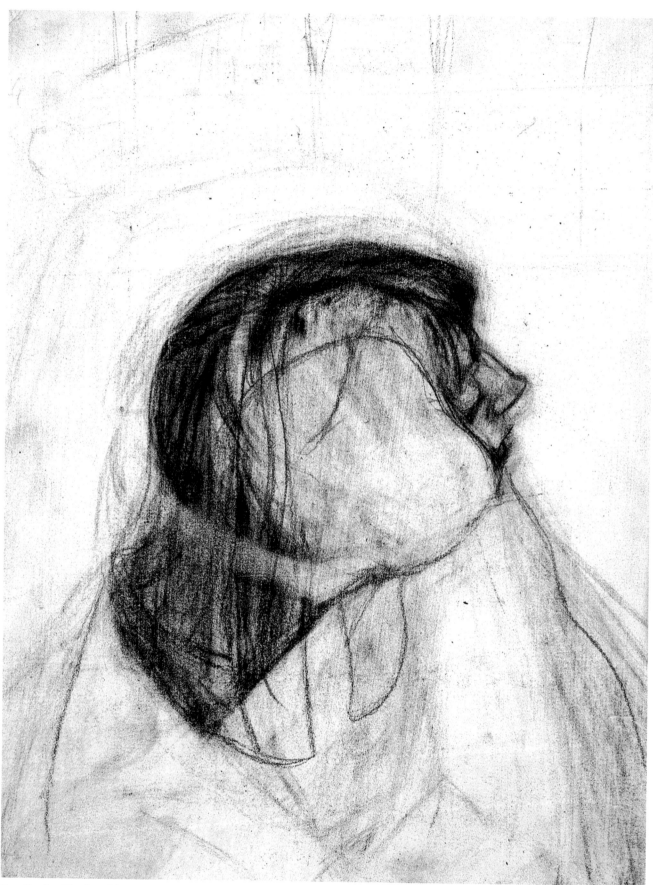

Tom Sander, *Sleeping Girl*, 2011, pencil on prepared paper

Maxwell Graham, untitled, 2011, charcoal on paper

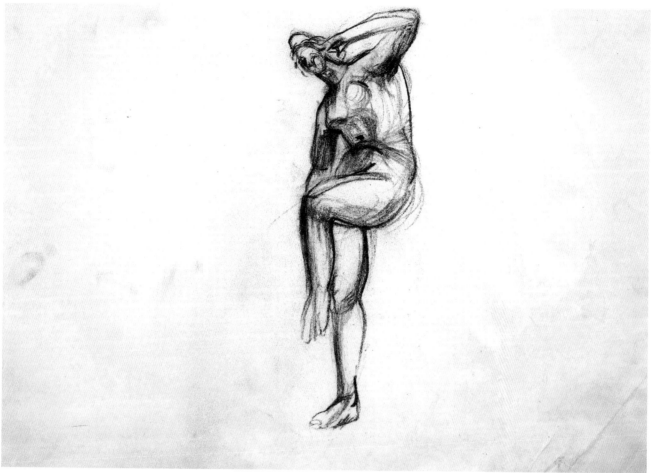

Georgina Sleap, *Dancer*, 2011, pencil on paper

with the two-dimensional space of the sheet. The student desires a fully rounded – three-dimensional – figure, and the paper's essential flatness, its reluctance to divulge its secrets, brings frustration. The tutor advises compromise: allow the figure to lose itself in the imagined space of the sheet and the whole rectangle will come alive from edge to edge, will be full of felt space. The student says: *I need to learn to draw the figure first.*

The tutor withdraws, returning later; the white paper around the student's marks is beginning to glow. The room hovers in the twilight. The student could and probably should start a new study, but works silently in the gloom, now reducing the number of elements in the drawing until one sees only what can be seen. The agony of losing, of sacrificing much of what has been so steadily achieved, prevents the student from calculating the tonal effect of their drawing or from noticing the way that all the concerns of the day have become wrapped up in the tapestry of line and tone that has woven the figure and surroundings together.

Flatness and Depth *Thomas Newbolt*

WHERE: *indoors*
WITH: *large sheet(s) of paper*

Cut a piece of paper or join two separate pieces to make a sheet 20 cm high and 60 cm long (approx. 8 x 24 in.)

Stand in a room and find a position from which you can see the entire space. It doesn't matter if there are a few easels or heads blocking your view. Now, try to limit your view, seeing things that are at eye level only – this should be a band of vision approximately 20 cm high. If it helps, you can use your hands to identify this space – one hand flat above your eyes and one below, as if shielding your eyes from the sun.

Draw this narrow section of the room on the narrow sheet of paper. Make sure to draw only what is at eye level. If you rotate your body slowly through 180°, there should be no part of the drawing that is hard to see.

It will be clear almost immediately that the results of your observations form a flat band. The exercise therefore depends on your ability to show depth despite these restrictions. Try to make your drawn observations read as depth, while hopefully enjoying the beauty of their flat arrangement.

Irene Montemurro, *What the Water Gave to Me*, 2018, ink on paper

Harry Parker, *Life Room/Las Meninas*, 2015, pencil on paper

Looking and Listening *Eileen Hogan*

How does personal knowledge of the subject change
a portrait? What happens when the sitter speaks?

I was first able to watch the changes flicker over a speaker's face as
they told their life story in 1997. The encounter was almost accidental.
When I first set eyes on the poet and artist Ian Hamilton Finlay, he was
in intense conversation with an oral historian armed with a tape machine.
They were inside a glass conservatory attached to Ian's cottage at Little
Sparta, the garden he created in the Pentland Hills near Edinburgh; I was
outside in the rain, unnoticed by Ian. I watched the theatre of his face
without being able to hear the words, and was transfixed. I found myself
speculating about what his expressions represented. This triggered
a desire to find out what was being said and to see how it might affect
a portrait sitting.

I don't consider myself a portrait painter, so I have been surprised
to find myself – on that occasion and many subsequently – involved in
portraiture. Since watching Ian being interviewed without being able to
hear what he was saying, I have, with everyone's agreement, sat in on oral
history sessions with the politician Peter Carington, the art and antiques
dealer Christopher Gibbs, the fashion designer Betty Jackson, the hedge
fund manager Paul Ruddock and the former ballerina Anya Linden, now
Anya Sainsbury. These were all recordings made for National Life Stories
at the British Library, London, an oral history charity that sets out to
capture social history. A selection of people are given the opportunity
to document their life in their own words, from far-back family history
through childhood, training, work and personal life. Usually there are
a number of sessions of roughly three hours at a time, sometimes spread
out over several years.

These sessions allowed me to witness the telling of in-depth
autobiographical narratives without ever being the focus of attention myself.
I was left free to register the relationship between spoken testimony and the
facial movements of the narrator, who became the subject of my drawings
and portraits. Listening as I drew, each person's story seeped into my
understanding, and I am sure that this indirect way of coming to know
them fed into the images I made. This is, I believe, quite a different
experience from the traditional studio relationship between artist and sitter,
in which a kind of tension can exist: either the artist feels obliged to make
conversation when actually they need to concentrate on what they are doing,

Eileen Hogan, *Ian Hamilton Finlay
Walking Towards the Roman Garden*,
2009, charcoal on paper

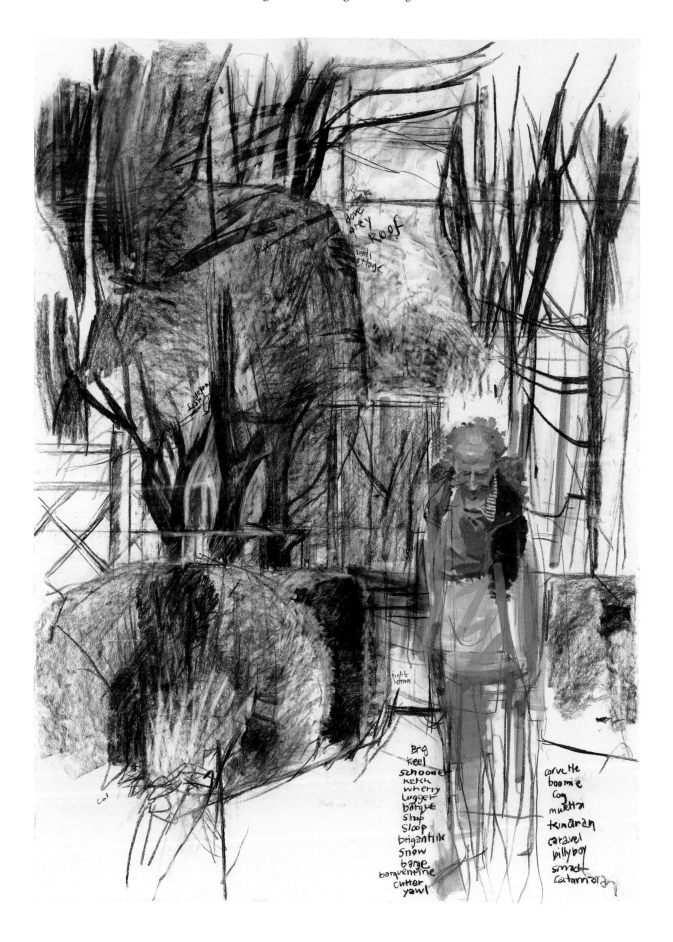

or else a silence arises while the person who is being painted stays fixed in a single position.

The oral history sittings were very much about watching the person as they spoke about their lives – talking about intimate, moving, occasionally harrowing or sometimes extremely happy episodes – and watching the effect that this had on their face and gestures. As I drew and painted, it was enormously helpful to listen to the recording and learn about the person and their life, but it was also useful to have the distraction of the recording to take their attention away from me: they more or less forgot that I was at work. Being a 'fly on the wall' observer meant that I did not choose the room, the poses or the clothing of my sitters. They were not there primarily because I was going to make a portrait of them. After the initial greetings, I did not have to – and indeed was not meant to – engage directly with the person being interviewed until the recorder was switched off and the session ended. I usually sat quite close to them, and my presence quickly became part of the background as they became absorbed in their engagement with the oral historian. Because of the length and nature of the recordings, the relationship between interviewer and interviewee became one of sustained trust, and I was able to share in the consequent intimacy and informality which developed.

Below:
AVIGDOR ARIKHA
Samuel Beckett, 1971, graphite on primed brown paper, 24.1 x 15.9 cm (9½ x 6⅜ in.)

Arikha drew Beckett, a close friend, many times; he described the Irish writer as his 'lighthouse'. Throughout their friendship the two discussed a broad spectrum of art, literature and music, and kernels of their shared interests can be found across their work.

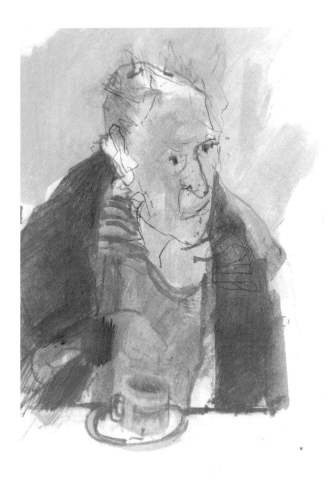

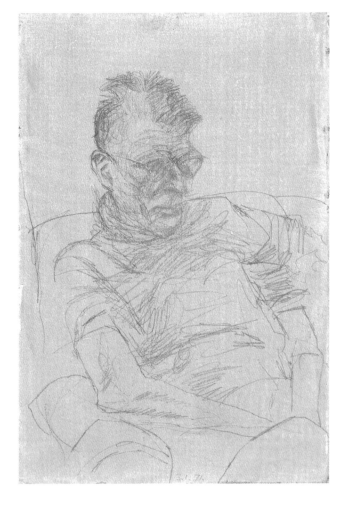

Eileen Hogan, *Ian Hamilton Finlay in the Coffee Spot, a cafe in Biggar*, 2005, oil and pen on paper

Above:
JEAN-MICHEL BASQUIAT
Monticello (The Daros Suite of 32 Drawings), 1983, acrylic, charcoal, crayon, pastel and pencil, 57 x 76.5 cm (22½ x 30⅛ in.)

The collection of words, phrases, erasures and underlinings is anchored here by a series of full or partial portraits – from the 'lower jaw' to a profile on a $1 coin, to the bright, central head, turned just slightly towards the viewer.

Right:
GRAYSON PERRY
Vanity of Small Differences
A4 sketchbook, 2012

Below this study for a 2 x 4 m tapestry, Perry has recorded small, revealing details of his subjects' lives – 'MC [middle class] stuff aga etc' – a reflection of the *Vanity* series' focus on taste and social class.

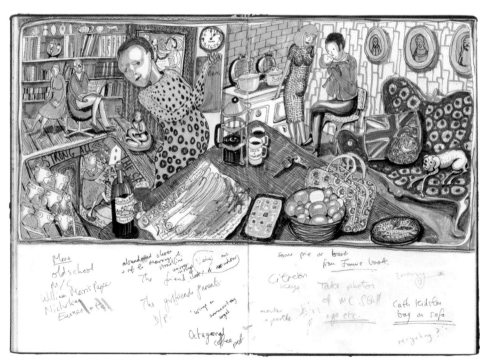

Timothy Hyman, *Judith*, 2011, pencil on paper Amy Ison, *Emily Convalescing*, 2011, pencil on paper

During each session, I drew and made a study of the person's head
using pencils, oil paint and wax. Returning for successive sessions,
I came to know each of the interviewees' faces in detail, and witnessed the
changes in energy and mood from one month to the next as well as more
literal alterations like haircuts and clothing. Crucially, unlike many portrait
sittings, the faces were in constant movement and the poses were not
sustained for long; people shifted in their chairs as they spoke, their whole
bodies expressive. There is a great deal of difference between trying to draw
a face in motion and drawing a person who is quite still. When the person
moves, I'm absorbed in looking for long periods without drawing in order
to discover their characteristic positions. My studies were unfinished, and
'unfinishedness' became a deliberate part of my process. I was capturing
the sitter in a state of flux, physically animated but also mentally moving
through time. In this way, my portraits came to represent the process of oral
history itself, as well as the sitter and my reaction to them. Focusing on the
process became as important as the final portraits I made later in my studio.

I sat in on eighteen recording sessions, each lasting about three to four
hours, while Anya Sainsbury was recorded by Cathy Courtney. My presence
obviously altered the dynamic of the recording – having an artist present
is not normal practice for oral historians. I discovered that I was interested
in what was *not* said in a recording – in the nuances of delivery and tone,
and in watching people's faces as they talk about their lives. Oral history
can reveal material that I can't imagine discovering in any other way. In the
1960s, Sainsbury had attended some drawing classes at Camberwell School
of Arts and Crafts, London, taught by the painter Anthony Fry. She recalled
an exceptionally thin male model. I was a student in the Painting School at

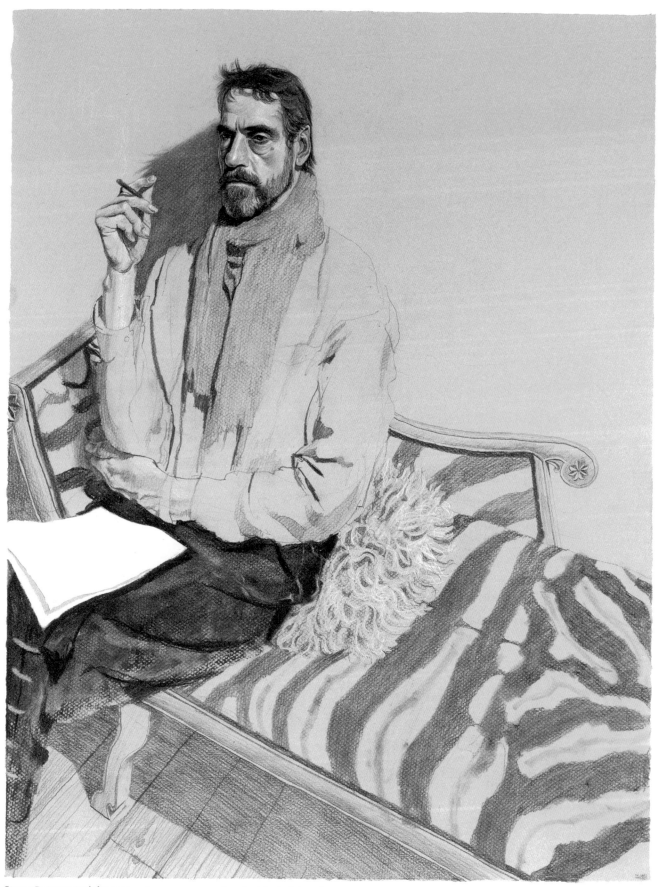

Stuart Pearson Wright, *Jeremy Irons*, 2005, pencil and white heightening

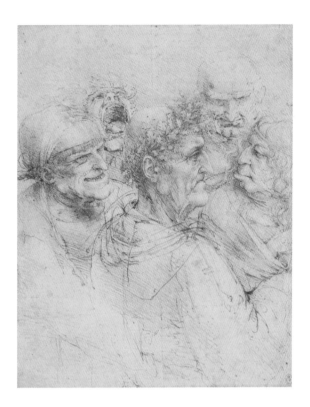

Rebecca Harper, untitled, 2013, watercolour and etching on paper

Opposite, left:
LEONARDO DA VINCI
A man tricked by Gypsies, c. 1494,
pen and brown ink, 26 x 20.5 cm
(10¼ x 8⅛ in.)

A claustrophobic, menacing
atmosphere is evoked here by
the densely worked, animated
faces and close composition
of the piece.

Opposite, right:
R.B. KITAJ
Study for Rock Garden, 1980,
etching and aquatint, 87 x 60.5 cm
(34⅜ x 23⅞ in.)

Kitaj was a skilled printmaker as
well as a painter – in this portrait,
aquatint and the burr of the
etching create a soft edge, picking
up the texture of the figure's hair
and shading their eyes, contrasting
with the illuminated mouth to add
drama to the expression.

the same time and realised that I had drawn the same model. He must have been very ill, because he was cadaverous; the painter Euan Uglow posed him next to a skeleton used for anatomical studies. Her recollection raised pertinent issues relating to life drawing, how models were treated and what their role was. We were taught to draw the life model not as a human being, but a series of shapes to be compared and measured – we rarely drew a person with a face, as I was doing with my oral history studies.

Although I didn't realise it at the time, I was taught at Camberwell by the first generation of artists who had been influenced by the Euston Road School of realist painters, and I became a user of the 'dot and carry' system of drawing. It took me a long time to learn how to draw more freely, without stopping the pencil every millimetre to measure – I broke the habit mostly through obsessive drawing in sketchbooks, much of which was internalized, psychological as well as observational. What I'm trying to do now in my work is to combine the rigour of observation, which I learned at Camberwell, with being very interested in people.

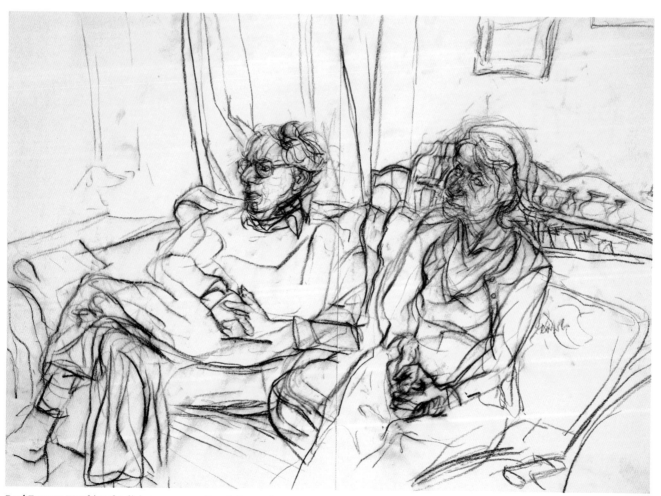

Paul Fenner, *Watching the diving*, 2012, pencil and charcoal on paper

Oral Histories *Eileen Hogan*

WHO: *a group of three drawers*
WITH: *pencils or charcoal and paper*

This project should take two hours in total. One person in the group will be the sitter being interviewed, one will act as the interviewer and one will draw the sitter. Each session will last forty minutes, after which the roles should be rotated. The exercise is to watch someone closely and draw their portrait while they are engaged in conversation with the interviewer.

Oral history interviewing is a special technique and is too probing for an exercise such as this; the person in the interviewer's role should take care not to dig too deeply

into very personal or sensitive issues. It might be helpful to agree on some topics to explore before you start. The person drawing should spend at least as much time looking: make notes, try to draw unselfconsciously and don't worry about whether your drawing is 'good'.

Produce a number of quick drawings as the person speaks. It may help initially to draw with your left hand if you are right handed, or vice versa, so that you don't have your usual level of control.

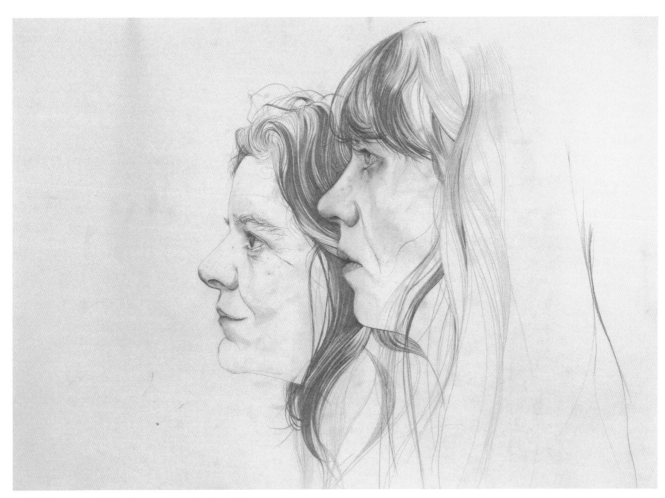

Ishbel Myerscough, *Friends*, 2015, pencil and pastel on paper

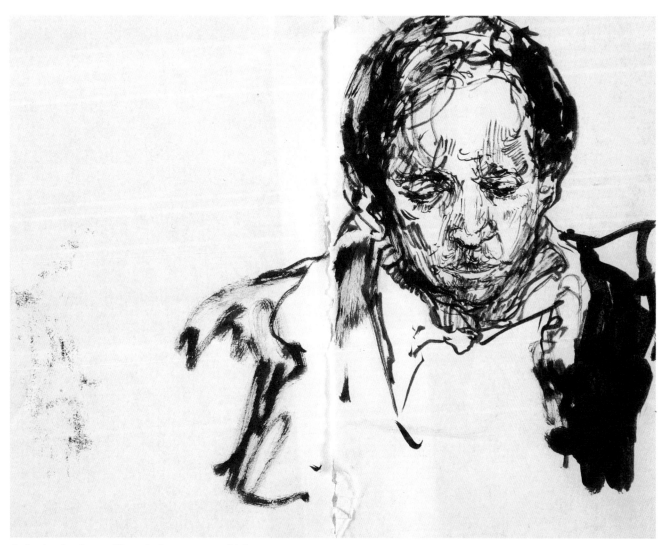

Catherine Goodman, *Vikram Seth*, 2011, pen and ink on paper

Skill and Vision *John Lessore*

What can teachable techniques add to an instinct
to draw?

Drawing is in all visual art, and paper is its most common medium.
One tries to create a luminosity as beautiful as the white sheet before we
began our assault upon it, and one strives to create a sense of light as well
as space on the page; drawing without light is not drawing. The draftsman
navigates between statement and suggestion to create movement and
life – as in literature, descent into too much description kills the image.
A drawing must feel alive.

 'Drawing' has two interconnected meanings: the rendering of the
artisan and the creation of the artist. One might look to the great Florentine
draftsmen of the Italian Renaissance for an example of the relationship
between the two: they were, at their best, both artisans and artists. Artisans
are skilled and highly trained; they know what they are doing and can
achieve a good end product. Artists aim to surpass themselves; they take
risks and are likely to fail as well as succeed. Our forebears were both.
Many of us today wish only to be artists; I think that this is a mistake,
and the reason we achieve so much less.

 In an observational drawing, the basis of rendering is the picture
plane: an imaginary, transparent pane through which one maps the
subject onto the paper. This invisible plane and one's paper must both
be perpendicular to the eye, to avoid distortion. One draws on the paper
as if one were tracing an image on the picture plane. This gives 'sight-size'
images – so a figure only a few feet away should fit comfortably on an
A4 sheet of paper. For most people, it will feel natural to draw at this
size. Some people will find it particularly hard to remember small
shapes, and it can help to draw larger in order to sidestep this difficulty.
It is worth bearing in mind that the draftsmen of the past used
methods such as this to make life easier for themselves, and regularly
took shortcuts in their work; it seems foolish not to do the same.

 I do not measure the subject I am trying to draw, or teach students
to do so. By nature we are bad at this. An alternative, which I do teach, is
directional reference. Using a straight edge, real or imaginary, one can line
up any two points on the subject, transfer this relationship to the drawing,
repeat to triangulate, and so on. We are better at thinking like this, using
the same part of the brain and nervous system that we use to pick up
and drink from an over-full glass without spilling a drop. One should not
have difficulty keeping angles; a good sense of proportion helps. Drawing

Thomas Harrison, *The Martyrdom
of St Sebastian by Antonio and Piero
del Pollaiolo*, 2017, pencil on paper

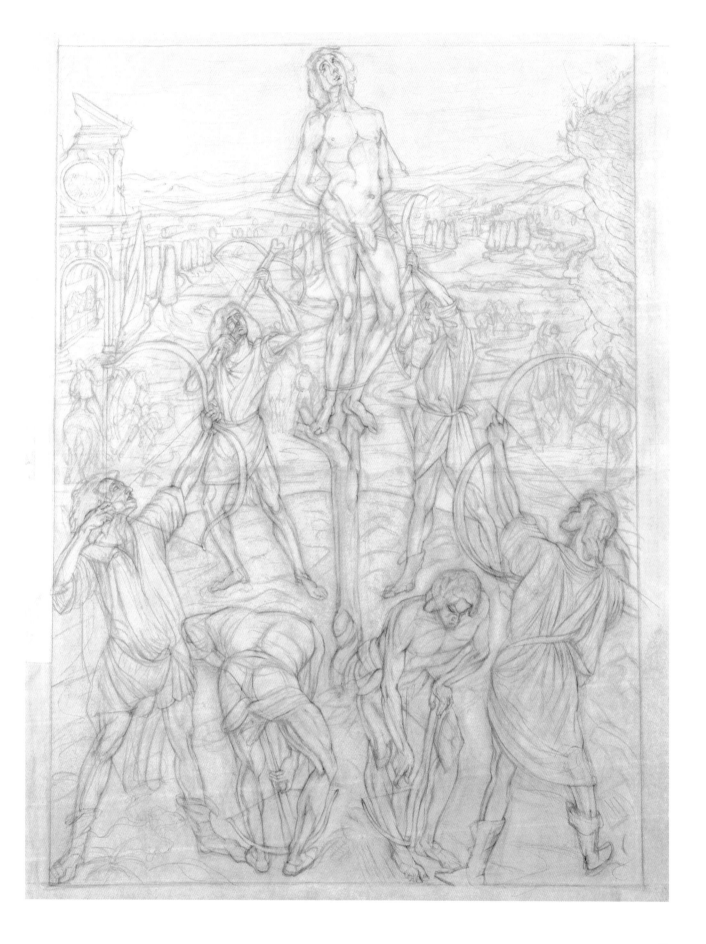

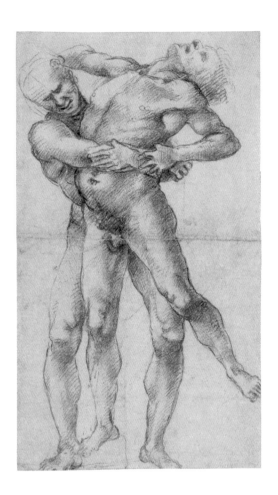

Left:
LUCA SIGNORELLI
Hercules and Antaeus, c. 1500, black chalk, 28.3 x 16.3 cm (11¼ x 6½ in.)

Strong, worked outlines and the artist's precise but energetic line creates a sense of solidity and movement here. On the left-hand figure (Hercules), the preparatory drawing used to mark out the face remain visible.

Below:
NICOLAS POUSSIN
Acis transformed into a river-god, c. 1622–3 graphite, pen, brown ink and ink wash, dimensions unknown

The brown ink wash lightens towards the centre of the page, emphasizing the central figure of Acis, mid-metamorphosis and surrounded by onlookers.

Opposite, top:
EDGAR DEGAS
Study of Nuns for Ballet Scene from Robert le Diable, 1871, essence on buff paper, 28.3 x 45.4 cm (11¼ x 17⅞ in.)

This study, one of four for Degas's painting *The Ballet Scene from Meyerbeer's Robert le Diable* (1871), catches the fall and movement of cloth as the nuns, raised from the dead in Meyerbeer's famous opera, begin to dance.

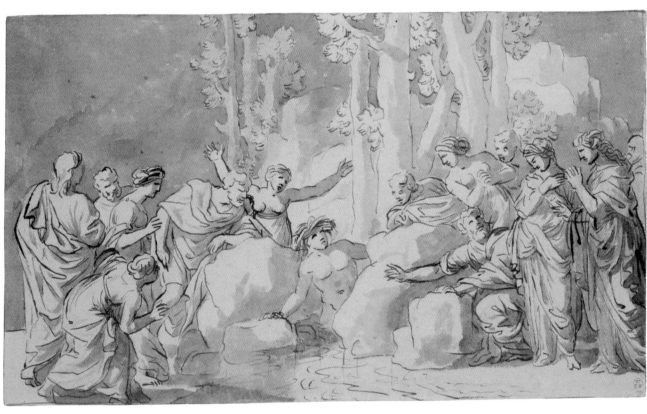

John Lessore, *Mitch*, 2015, pencil and pastel on paper

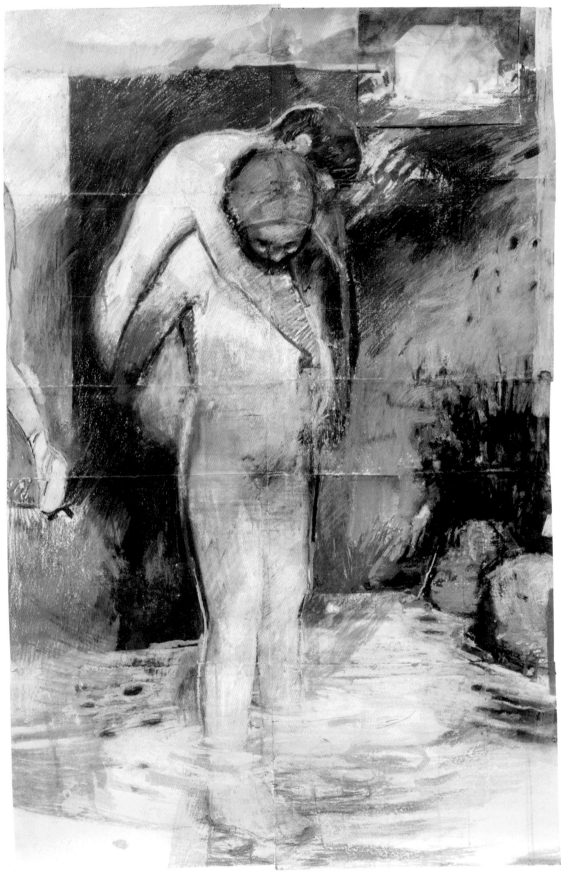

Joana Galego, *Sleepless Lover*, 2017, mixed media on paper

by directional reference is not usually necessary for very short intervals, because these are easy to judge by eye, but it is helpful for lining up objects across the larger picture plane.

As a painter, I see drawings as a repertory of subject matter from which to do one's work. The aim, therefore, is that they should be simple, direct and not cluttered with unnecessary information, yet detailed enough that they might be used to recreate the identity of a subject with conviction, so that the work one makes has 'probability' even if it is executed away from the subject. I have fed this into my teaching.

My remarks so far relate mainly to accuracy, which is the basis of rendering. Accuracy is not essential to art, but its absence tends to be a nuisance. It should become a habit and not require much thought. It is like the notes on a page of music: playing the correct notes will not necessarily turn them back into music, but not doing so will make life even harder. I don't think it matters if one's drawing is 'inaccurate', but I believe that one needs to be aware of whatever departures it makes from accurate rendering. Great drawing usually breaks all sorts of established rules; alas, breaking rules does not create great drawing. Much beauty in art is due to human error, which must be because it is the product of instinct, the great part of all creativity. Vision and expression are instinctive: we all see differently and so we should all draw differently. It is skill that stylizes and personal vision

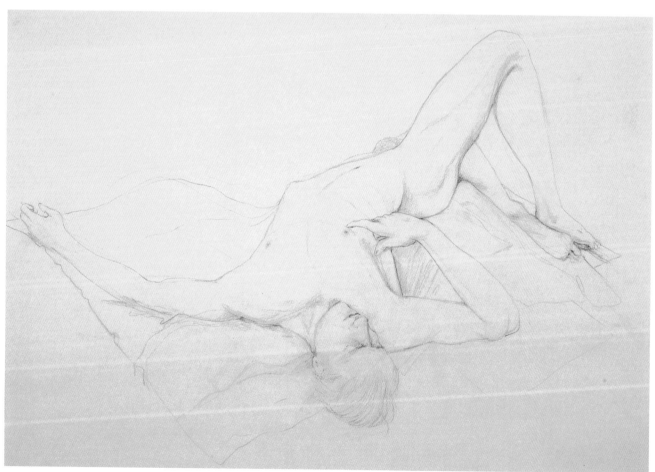

Kirsty Buchanan, *Adrian*, 2013, pencil on paper

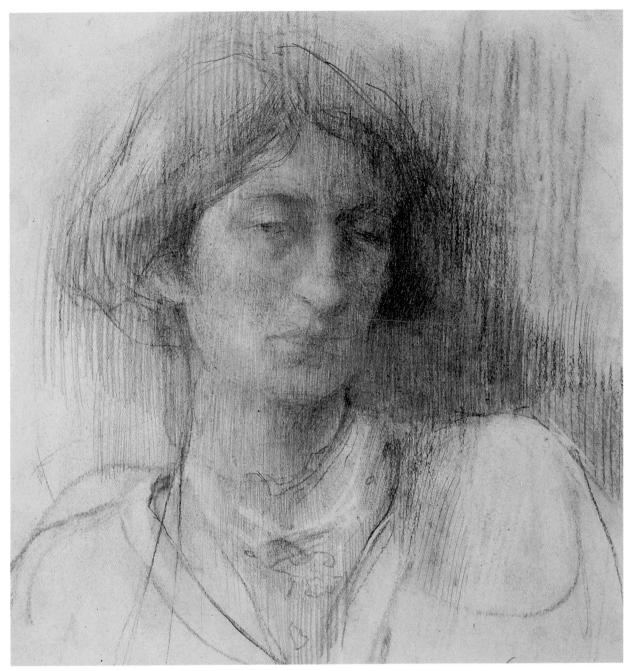

Serena Rowe, *Hanna*, 2007, pencil on paper

that differentiates: the artisan and artist working together. Art, as Proust observed, is not solely a matter of intelligence.

One cannot learn to draw: the gift is, or isn't, in us. One can learn to render: the rudiments, outlined here, are relatively quickly acquired and the skill can support the art. But the alchemical magic of drawing is inside us. Teaching can help, especially with the use of ancillary facts, but I think its greatest benefit is that one can teach people to see what they have or haven't done, and so appreciate their personal vision. This is no small thing. We have difficulties doing so – sometimes when we look at a work upside down, in a mirror or after a long interval a level of objectivity occurs, but one never really knows. We seem incapable of seeing our own poetry.

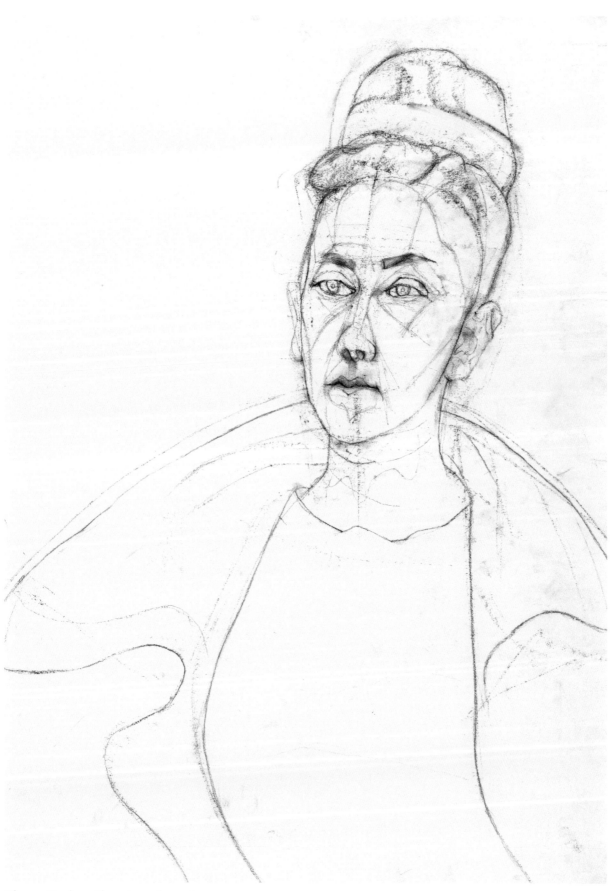

Thomas Harrison, *Florencia*, 2016, pencil on paper

Inversions *Orlando Mostyn Owen*

WHO: *with a sitter*

We often approach the model with a level of passivity, especially after many years of drawing from life. Expectations are created about the shape and structure of the body, and the processes by which we interpret what we see can become habitual. This exercise invites you to reexamine your approach to the familiar human figure and to observe it with greater intensity. It will also encourage you to extend the amount of time spent contemplating the model in the studio.

In this exercise, you will imagine the figure before you as a mirror image.

Draw the inverse of the shape that you see in front of you. To make it easier, try to draw an invisible line in your mind down the middle of the model and use this line to help you reverse the image.

During this exercise, students are often surprised by the speed at which, without steadfast concentration and control, the mind returns to the familiar, non-inverted form and the hand subconsciously reverts to drawing what is in front of it. This is a tough exercise and provides a great warm-up before a drawing session, awakening the connection between hand, eye and brain, increasing our level of concentration and encouraging us to really look.

Top tip: *Drawing the part of the model closest to the 'mirror line' is often easier; the further away from the line, the more one has to consider the shapes made by the body.*

Jake Garfield, *Dying of Thirst*, 2013, four-colour monotype

The Gallery as Visual Dictionary *Ann Dowker*

What can be learned by drawing from the work of great artists?

I only remember drawing from art once while at art school in the 1960s. It wasn't encouraged – after all, we were meant to be 'modern painters'. In retrospect, this was a very short-sighted view. Acknowledging your past helps you to understand and absorb your present and your future.

Drawing from art is not mimetic; it is not about copying. In museums such as the Prado in Madrid, you can come across copyists who do that for a living. The activity I am describing is about discovering or uncovering the way that you yourself draw, and finding a personal index. This can only be grasped through the kind of drawing in which you use the whole of yourself – mind, eyes, physicality and intuition. You uncover elements you had previously never considered: space, structure, placement and the all-important container, the frame. In effect, drawing from painting becomes your visual dictionary. I first started to draw from art at the National Gallery, London, because of a comment made to me during a life drawing class: 'You draw just like Frank Auerbach'. As much as I admired Auerbach's work, I wanted to make my own drawings. I resolved to find what I thought at the time was his antithesis – and so chose Rubens. I had no interest in Rubens's subject matter, but nonetheless the forms and energy of what I later understood to be the Baroque style extended my way of drawing.

From day to day, we are so bombarded with images that almost nothing is digested. On a daily basis we view the world through a frame, and could easily pass all twenty-four hours in screen time. Press a button and get an image; nothing is demanded of you. Drawing from art asks a more active form of engagement, and what it gives back in return may be richer and more sustaining. The actual process of drawing is an experience that stays with you. The sheet on which you have drawn becomes evidence of your existence, your identity at a unique moment in time. In a sense, you are doing what the camera lens does – yet somehow you are more in possession of the resulting image.

There are many extraordinary collections – in books, in galleries and museums worldwide, online even – from which to draw. In my work with students, my major resources have been London's National Gallery, the British Museum and the Courtauld and Wallace Collections. Galleries offer places for physical encounter. A Chinese student of mine had been unfamiliar with the direct experience of European paintings, having spent much of her life working from computer screens, and when she came to

Rosie Vohra, untitled (from three studies of Indian miniatures), 2014, etching

draw Cézanne's *Bathers* in the National Gallery, knowing little about the canon of Western art, she became obsessed. It wasn't the narrative which held her, nor the reputation of Cézanne; it was the physical fact of the drawing with the paint. Up to that point, images had been virtual. Here was this living material, oil paint, used in such a way that it expressed feelings no image had previously communicated.

When visiting collections such as this, it is worth thinking about what we mean by drawing from 'art'. In museums one is likely to encounter pieces made centuries ago for purposes other than aesthetic – for example Christian devotional images, painted on wood primed with gesso and finished with a considerable amount of gilding. The majority were intended to be seen in situ, as parts of a corpus that included a church's architecture, its sculpture, its altarpieces, its music and indeed its priests. Stop for a minute and ask yourself: is this 'art'? Is this what we in the twenty-first century consider to be art? These are documents of faith – of unconditional

Olivia Kemp, *After Gainsborough*, 2014, pen on paper

Constanza Dessain, *After Velázquez's Boar Hunt*, 2012, pencil on paper

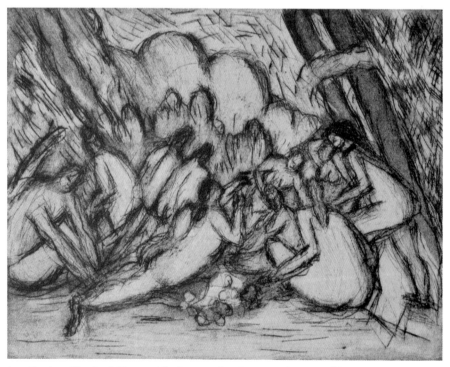

Ann Dowker, *After Paul Cézanne, The Large Bathers (1894–1905)*, 2012, etching on copper

Jessie Makinson, *Blue Study* (a reimagining of scenes from the
National Gallery, London), 2012, coloured pencil on paper

Poppy Chancellor, *After Francisco de Zurbarán*, 2012, felt-tip pen on paper

Right:
PABLO PICASSO
Minotaur Caressing a Sleeping Woman, 1933, etching, 29.7 x 36.8 cm (11¾ x 14½ in.)

None of the etchings in the Vollard suite (of which this is one) illustrate a known myth; instead the classical figure of the Minotaur is transposed into a series of scenes which address art-making, voyeurism, tenderness and violence.

Below:
HENRI MATISSE
Reclining Nude (The Painter and his Model), 1935, pen and Indian ink, 37.8 x 50.5 cm (15 x 20 in.)

Radically cropped, this image is as much a portrait of the artist as the model: at the bottom of the page the board, pen and paper cut in, while at the top, a mirror shows the artist's face.

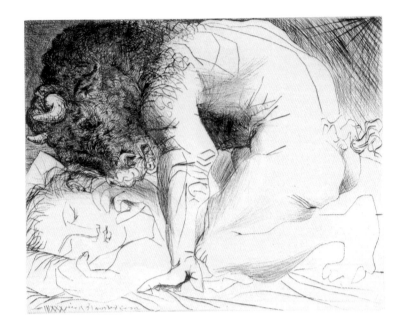

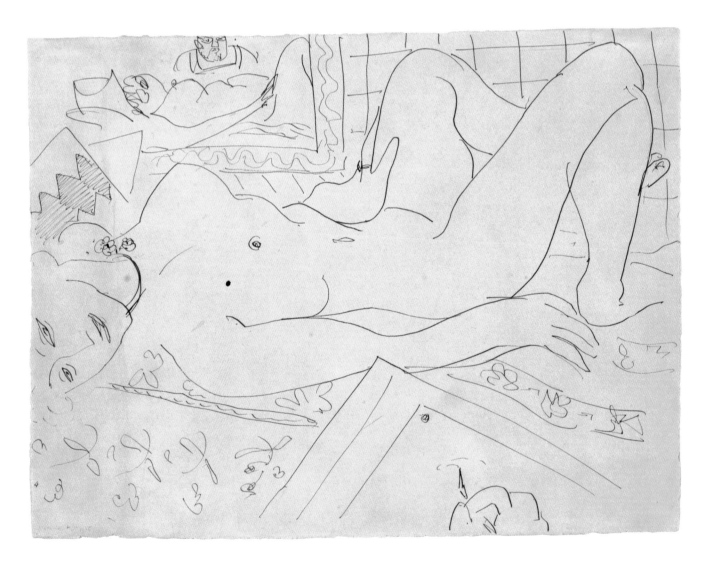

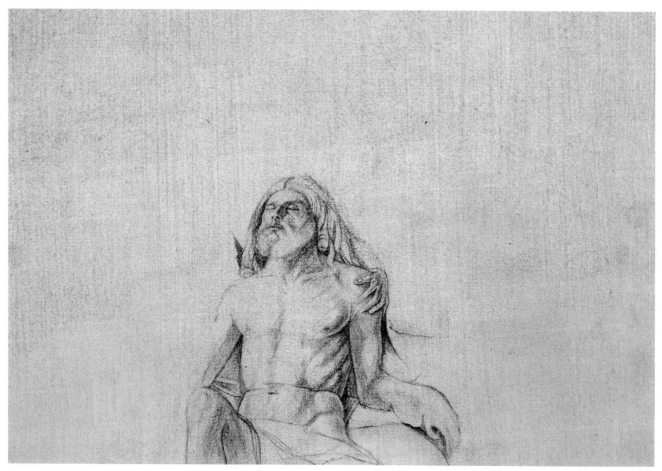

George Rice Smith, *After Bellini, Lamentation*, 2013, pencil on prepared paper

belief and contemplation – made to be illuminated by torches, candles or natural light. Yet the images remain so powerful in their structure that they override this original intent. We may respond to them now in a different way, yet still they can speak to us.

In works from sixteenth-century Venice, the scale becomes vast: canvases and oils arrived and changed the nature of painting, just as photography would in the nineteenth century. By looking at the history of Western art, one becomes aware that there is always a zeitgeist, through which some traditions are retained and others discarded. Take, for example, the Renaissance painter Veronese. It is clear that some of the pigments used in his works – the blues and the reds – have faded over time. But visually they still work; the structure is very clear and holds the idea. In many ways, the colour is an addition. Generations later, this cannot be said of Matisse, who used colour to create space, mass and structure. He used reds, greens or blues in the way Veronese might have used contour lines or cross-hatchings.

Artists from Matisse's generation, around the turn of the twentieth century, used museums as extensions of their studios. They drew from casts of classical sculpture, but by this time any colour on the casts had gone and they were left with the form – this having to be made on a flat surface: the paper. If a head was to be drawn then the viewer had to be

Tara Versey, *Between the Animals*, 2010, etching

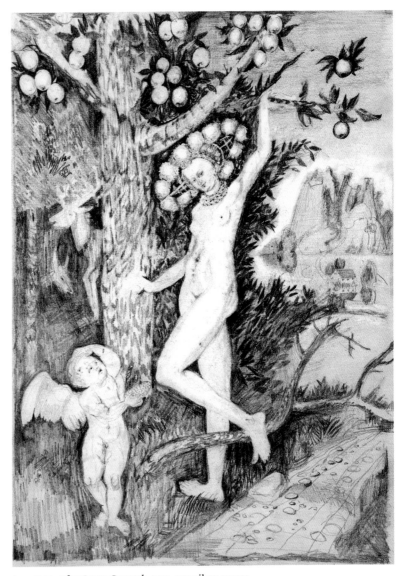

Amy Ison, *After Lucas Cranach*, 2011, pencil on paper

informed, somehow, that there was a back to that head. Working like this, they eventually began to use the space of the paper in conjunction with line. Paper itself became the form. We can see the results in Picasso's Vollard suite or Matisse's ink drawings.

Narratives are rarely at the front of my mind when I work from paintings. An exception might be Watteau's *fêtes galantes*, where the people in the parkland look out at you as though you are an intruder. Watteau's paintings are full of formal structures and consideration of space – the women are almost plugged into the ground in their voluminous dresses. I often end up realising that I have not been following the narratives of the paintings after all, but rather inventing my own. When drawing from paintings, you may uncover connections you would never have noticed by just passively looking. A student of mine was drawing from Cranach's *Cupid Complaining to Venus* (1526–7). In it stands a nubile, provocative, slender Venus taking an apple from a heavily laden apple tree; at her feet Cupid

is holding a honeycomb and the bees are stinging him. Cupid has a curved branch beneath his feet. The student's drawing made it apparent that this branch had to be the serpent. Here, it was revealed, was the Biblical story of Eve, wrapped up in the mythology of Venus and Cupid.

When drawing, you are looking for the underlying structures that create the surface. In fact, the best way to explain my approach to drawing from paintings is by comparing it to drawing from life – for the two activities are not separate. At one period I drew from the human skeleton. It never crossed my mind that this had to do with anatomy: rather, the attraction lay in the skeleton's beauty, its space, form and structure and how they fused and hung together. The structure was both delicate and strong, the space as tangible as the form it contained. My mind and eye worked in unison. As I drew, I felt I was almost touching the skeleton. I have the same feeling when drawing from a painting. In the end, it is a need for possession – a need to make the painting yours, rather than Rubens's or Manet's. I will try any means I can devise to establish this ownership, until I am almost drawing what I can't see. I am drawing my understanding of the work.

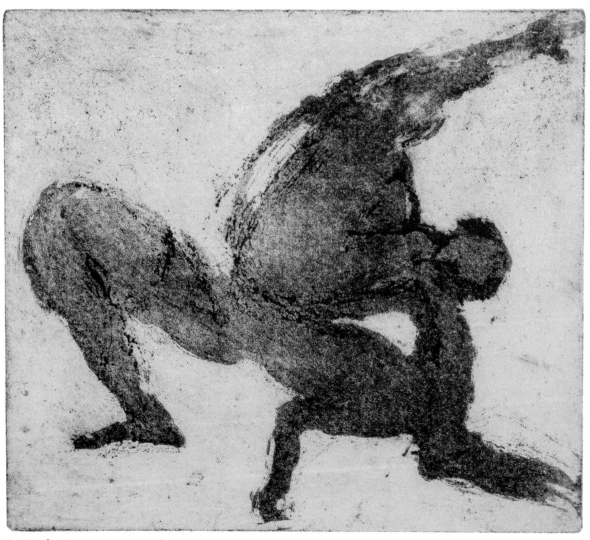

Ann Dowker, *Dancer 2*, 2001, aquatint

IN PRACTICE

Turning Art on its Head *Ann Dowker*

WITH: *reproductions of paintings*

Choose a painting from any collection, ideally something pre-twentieth century.

Get hold of a reproduction in a book, a postcard, photocopy or print-out. For this exercise, let's take a reproduction of Vermeer's Young Woman seated at a Virginal *(c. 1670–72), which is in the National Gallery, London.*

Turn the reproduction upside down and draw from it. This will help you to draw what you see, rather than what you think you see or know. In the Vermeer painting the edges of the walls and windows do not seem so hard, and

the space becomes compressed. Always be aware of the shape of the work; everything in it relates to the edges.

Once you have completed your upside-down drawing, turn it the right way up. You will be surprised at how awkward the drawing is – gauche and untutored. Don't be discouraged! By attempting to draw from the painting in this way, with time your observation will grow sharper, more acute, until you find that you are drawing form and not labels.

This exercise can be extended by making drawings from memory, or by changing the scale of the piece.

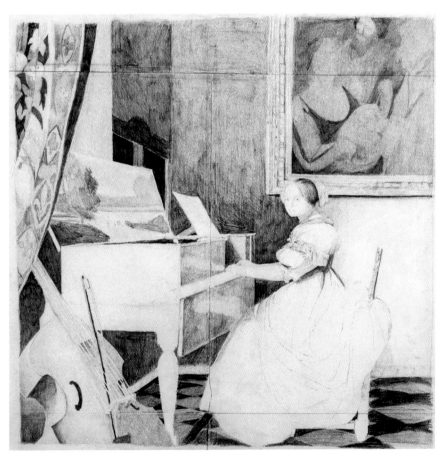

Bobbye Fermie, *After Vermeer*, 2015, pencil on paper

Jessie Makinson, *Sleepwalkers*, 2012, ink and watercolour on paper

Drawing from Ancient Sculpture *Ian Jenkins*

A museum curator's view of what we gain when we draw
from great stone carvings.

To draw is to internalize our experience of a subject; to capture its
essence and in some way to 'own' it. Those who draw in museums may
feel that the exercise brings them closer to the great art of the past.

As a curator at the British Museum, I am as close as one can be to
some of the greatest works known to man, not least the sculptures of the
Parthenon. Ever since they were first put on show in London from May
1807, the Parthenon sculptures have been at the centre of debates about
the nature and meaning of art. Indeed, discussion of their maker can be
found far earlier than this, in the works of the Roman authors Cicero,
Quintilian and Plutarch, who spoke of Phidias's powerful imagination
– his *phantasia* – and his ability to beckon the gods from Mount Olympus
and place them before the viewer.

The experience of drawing from sculptures such as those made by
Phidias and his School is markedly different to that of drawing in the
life room. Francis Hoyland, who taught drawing in the Greek galleries
of the British Museum for many years, describes the drawer as 'studying
an order that has already been deciphered and organised by somebody
in the School of Phidias.' Three-dimensional subjects have been visually
translated, projected onto a flat picture plane and worked in relief to
create the seemingly mobile friezes – and the drawer might learn to share
this form of projection in order to draw the sculptor's works. One might
also bring something of the surroundings to the drawing: the museum,
the people milling about. To draw from the Parthenon sculptures, or, for
example, from the ancient Assyrian friezes created for Ashurbanipal, is to
focus on works that were made almost three thousand years ago. We may
learn similar techniques, but our responses are ultimately unique, a result
of each drawer's very different context and sensibility.

Among the first to produce drawings of the Parthenon sculptures was
Jacques Carré, draftsman to the Marquis de Nointel, who passed through
Athens on his way to Istanbul in 1674. His sketches of the sculptures viewed
from the ground were to become exceptionally valuable when the Parthenon
was wrecked by an explosion in 1687. They remain helpful to archaeologists –
but for artists and art historians, the most important record of the sculptures
before their removal from the Acropolis is a series of drawings by William
Pars, completed in 1765–6 and acquired by Richard Worsley, the British

Opposite, top: Gabriela Adach, *The Lion Hunt* (Study 1, from the Assyrian galleries, British Museum, London), 2018, coloured pencil on paper

Opposite, bottom: Gabriela Adach, *The Lion Hunt* (Study 2, from the Assyrian galleries, British Museum, London), 2018, coloured pencil on paper

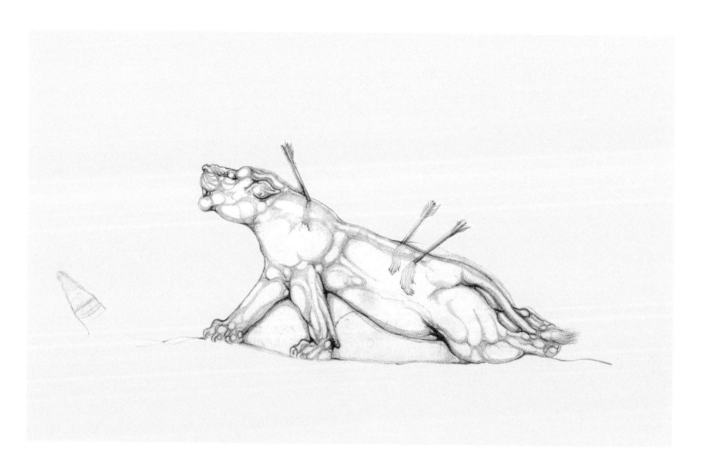

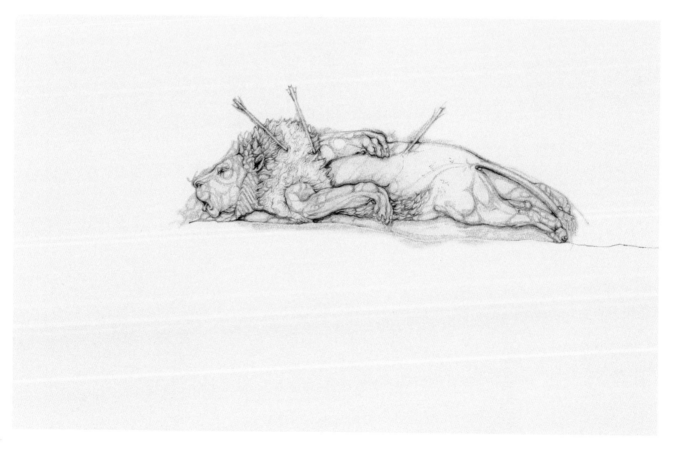

representative to Venice. Worsley showed them to the poet Goethe, who
in 1787 hailed the sculptures as 'the beginning of a new age for Great Art'.

It is often said that when, between 1801 and 1812, they were
dismantled and dispatched to England at Lord Elgin's behest, the
Parthenon sculptures brought about Goethe's promised revolution in art.
This was not so. Their early setting in the British Museum is captured in an
1819 painting by Archibald Archer, and his fellow painter Benjamin Robert
Haydon's drawings of them show a deep understanding of the sculptures'
forms, but with a few other exceptions they were not much drawn by artists
at the time. The initial change that occurred was in the realm of taste and
artistic theory, rather than in art practice. Artists and connoisseurs were
quite content to see the sculptures of the Parthenon as the most beautiful
things on earth, but many felt that the enormous size of some of the pieces,
and their broken and discoloured condition, made them unsuitable for
art school training. In fact, the Royal Academy banned students seeking
entrance to the Schools from submitting a drawing of them.

Yet in the British Museum, the reclining male nudes from the west
and east pediments of the Parthenon were originally located on rotating
bases so as to catch the light – a decision which seems to have been
made almost entirely with artists in mind. In the nineteenth century,
casts of the Parthenon sculptures circulated throughout Europe and were

Caitlin Stone, *Statue* (from the Greek and Roman collection, Metropolitan Museum
of Art, New York), 2015, pencil on paper

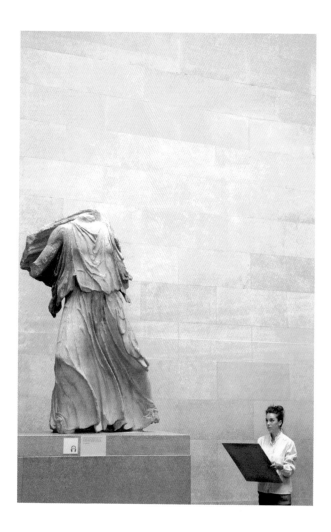

Jessica Jane Charleston, *Goddess of Childbirth and Motherhood*
(from the Egyptian galleries, British Museum, London), 2017,
graphite pencil on paper

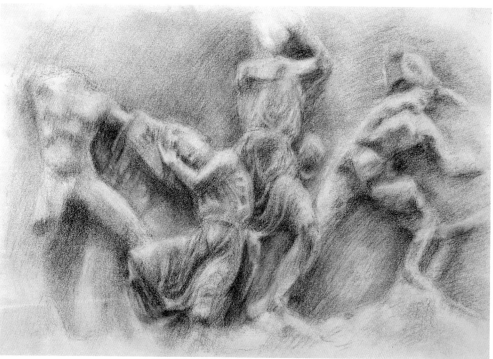

Eleanor Davies, *Parthenon Frieze* (from the Greek galleries, British Museum,
London), 2010, pencil on paper

Ethan Pollock, untitled (from Shalabhanjika, South Asian galleries,
British Museum, London), 2012, etching

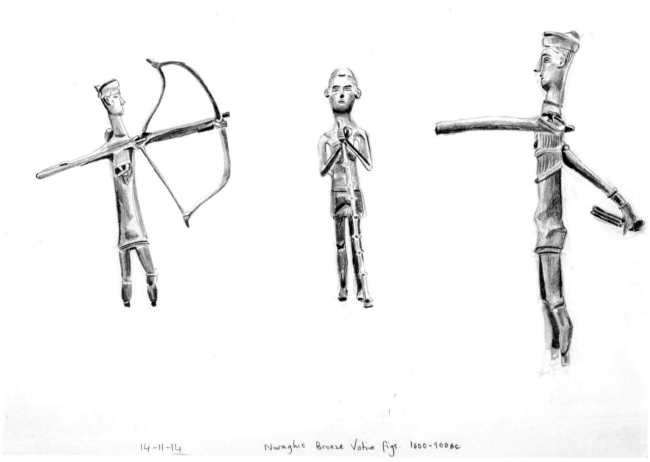

14-11-14 Nuraghic Bronze Votive figs. 1600-900 BC

Lottie Stoddart, *Nuraghe Meeting* (from Nuraghic bronze votive figures, Etruscan gallery, British Museum, London), 2015, felt-tip pen and coloured pencil on paper

drawn by artists including Auguste Rodin, whose lifelong love for the sculptures, which he first saw as originals in England in 1881, inspired the extraordinary works he would later have carved in stone. Rodin also drew objects from the Egyptian, Chinese and Assyrian collections of the British Museum, and his work displays the broad artistic vocabulary which might be gleaned from such an experience.

Among the reactions that the Parthenon sculptures continue to provoke, there is the claim that this art is 'elitist'. But people who say that may merely be reading them – along with other monumental art in the Museum – as records of empires past. They are not actually looking at the marvellous handiwork of the nameless slaves and one-drachma-a-day men who carved the stone, and who thus suffered all the wounds that masons are prone to. When I march London schoolchildren into the Parthenon Gallery, I tell them: 'I know what you're thinking: This is white man's posh art, and this guy is posh.' Then I add: 'But by the end of this session, I'm going to persuade you that these are yours. This is your legacy. This is your inheritance. You belong with these, and they are representations of you as your own best selves.'

Drawing as Sculpture *Marcus Cornish*

WHO: *with a model*

Many of Michelangelo's most basic drawings and underdrawings initially construct the body as a series of differently proportioned sausage shapes. These shapes encircle the three-dimensional features of the body and show their distribution and orientation in space. In this way, the artist thought about and understood the model physically right away. He conceived of the body in harmonious physical units and segmented forms, emulating the Greeks whom he so admired.

In the Renaissance, this approach to the three-dimensional form in art dominated both painters' and sculptors' approaches to the human body, inspired by ancient reliefs and free-standing sculptures.

This approach to drawing seeks to understand the body sculpturally, and to infer its form from other vantage points rather than just from the artist's viewing position.

So, how do we do this?

FIRST, SEE THE SHAPE FLAT

+ *Set up a simple, 'straight-on' pose, the model's feet planted on the ground and hands by the side, to find their general, idiosyncratic shape. Ask yourself, would the body fit into...*

a vertical ellipse?
a tall, thin box?
a squarer box?
a circular shape?
a pear shape?
a peg shape?

To help yourself, use the head as a unit of proportional measurement. Ask:

How many times does the size of the vertical head fit into the length of the body – 6? 7½?
How wide are the shoulders? Placing the head-size on its side – 2 heads?
What about the waist – 1½ heads?

Is the pubic mound half way up the body or not?
What is the hip width?
Knee to foot: 2 vertical heads?
Knee to hip: 2 vertical heads?

+ *Drawing from the same, simple pose, make a stick figure that accommodates the shape you have discovered. Then build up long, oval shapes on this frame that encircle features such as the skull, ribcage, chest, pectoral muscles, stomach, pelvis and the parts of the legs and arms.*

THEN, SEE THE SHAPE IN 3D

+ *Set a more active, dynamic pose with the model standing on a board. Starting with a stick person, draw the model facing straight ahead, rising up from the board. Notice the axis through the shoulders, pelvis and head as they tilt in relation to each other; they counter each other in order to create overall balance, even though the pose is no longer simple and regular.*

+ *Now view the model and pose from a more oblique angle. First, draw the board in perspective to engage with the space. Then draw the stick person rising up from it. Draw a frame that will accommodate the new pose, the oblique angle and your understanding of the body shape.*

+ *With the stick person in place, build up the figure as before, using long, oval shapes. This time, also try to think about how these volumes are orientated in relation to your own position and the board below them.*

+ *Once this is done, refine the drawing, smoothing the outside edge lines that link the different volumes together. These lines can be made to look closer to the viewer by drawing them slightly darker and thicker. The lines that make up the volumes – the limbs or torso – which are receding away from the viewer can be drawn with slightly thinner, more broken-up strokes.*

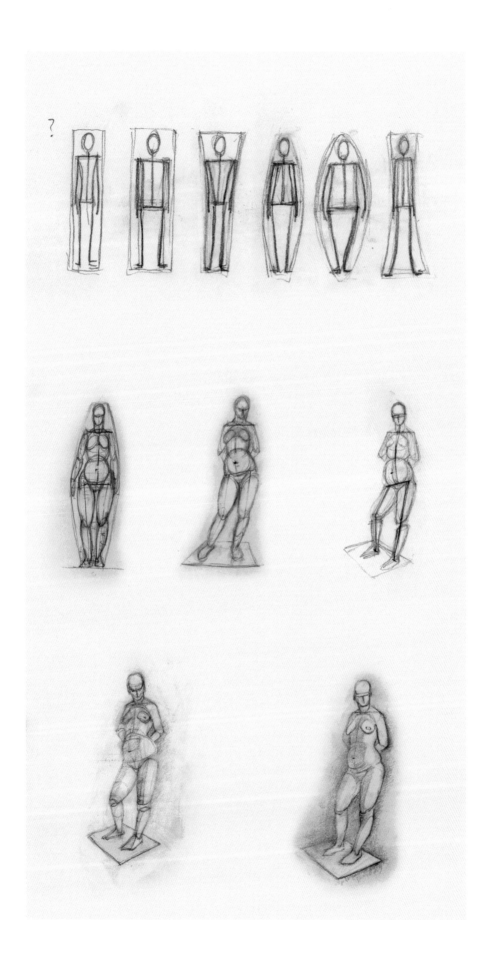

Modelling *Isley Lynn*

Insights from the other side of the easel: a life model
on what it is like to be drawn.

Most people – most artists, in fact, even those who teach life drawing
– don't know a great deal about my work as a life model: what that really
means, what it really is. There are plenty of models who don't take their
clothes off. I do. There are plenty of life models who are also artists in their
own right. I'm not. I'm a writer, actually. And it's especially difficult to
convince people that theatre is where my heart is and nude modelling is
like an office job for me. To be fair to them, it's not unrealistic to think that
to be a 'muse' would be the most romantic and exciting part of someone's
life. But I am not a muse. I promise.

I've been a life model for four years and in that time I've been plenty
of things: queens, goddesses, nymphs, mermaids, peasants, mothers. The
list goes on and gets increasingly bizarre – the time I channelled a mountain
comes to mind. But outside of playing those roles, my role as a model is
similarly multitudinous: object, friend, counsellor, teacher, doll, witness
and, of course, subject. Newer artists are the most likely to ask if I recognize
myself. They're also the most likely to apologize: 'I'm so sorry I made you
so angry/chubby/old, you're not like that at all.' It's hard to convince them
that actually it's not about me, which sounds socially diplomatic even when
it's not. Honestly, it's quite rare to recognize myself. I was once at a private
view for an artist for whom I was one of many models, and I struggled to
pick myself out, resorting to secretly mimicking the poses in the pictures
to try and jog some muscle memory that would identify them as mine.

My answer every time is 'I always recognize myself' – which is not *untrue*.
I'm in all those paintings of me, even the ones which bear no resemblance
to me whatsoever, because they're always a response to me, to my presence.
And really it's nothing to do with likeness at all. Likeness doesn't matter.
What does matter is that I'm a participant, however that manifests, and it's
different with each artist, each environment, each setting. In all cases I'm
a mirror. I'm trying to gauge where you, the maker, are. I'm trying to meet
you there. I'm doing this when we talk and drink tea and set up a pose and of
course during the pose itself. Some don't mind if I fall asleep as long as I keep
the pose, which I'm quite good at now. In fact, it means that they too can relax
and have a strange sort of privacy. Some don't mind if I pet their dog with one
hand while they're working on the other. Some are more demanding, which is
fine, and I need to be strategic in protecting myself while meeting their needs.

Clara Drummond, *Portrait Study of
Kirsty Buchanan*, 2005, pencil on paper

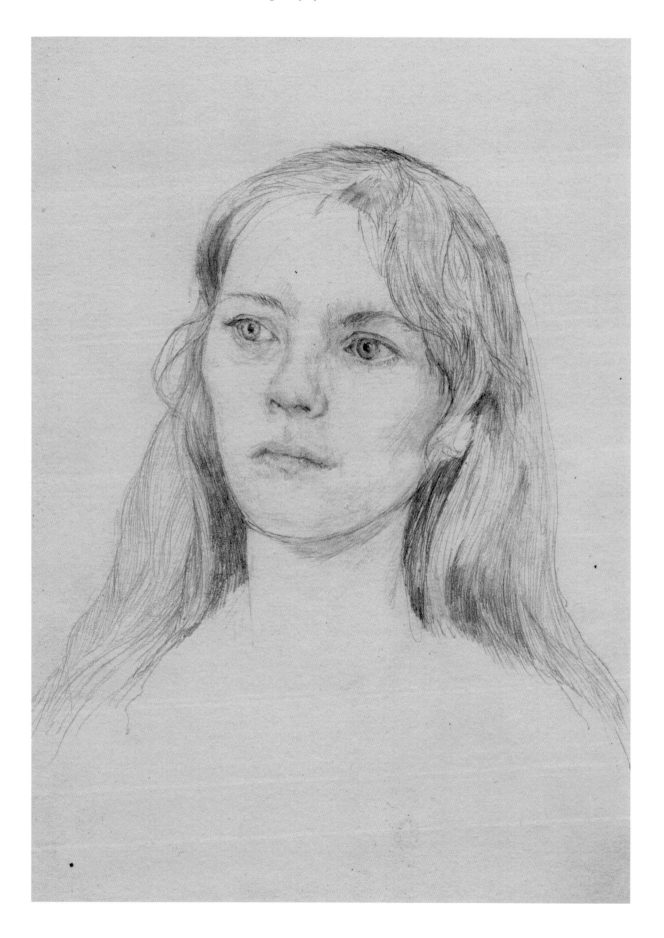

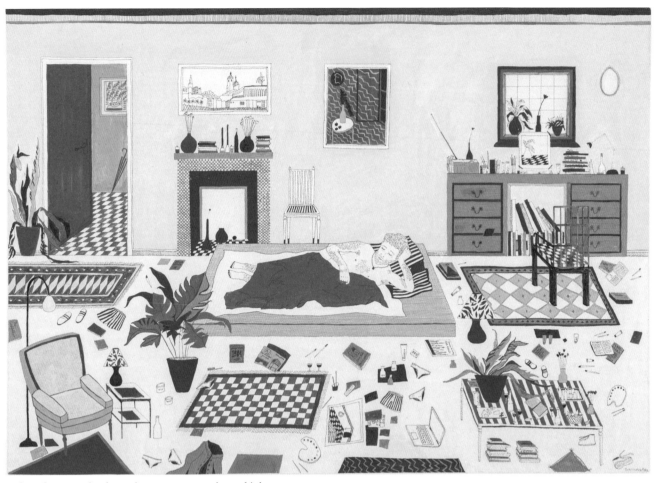

Beth Rodway, *Boy in Blue Bedroom*, 2018, gouache and ink on paper

This extends to inappropriate behaviour too, obviously. The vast majority of my clients are supportive and compassionate and generous and kind, and it's very, very rare for one of them to cross a line. I only encounter this in a way that makes me feel unsafe about once a year – and I model enough to count it as full-time employment – though little disappointments do crop up more regularly. I've been asked to do the impossible and shamed when I couldn't or wouldn't. I've been flirted with, propositioned and outright groped. I've been photographed without my permission while posing and changing and on a break and every other possible time, too many times to count. To the people who do this I'm a working animal, like a horse or a donkey, there only to serve their needs. Or perhaps I'm prey.

Perhaps the most charitable explanation is that they see me as just a body, which for someone whose job it is to investigate my body is not strange, I suppose. But what they forget is that I am not my body. My body is inherited. It is a place for me to live – but I am so much more than it. In fact, modelling has brought me closer to and made me distant from my body in radical ways. Especially for someone who doesn't meet all the standards of modern Western beauty, it has been equally revelatory and revolutionary to work in a space where my looks are literally valued, with

compliments and with cash. I fear for those many women whose bodies occupy a similar place on the spectrum of mainstream desirability, who never get to experience a space like the life room.

But for anyone, being stared at by strangers, whether you are clothed or not, will completely change your relationship with your body, other people's bodies, fashion, the beauty industry, health, pain, focus, time and many other things. It will inevitably connect you with an intrinsic sense of beauty, which is unassailable and ultimately out of anyone's control or manipulation. A tree is beautiful because of course it is; it doesn't matter what it looks like, it just *is*. And so am I.

It is at this point that I should acknowledge that my experience in the art world is balanced by my experience in my other world, the theatre world. 'The Playwright' is so revered and mysterious that I think people are honestly surprised when we come out of our caves with brushed hair and clean clothes. The bar for beauty is low for a playwright. And it's liberating for my appearance to be genuinely incidental there, for that to be so clearly not the seat of my value. A tree cleans the air and houses animals and grows fruit and gives many other good things than its pretty flowers and leaves. And so do I.

One could argue that the artist only has access to the body that I do all these things in and with, and so can only paint that. But this is also wrong –

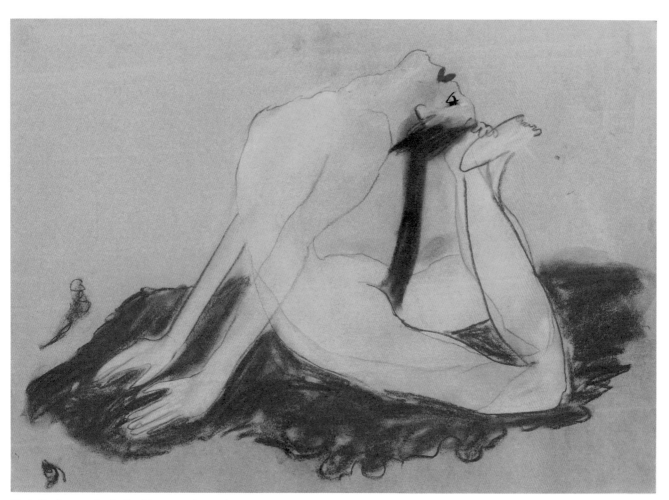

Kirsty Buchanan, *Contortionist*, 2013, soft pastel on paper

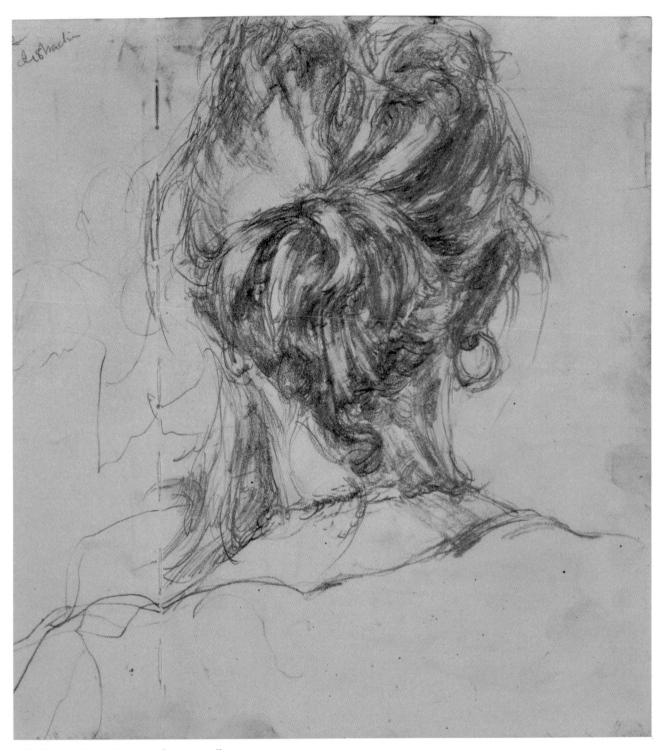

Catherine Goodman, *Kate's Head*, 2017, pencil on paper

or incomplete, at least. Because I don't live in my body, and neither does their painting or drawing or etching or whatever. That lives in the artist's brain, in the synaptic relationship between their head and their hand. It lives in the light of that particular place, in that particular moment of that particular day, which is always different no matter how you try to control it. It's in the too-long chat before the pose and the sound of roadworks down the street, and the taste of fig rolls and nougat in the break, and the smell of my feet sweating and the breeze from the cracked window. The work is all these things, and so am I. In this way, I'm a ghost. Which, after a lot of thought, feels like the most accurate way I can place myself in all this. I appear and I leave and the artwork is the trace of my visit. Thousands of people have seen me intimately without knowing me. They never see me, they see a reflection of me, a version of me, someone else's story of me. And art to a model is like money to the dead – you can't take it with you when you go.

Rosie Vohra, *The Library*, 2014, gouache on paper

OPEN SPACE

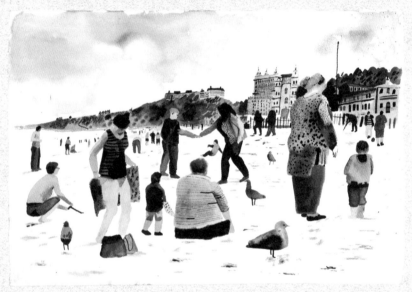

OPEN SPACE Introduction *Julian Bell*

The second group of essays in this book considers forms of drawing that are more outward-looking and less reflective than those discussed in the first group. Let me sketch the historical background that underlies this set of practices.

Some images, as I suggested in the previous section's introduction, are made for standing before. Others are made for holding in the hands. The space between an image so held and the eyes that inspect it is a more or less private one. A few literati, perhaps, might have clustered round in appreciation as a Chinese handscroll was unfurled. A shah might have shared the wonders of a Persian miniature with his courtiers, as a folio was held open, or titters might have passed between dukes provoked by the ridiculous peasants in a Netherlandish illumination. But in all cases, eyes and minds plunged in. Where the viewers stood was of no account. The room about them was banished.

And so the intimate hand-held image might open up and, strange to say, reveal a more extensive space than the big figure picture that had been made to meet its viewer on an upright surface, body to body, head to toe.

> The forms of the Kunlun and Langchung mountains can be perceived within a square inch. A vertical height of three inches can represent a thousand fathoms, while a horizontal stretch of several feet can stand for the distance of several hundred miles.

Zong Bing's fifth-century celebration of the thrills of the handscroll suggests the way the mind might gain a bird's freedom to rove and swoop, all from marks made on a small blank surface that is treated as indefinite in depth. What both drawer and viewer experience may be continuous with the poetry that has often accompanied such handiwork. The poem's words resonate in the silence they interrupt; likewise, the lines which break a bare surface turn it airy and evocative. They suggest far more than they state – they conjure up worlds.

The hand-held image, then, offers an opening for private reverie. The people making such dream-worlds may feel themselves to be directed from within or from above. William Blake, creating his illuminated books of self-styled 'prophecy', asserted that every line flowing from his brush came purely from the mind, a God-given resource that was 'inexhaustible', like 'a garden ready planted & sown.' His idealism aligns with that of the

Pollyanna Johnson, *Be Still*, 2016, pencil and charcoal on paper

白雲如帶東山腰石
磴飛空細路遙攜倚
秋蒸錄眺望欲因鳴
澗蕃吹簫洗開

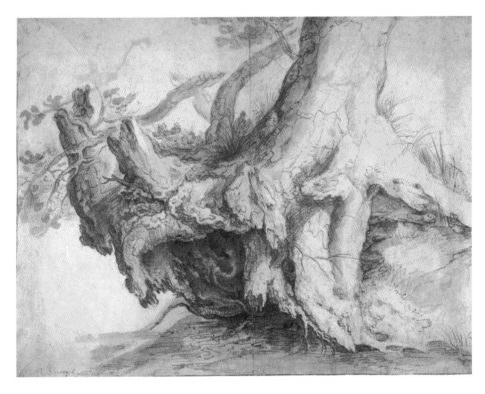

Above:
SHEN ZHOU
Poet on a Mountain Top, 1496, album
leaf mounted as a handscroll, ink on
paper, 38.7 x 60.3 cm (15¼ x 23¾ in.)

Here, the poet looks out not only
at the view, but towards a poem
incorporated into the scene. Drawn
using the same materials, word
and image interact to describe an
experience of the natural world.

Right:
ROELANDT SAVERY
Study of a Tree, c. 1606–7, grey
watercolour wash, red chalk wash,
graphite and charcoal dipped
in oil on laid paper, 30.6 x 39.4 cm
(12⅛ x 15⅝ in.)

The trunk and roots of an uprooted
tree fill the artist's sheet, with just
enough earth below to anchor it
securely in space. Detail is built up
with layers of chalk and watercolour
washes and Savery's assured,
minutely observed graphite line.

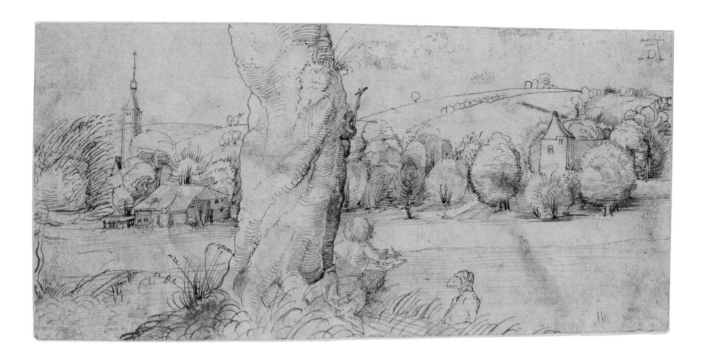

SEBALD BEHAM
Artist sketching outdoors, 1515–50, pen
and brown ink on paper, 9.4 x 19.5 cm
(3¾ x 7¾ in.)

One of the earliest known Northern
European images of an artist working
from life outdoors, this image is
dominated by the gnarled tree trunk
against which the artist leans. The
hatching and sharp, defined line show
the influence of Beham's work as an
engraver.

earlier Persian miniaturists, who painted figures without bodily mass
so as to approximate them to their divine prototypes. In the present day,
there will be many other drawers around us who are neither seers nor
disciples of some high tradition, but who likewise wish for nothing
external to interrupt their vision.

The majority of us, however, expect to learn more broadly from
experience. Our instinct is that the inward will to draw must be brought
into relationship with an outward world. We seek teachers to help that
process. The teacher must alert the student to the possibility that there
might be more present than meets the mind's eye, and that the first line
one draws should be treated as merely a hypothesis, which may need
revising. It is by no means necessary for the teacher to claim that drawings
can be *correct*, but it is inevitably necessary to argue that they could be
corrected. Look outwards, the instruction comes: whatever it was that you
imagined you were representing, you may find that the object objects.
Accordingly, at the Royal Drawing School, the bound sketchbook – a format
necessarily debarred from public wall display – is a regular component of
any student's career, lending it a backbone of personal and self-directed
vision. But equally, so are the independent sheets on which groups of
students perform observational exercises, inside and outside the studios.

These sheets are at least potentially exhibitable; the artistic product
we have long been most familiar with in London is a two-dimensional item
hung on a wall. That format's parentage is so remote as to seem misty. Just
as a major part of the European tradition derives from site-specific frescoes
in Italy that are not immediately on view in the modern museum, another
part derives from a book art tradition that is likewise out of sight. Late-
medieval manuscript illuminators rejoiced increasingly in the recording
of observed particulars, and this fascination with worldly appearances
went on to infuse the new art of oil painting on panel that arose in early

fifteenth-century Flanders. This world-in-a-picture approach to art might be considered typically 'Northern'. In fact, the Italian names of the patrons in Van Eyck's much-loved *Arnolfini Portrait* (or *Arnolfini Wedding*) of 1434 tell us that, from at least this date onwards, there was an interplay between the homeland of large-scale figure painting and the homeland of intimate itemization – a kind of marriage in itself.

Van Eyck's art is often also referred to as 'naturalistic'. What is nature, for the drawer? The most concise definition might be: whatever lies outside the circuit that runs between mind and hand and page. We can, however, mark out several subdivisions to this category, which could comprise the entire visible universe. The aspect of nature that most readily comes to mind when we hear the term nowadays is the range of phenomena that remain independent of human intervention. People have regarded nature of this kind with ever-deeper reverence since the era of Romanticism and the Industrial Revolution. For the artist, belief in nature may be a matter of submitting yourself, as receptively and as empathetically as possible, to the rhythms of some environment in which weather and plant life and the roll of the terrain sing out loud. It might equally entail intense scrutiny of some singular specimen, some animal's body; either way, there is the hope of reading the signs well so as to approach by other means those archetypes that concerned idealistic artists such as the aforementioned Persian miniaturists. For it is certain that all we see is underpinned by distinctive structures, whether we take these to be biological, geological or cosmic; it is certain that there are realities here that we could aim to understand. Drawing, pursued with this form of devout humility, might thus rise to the status of science, as it did for Leonardo and has for many an anatomist since.

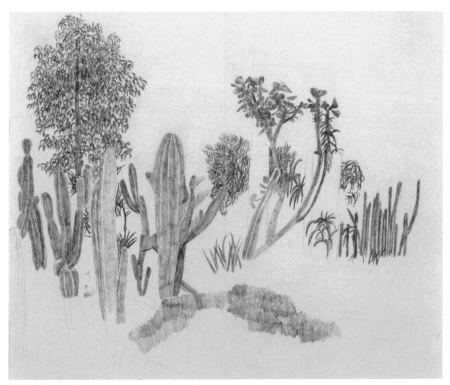

Caitlin Stone, *Cactus Garden*, 2015, pencil on paper

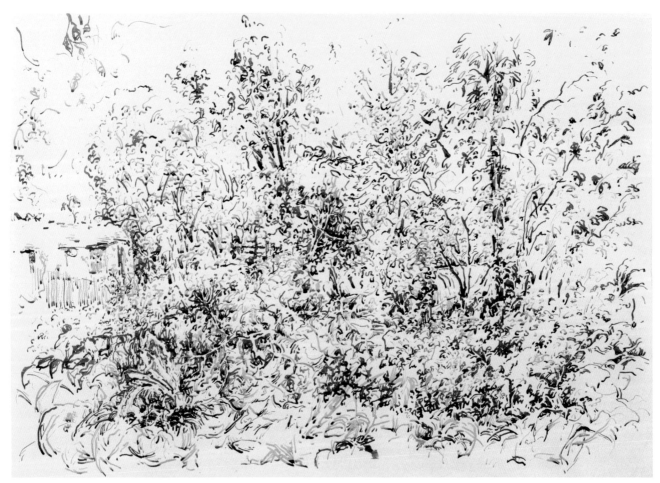

Tyga Helme, *Behind Knole*, 2015, ink on paper

All that we draw may be underpinned by structures, but these structures are not necessarily what we get to see. One way or another, the object is liable to be obstructed: if it's not raindrops that splatter the sheet, it's a truck that parks before a tree. Accidents such as these remind us that we are engaged in an activity constrained by time and circumstance. Is there something to learn from this, too? Nature might also include the time-beset, the history-ruffled landscape, the look of which is by no means independent of human intervention. It could be argued that in following the lines our species has drawn on this planet's face – roads, walls, canals – we are simply studying the geology of the Anthropocene. It would follow, then, that the city must be a further subdivision of nature. Yes, the city is what my species has made; it is in that sense 'art', it is an accumulation of works of human purpose. But that concatenation so far exceeds in complexity any purpose that I myself possess that it is other to me, even mysterious. The city too needs to be learned.

How might we go about studying the city? Human handiwork tends to result in products with regular, right-angled planes and edges, ranging in scale from the sheet held in the hand to the rooms and architecture we walk among. It was to relate the former – the flat rectangle – to the latter – the orthogonal solids – that European systems of perspective were initially devised. In contrast to the Chinese tradition, in which open, irregular

landscape predominated and the viewers' eyes kept moving as the scroll unfurled, the two fifteenth-century Florentines who promoted 'artificial perspective' talked of pointing a counterfeit mirror (Brunelleschi) or looking through a window (Alberti) at their own city's buildings. These metaphors and their mathematical expressions, which could be progressively extended to tackle whatever lay inside or outside the walls, remain potent. They promise reliable methods for studying what's outside us – 'nature', in the broadest sense – that feel hard to escape, even if we know that they give rise to spatial paradoxes as soon as the area we observe exceeds a certain angle. How far to fall in with them is a conundrum that a great deal of modern art, from Cézanne and the Cubists onwards, has tussled with.

This tension arises out of an anxiety that 'window vision' might be existentially cowardly. One famed definition of the modern artist – Baudelaire's – is the person who plunges *into* the street, with a will to swim its surging human currents. From the studio, with its all-too-manageable rectangle on the easel, Baudelaire's hero descends into a crowd on the boulevards that is 'an immense reservoir of electrical energy', embracing 'the fugitive, fleeting beauty of modern life.' Yet in a sense, whoever takes up drawing, no matter where they head, ends up taking the window along with them. Observation is not participation. When I draw, I most certainly act: I focus, I furiously scribble, my faculties are engaged and intensely alive. Yet I hardly interact. It would be difficult to claim – unless, of course, I have been in some way commissioned – that what I do is done for anyone else.

I might attempt the negative claim that I do no harm to anyone. I merely take in appearance as a plant takes in sunlight, a freely given and endless supply that is not thereby diminished. Yet that proposition also feels shaky. We intuitively sense, particularly if we start to draw someone who has not asked to be drawn, that there is an edginess to the notion of 'taking' a likeness. Who has the right to draw whom, and at how much remove? Age-old fears of soul-stealing are overlaid by very contemporary contests as to what constitutes personal space, in an era when the passers-by on the boulevard all have their heads bowed – each down his digital wormhole, held in cold unity only by the automated surveillance overhead. Should all acts of vision between these units of privacy be like acts of sex, consensual?

Once again we have no stable answers: what the drawer looks out on, looking up from the sheet, is a category that slithers. The verbs translate reliably enough: *to see* in English is *voir* in French. The verbal agents do not. Between *seer* and *voyeur* yawns a rather wide gap. It is a gulf inhabited by half of drawing.

The essays in this section all deal with aspects of drawing from 'nature', but the sequence in which those aspects appear runs more or less in reverse to the order in which this introduction has addressed them. No essay could better steer the transition from the previous section's studio concerns to the challenges set by the external world than *Timothy Hyman*'s. One of the School's most influential voices speaks at once in his roles as tutor, as singularly original narrative painter and erudite yet subversive art historian. *Liza Dimbleby* further explores Hyman's discussion of what it means to experience urban environments, from Glasgow to Moscow – falling in, sketchpad in hand, with the pace of the streets so as to register something

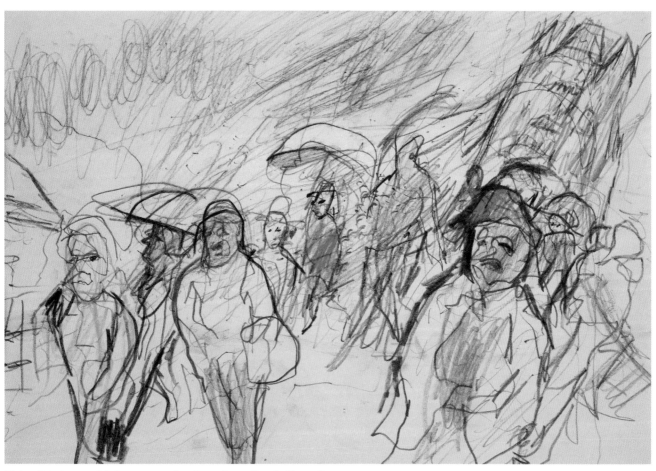

Richard Burton, untitled, 2009, pencil, coloured pencil and oil pastel on paper

Overleaf: Kathryn Maple, *Roots*, 2013, watercolour on paper

of a city's character. Her text, which has a rhythmic energy of its own, is keyed closely to her drawing practice. From the city we turn to the buildings that comprise it, in a piece by *Martin Shortis*, who creates complex and highly evolved observation-based drawings. Shortis confronts the limitations of perspective and helpfully suggests ways in which they might be mitigated.

It is not so much the urban as the *sub*urban – and, moreover, the border zones where drawer and the drawn face each other as foreigners – that concern *Mark Cazalet*, a painter otherwise known for his investigations of colour. His piece tangles at once with textures of experience and with the ethics of drawing and place. With *Daniel Chatto*, we step away from the town altogether, as this landscape artist rehearses for us the way that a drawer might respond to nature in Britain at its most exuberant and untrammelled. *William Feaver*, one of England's most experienced and discerning art critics and a landscape painter besides, shows us a more historically tinged approach to reading terrain, while reflecting on the whole habit of drawing. Lastly, *Clara Drummond* writes – with scrupulosity equal to that which she brings to portraiture – about the drawer's close inspection of the natural specimen, a tradition in European art headed by Dürer and Leonardo. Seven widely differing voices: but in all of them, an excitement not so much about the finished product as about the unique experiences that the activity of drawing from observation can offer.

109

From the Studio to the Street *Timothy Hyman*

The relation between the limited studio workspace
and the overwhelming flow of life outside its walls.

When we first find ourselves drawing in the crowded street, we're likely to
feel a loss of control. It demands a very different language to that of the life
room – everything is in flux, space no longer measurable. As Maurice Merleau-
Ponty puts it: 'The world is not in front of us, it is all around us.' My own
principal reason for going out drawing is to renew that sense of space, of being-
in-the-world. If I stop drawing for several weeks, I find that in the studio my
spatial invention goes dead and my art becomes schematic. My first drawings
are nearly always fuelled by a rush of panic – an initial sense of floundering,
of my utter inability to calmly build a representation in the midst of so much
complexity. Red Grooms, creator of urban 'sculpto-pictoramas', told me:

> When I draw in the city, it's great fun, but it's frustrating too...
> because there's so much going on, you're always so far behind.
> I find that while you're out there you feel almost ludicrously
> helpless. But when you get back to the studio you latch on to
> it for all your life is worth.

You have to take many leaps in the dark; to trust your perceptions,
however surprising. Bonnard's definition of art as 'the transcription of the
adventures of the optic nerve' may be helpful. Bonnard set out to unlearn the
kinds of seeing associated with one-point perspective, with the lens or the
fixed stare of the life room. His drawings can appear informal, yet they are
packed with the information necessary to trigger memories that would inform
his paintings, while his line remains tender and vulnerable. Though he never
painted from life, Bonnard's drawings made him the heir to the tradition
heralded in Baudelaire's famous essay 'The Painter of Modern Life' (1863)
– a tradition that would eventually encompass the Impressionists:

> He watches the flow of life move by, majestic and dazzling...
> he gazes at the landscapes of the great city, landscapes of stone....
> Modernity is the transient, the fleeting, the contingent; it is one
> half of art, the other being the eternal and the immoveable.

Speed is one of the issues. Baudelaire tells of Delacroix, out with his
students, pointing up to a high building: 'If you haven't sufficient skill to
make a sketch of that man throwing himself out of that window in the
time it takes him to fall from the fourth floor to the ground, you will never
be capable of producing *Grandes Machines*.' Implicit in this is the idea that

Christabel Forbes, *Singal Iron Store*, 2015, oil pastel on paper

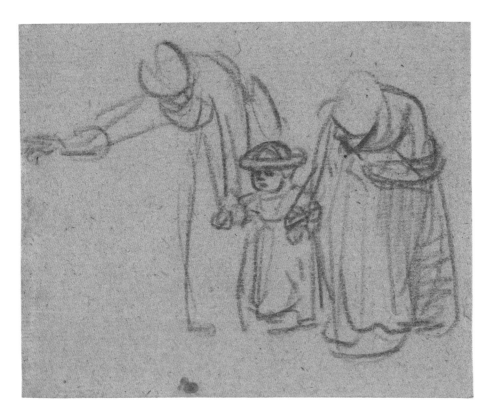

REMBRANDT VAN RIJN
Two women teaching a child to walk,
1635–7, red chalk on paper,
10.3 x 12.8 cm (4⅛ x 5⅛ in.)

One woman bends down to the
child and points forwards, lending
a sense of direction and momentum
to the composition. The chalk lines
are swiftly, purposefully made, as
though setting down an impression
in the moment.

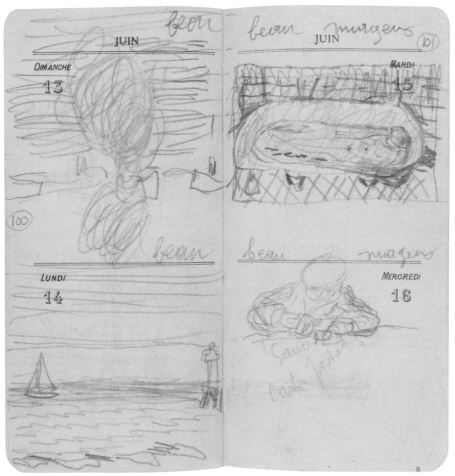

PIERRE BONNARD
Pages in Bonnard's diary, June 1937

Bonnard recorded the weather and
sky conditions of the day in his
diary, to preserve memories of light
and atmosphere. Here, drawings of
daily life and a harbour in different
weather conditions are annotated
simply, 'beau'.

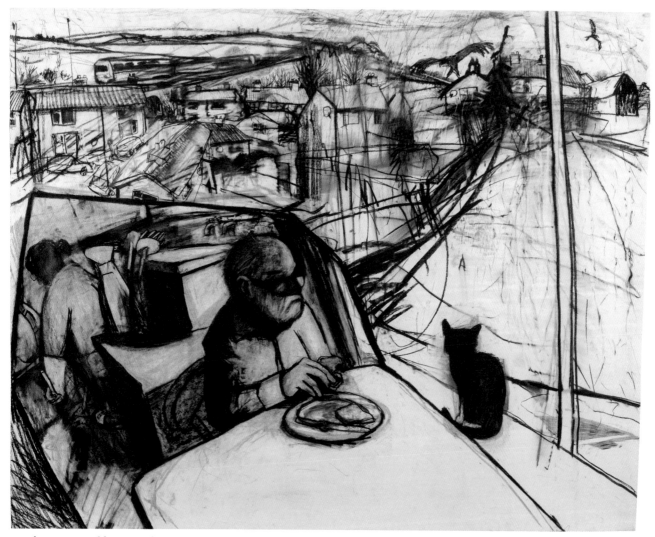

Jonathan Farr, *Breakfast*, 2011, charcoal on paper

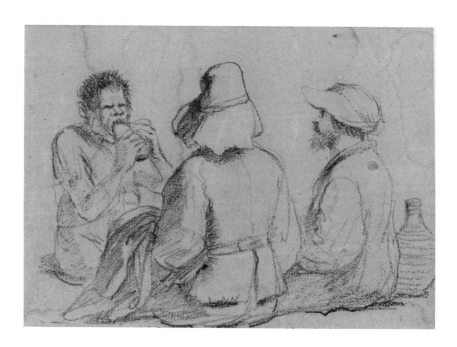

GUERCINO
Three Peasants Picnicking, c. 1619–20,
charcoal and black chalk on paper,
24.4 x 34.3 cm (9⅝ x 13⅝ in.)

This charcoal drawing catches
a brief pause: three men sit on the
ground, one eating a loaf of bread.
The rough surface of the paper
is used to describe the texture of
clothes and hair effectively with
a reduced set of materials.

George Colley, *Royal Exchange* (sketchbook), 2013, watercolour, graphite and watercolour pencil on paper

Asya Lukin, *Lombard Street*, 2009, ink on paper

we must learn to make an intuitive mark, a 'sign' – marks made at speed
that become not just descriptive, but form an autonomous language,
compressing complex content. The word 'sketch' has become synonymous
with the preparatory, the superficial, the insubstantial; but its Latin
derivation is 'a poetic improvisation.' In Rembrandt's sketches a few chalk
lines create in one minute a poetic image; and Ernst Ludwig Kirchner's best
calligraphic sheets attain a comparable authority. The marks call attention
to the act of drawing, shifting the emphasis away from the object analysed.
Kirchner's drawings are, in his own words, 'born in the ecstasy of first sight',
his sensations 'set down unmediated' (Alex Katz admires how Kirchner
'surrendered himself to the moment as he lived it.')

The contemporary I looked to most in my youth was Frank Auerbach;
I loved his arduousness, his erasures. As he wrote in 1975, 'I hope to
celebrate the truth after having exhausted the stock of lies, as one might
find oneself telling the truth after a quarrel.' Later, I found I wanted more
specificity – more sense of place and of the individual – than Auerbach's
half-abstracted zigzag idiom allowed me. I hoped some parts of my drawing
might flower into focus and detail without losing the essential image.
Each of us has to discover our own accommodation with reality.

'Ah, Giotto, let me see Paris: and Paris, let me see Giotto', wrote
Degas in 1866. At the Royal Drawing School, I took my students out only

Richard Burton, untitled, 2009, pencil, coloured pencil and oil pastel on paper

BHUPEN KHAKHAR
From the River Jamuna, 1990–94,
intaglio print on paper, 63 x 63.5 cm
(24⅞ x 25 in.)

Khakhar's aquatint imagery, a half-bestial, underwater world of free-floating 'homosocial' pleasure, might not seem to bear much connection to Street Drawing. Yet his fantasy was nourished by his constant everyday sketchbook notations, in a reciprocal exchange which Odilon Redon termed 'putting The Visible at the service of The Invisible.'

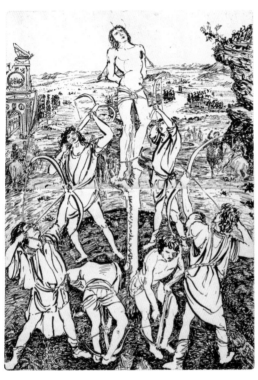

Peter Wenman, *After Pollaiolo*, 2017, pen on paper

Timothy Hyman, *At Cambridge Circus*, 2010, pencil on paper

on alternate weeks. The other five days of the course, they worked with a different teacher on a single drawing in front of a chosen picture at the National Gallery (see p. 72). Between Life and Art, between fast and slow – that contrast is to some extent built into the life of a city: the fixed architecture against the counterpoint of all those people, cars, birds, buses, building sites, clouds and sunbursts that disrupt it. We go out into the everyday, alert to the exceptional – to those moments of sudden seeing that detach themselves from the flow of ordinary living. Some have called these moments 'epiphanies'. We have to find a visual language equivalent to that excitement.

In India, drawing beside my painter friend Bhupen Khakhar, I found my eyes were 'on stalks' and the ninety degrees of focused seeing was not enough. I had to include peripheral vision and to experience the curvature of the panorama, as the world fanned out around me. What I most value in my students' drawings is the trace of their response, their encounter with the world. Once, after preaching this gospel and moving on with the group between the National Gallery and the South Bank in London, I overheard a bright student ask: 'Is he peddling Expressionist Drawing?' 'No', her companion replied – 'it's Experiential drawing.' I was greatly relieved.

Christabel Forbes, *Valenciennes, Place du Musée*, 2015, oil pastel on paper

Drawing in the Street *Timothy Hyman*

Timothy Hyman, *Along Shaftesbury Avenue*, 2016, pencil on paper

WHO: *a group of drawers (preferably)*
WHERE: *in a town or city*

Choose an area with some history and a distinct identity – in London you might choose Spitalfields, opposite Hawksmoor's great church, or The George Inn, Southwark. If you're working in a group make this your meeting point. Take drawing materials you can work fast with.

You might also bring with you some favourite images in books or cards, and perhaps a poem, too – for instance a Manhattan poem by the New York poet Frank O'Hara. Spend some time looking at these,

all of which can be a good preparation for taking a plunge into the city.

After a few minutes, you are ready to go out individually into the city. Take in your surroundings and let your eye be caught, but don't spend too long searching before you begin to draw.

Start drawing. Try to stand rather than sit – you will become more of a participant.

Register where you are; allow your eye to be pulled back

and forth, to travel from the far distance and back to your own hand as it draws.

Seize the diagonals in what you see – let them fan out from you, like a spider spinning a web. Don't be intimidated by perspective; draw intuitively and take the shapes and angles as your starting point. Notice the slant of figures as they walk, the camber of the street which tilts the buses and the traffic. The city isn't a rigid vertical/horizontal grid – it is full of movement.

Try to draw to the edge of the paper, so that each sheet

becomes equivalent to your visual field; you're not drawing just an object, but taking on the entirety of your visual experience.

See if you can suggest the individuals, the traffic, the weather, the architecture and the place all together – that's our holy grail.

If you're working in a group, agree to meet up with your fellow drawers after a specific period of time. Look at one another's drawings and see how different they are – in scale, in materials and in meaning.

Learning the City *Liza Dimbleby*

What walking the streets, with their rhythms and their surprises, may offer the drawer.

Drawing the city is another way of walking it, but a physical stride is needed to set the work in motion, as preamble and accompaniment. Both actions start from a sort of restlessness, an inability to stay put, to be at ease in the given world. The city that we imagine and experience around us is a familiar yet constantly changing space. It contains hints and promises of transformation. A drawing walk begins with a decision to trust these obscure potentials, to give ourselves up to the unforeseen. In what follows, I look at three ways that we – myself and fellow walkers, such as my students – might approach such a journey into the unknown.

Setting forth on the city: Rhythm

Our drawing walks are not made in hopes of perfecting an urban perspective or depicting an immaculate façade. We walk, and as we walk the nervy distractions of our mind are slowed, as we tire and yield to the rhythm of the streets themselves. Robert Musil wrote:

> Cities, like people, can be recognised by their walk. Opening his eyes, he would know the place by the rhythm of movement in the streets long before he caught any characteristic detail. It would not even matter if he only imagined he could do this [...]

This trust in the rhythm of the streets is crucial to a sort of drawing that can hook itself in, underneath the geometry and façades, to show something of how it was at this moment of this day, in this place, in this person.

The person setting forth in the contemporary city is subject to the immense space beyond them, and this person attempts to conjure or field that space by marking it. We walk to establish the ground of our drawing and then we make our own incursion, fielding the space again with our marking of it. The notes or marks are the meeting point of our inner rhythm with that of the encompassing landscape; the measure of the freedom with which we can inflect this space that we are ultimately subject to, in notes or pencil strokes. Setting forth is also the setting of a rhythm.

There is the bodily pace of our walk and our thoughts; the movement of the city around us; the noise and variety of traffic, of people, a seagull's swoop. You notice the shape and pace of exchanges, the clatter of coffee shops, the repetitions and variations of a day. You stop and draw, and as

Sophie Charalambous, *Pearly Kings and Queens*, 2014, watercolour and gouache on paper

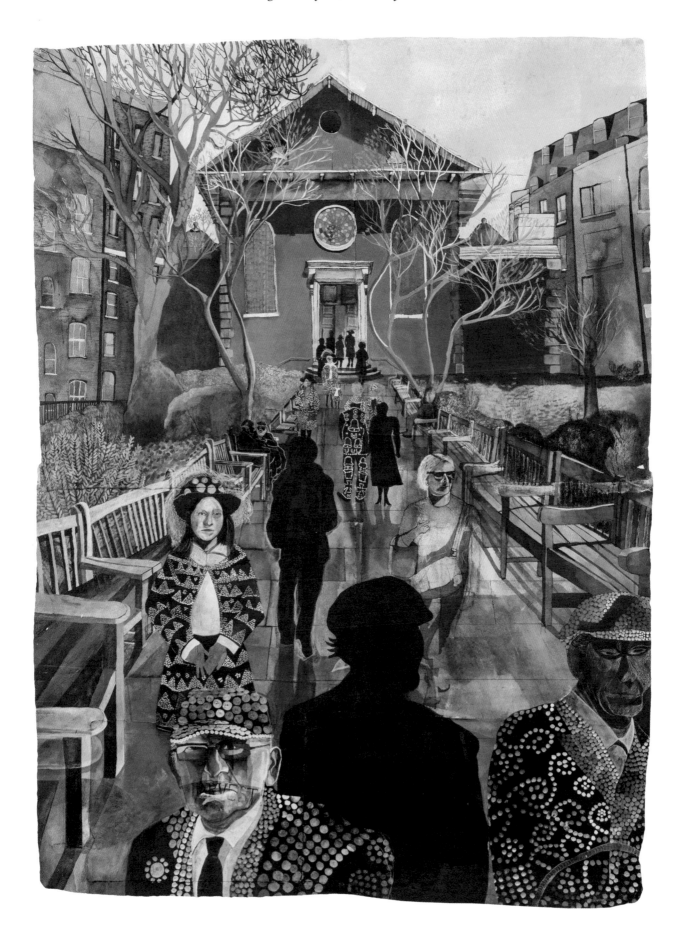

Left:
ALBERTO GIACOMETTI
Crowd at Intersection, c. 1965, lithograph,
42.5 x 32.5 cm (16¾ x 12⅞ in.)

Crowd at Intersection is no. 16 in a series
of prints, *Paris sans fin* (1969), depicting
daily life in Giacometti's beloved Paris.
He described the works, which seek
to capture something of the fleeting,
chaotic character of the city, as 'images
and memories of images.'

Below:
LEON KOSSOFF
A Street in Willesden no. 2, 1982, charcoal
and pastel on paper, 59 x 65.4 cm
(23¼ x 25¾ in.)

London, particularly the East End
and areas of Kilburn and Willesden,
has long been the focus of Leon
Kossoff's frenetic, layered drawings
and paintings – pictures, he says,
of 'life going on.' He draws *in situ*,
often returning to the same places.

Liza Dimbleby, *Val D'oro, Glasgow*, 2003, water-soluble pencil on paper

you draw you notice more, you see how the rhythm of your drawing might change in response to the world as you go to meet it; to the speed, sound and mood of its unfolding. Some people seek out traffic junctions at rush hour; others prefer the slower motion of a cafe, a side street or shop window. If at a loss, a subway or a station exit can be a good place to re-engage. You stand, unseen, and catch the lulls and flurries of activity. Bodies emerge in random parts: legs, torsos, heads; then heads, torsos, legs shuttering from the stairs or concrete dark like the clattering segments of a Jacob's Ladder toy. Unseeing faces rise to meet you. Objects are borne upwards on a tide of random offerings: a bunch of flowers, an umbrella, oddly shaped packages – sudden gifts.

The city is full of such odd-shaped offerings, and it is only through drawing that we realise their playful strangeness; that we notice them differently. The chamois-leather omelette on a plate through a cafe window, or the exuberant array of irons, mops, a hundred pairs of shoes walking up a shop display board. Everyday shapes and arbitrary framings become the punctuation and patterning of a page. At a market, the stuttering metal clamps that peg out the stalls' tarpaulins have a weight and accent, a percussive beat that sets a rhythm for the drawing. There is shape-shifting – one thing abuts another and is transformed into a third. In your drawing

Matthew Booker, *Drumming*, 2016, lino print

Rebecca Harper, *Southbank* (sketchbook), 2013, graphite on paper

you catch a head next to a curl of carved pediment, or eyes between a wall strung with bags; odd coincidences and diversions drawn from the visual cacophony of the street.

Setting forth on the city: Map

You can begin with a hunch, following the instinct of your feet and eyes, or you can set yourself an arbitrary itinerary, throw a patterning net across the city's infinite complexity. In Moscow, I walked the ten-mile Garden Ring Road, the route of the old city ramparts, as a way of returning to the city, in the hope that I might thus encompass or contain the whole of it – take it inside me. In Glasgow, I set off into the city wastelands, the strange hidden countries full of sky at Possil and at Ruchill; like something stumbled on in a dream. From their high concealed plateaux you can look down on this city among hills. Sometimes you will seek out this higher viewpoint, from which you might make imaginary walks across the shrunken towers and rooftops. At other times you may prefer to make your way low, obscured and without a plan, through the side streets. Our imagined topographies, different for each city, shape our direction. Cities we have walked and drawn in can layer

Thomas Treherne, *Man Photographing Stars*, 2015, charcoal on paper

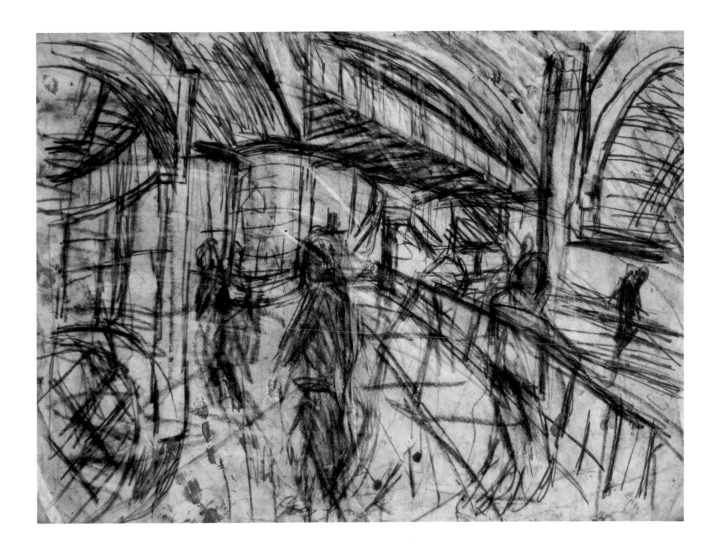

LEON KOSSOFF
Outside Kilburn Underground, c. 1984,
*c*harcoal on paper, 40.6 x 50.8 cm
(16 x 20 in.)

Drawn outside a North London
underground station, the architecture
of the road and rail bridge is at points
visible through the loosely worked
figures, emphasizing their transience
and giving this piece its sense of
relentless motion.

themselves inside us, and so we recognize one city in another; a specific
confluence of streets summons forth an echoing space from miles and years
away. Our moments of connection with these spaces provide the link, our
own particular displacement.

Layering in time
The places in which you have drawn are never the same again. You may walk
through them, but you walk through a different reality – the reality of seeing
through your drawing. Through drawing we trap specific instants in our
stuttered notation. These abstractions have a precise hold on memory, so
you may return again and again to the same site to find it each time newly
textured. The energy of drawing is necessary to overcome the separation or
estrangement often felt in the face of the city, to achieve the flash point in
which the city's offerings and the drawing response are melded into a new
third thing; a world transposed, but newly articulate.

When I am not drawing, the city recedes. It becomes resistant,
indifferent. Walking and drawing make the city once more compelling,
with the promise that a different sort of reality might be unlocked or

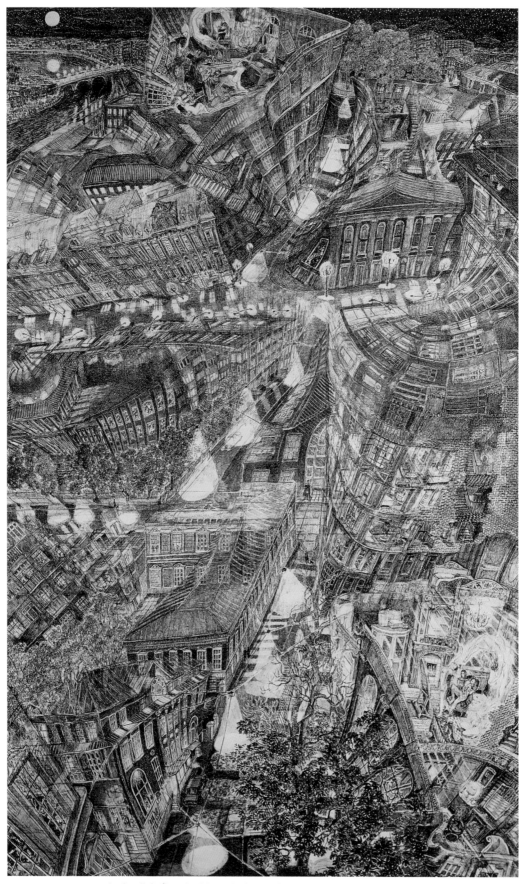

Laura Footes, *Margarita in Flight* (inspired by Bulgakov's *The Master and Margarita*), 2018, ink on paper

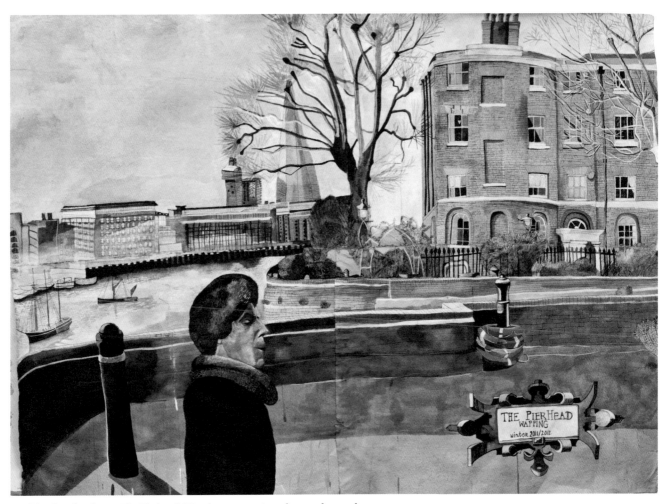

Sophie Charalambous, *The Pierhead, Wapping*, 2011, watercolour and gouache on paper

Elvira Rose Oddy, *Borderlands*, 2015, oil pastel, conté and charcoal on paper

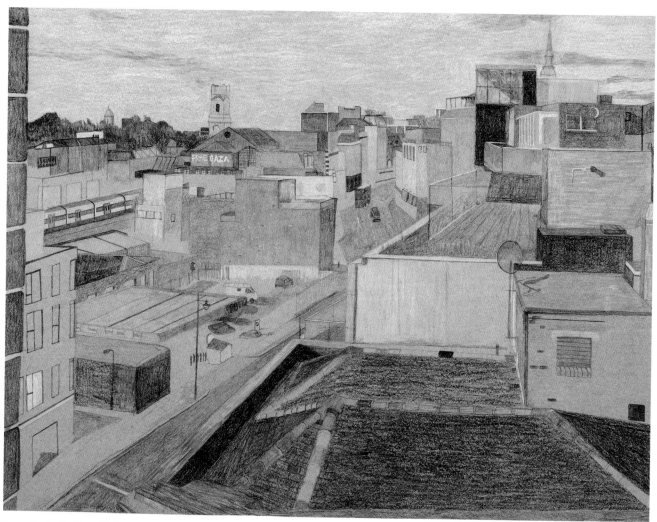

Esme Hodsoll, *Shoreditch Exterior*, 2015, crayon and coloured pencil on paper

revealed, something more strange than our ordinary seeing. This promise can tempt you to keep walking, drawing in your head but not risking pencil to paper; but the real transformations of experience demand that commitment, that attempt at articulation. While you are drawing, it may seem that you are simply stabbing at the chaos, barely fielding the onslaught of visual and sensory information; the movement of cars or people, street and shop signs, words, noises, lights blurring, weather changing, all at once. A scribbled line seems only to increase the confusion; you feel that you are being submerged as you try to chase its movement and collisions, always falling short. Yet later, if you dare to look back at your drawings, you may be surprised by a life that has been caught in these markings, as in a net. Things can get in among the lines that you were not aware of at the time: a moment of life more intensely held, something that holds you.

Drawing Walks *Liza Dimbleby*

WHERE: *in a town*
WITH: *sheets of paper or a landscape sketchbook,*
not too large, and pencils, not too hard

Here are two related exercises for walking and drawing the spaces and movement of the city, which might be undertaken one after the other. Set aside half a day or an evening for each. Rush hour can be a good time to catch movement without being noticed. If you get stuck, try making timed drawings. Don't worry too much about the results – the aim is to try and establish a pace from your walk, your looking and your pencil. Make lots of drawings and gradually you will find your way.

A DRAWING WALK: RHYTHM

Go for a walk in the city. You can start somewhere familiar or unknown: your neighbourhood or a place you have never explored. Choose a starting point and walk without a plan. Don't look at maps or phones. Avoid practical aims, like shopping. Notice what leads you – the look of a building, the name of a street, the path of a passer-by. Keep walking until you are tired. Notice the rhythm of your walk, the rhythms of other people, of transport, birds, trees, the wind. Look up, look around.

As you walk, notice the lines from the tops of the buildings, the lines alongside you, the lines that lead in the direction you are going, and think of yourself as part of this movement.

Rest. Sit and watch the rhythm of the passers-by as you remain still.

Take a sketchbook and begin to draw the lines of streets, of houses as you walk. Think of the drawing as notation. Don't try to draw a picture. You are collecting traces. Your pencil marks should respond to the sounds and rhythms you encounter as you move along the street. Translate the weight and sensation of rhythm and sound with the weight and attack of your pencil: tentative or staccato, light or heavy.

Walk and draw for about half an hour, or until your sketchbook is full.

A DRAWING WALK: MOVEMENT

Return to the area that you walked through in the first exercise. Find a place where you can be at ease in the midst of the city's movement. A busy thoroughfare; an underground subway; the steps or entrance hall of a station.

Watch the people as they pass. When you have watched for some time without drawing, begin to draw. Make several rapid drawings in succession. Start by timing yourself: draw for a minute, make ten or twelve one-minute drawings. You can make even faster drawings if you want. Then make longer drawings on the same page; four minutes, or even ten. Do not get stuck on detail.

Try to bring together the feeling of 'seeing in motion': the movement of the whole and the sudden detail. Chase after the things that pass through and don't get stuck trying to place the permanent fixtures. Walls, windows and doorways can be useful frames to hold passing transcriptions of movement.

Layer several movements on one sheet of paper. Work out the rough staging of your space: the edges of buildings, walls or street signs. Then trace the flow: the layers and over-layers of people and things as they come towards you. Make marks lightly at first and then more heavily as you get a sense of what feels most important.

Compose on the spot. Draw what you have just seen – it doesn't need to still be in front of you. Select from the overflow of passing images. Trust that you will find what you need. You do not need it all.

Liza Dimbleby, *Whitechapel Market*, 2006, pencil on paper

Liza Dimbleby, *Whitechapel Market Series (4)*, 2006, pencil on paper

Buildings as Objects in Space *Martin Shortis*

Overcoming the structural challenges of drawing an object in space, especially when dealing with large objects such as buildings.

Drawing is a powerful tool of investigation. The pleasure of drawing is in exploring a subject: from life, from imagination and from memory. When we draw, we make two-dimensional models of our understanding, and what is in those models will inform the way in which our understanding develops.

We tend to be primarily concerned with the depiction of objects. Most drawing systems, regardless of culture, embody this concern. Objects exist in space, and space extends in all directions; but the space itself is often the last thing that a drawer considers when drawing. We assume that the top of the paper will be up and that side to side will be across. The challenge is how to depict the space inside the object and inside the surface of the drawing – and for this, various conventions have been adopted.

Establishing the sense that the paper is showing us a solid object on its flat surface becomes the most complicated and interesting agenda, even if it is only a single object we are describing with our pencil or pen. Our curiosity drives the drawing; our imaginative grasp of a three-dimensional world inside a two-dimensional plane is the oxygen that enables it to breathe. And yet until we can establish a space for things, we may be unable to draw them. Sometimes we literally cannot see objects until we have found their place in the drawing. How are we to find space inside the drawing?

Drawing Systems

If we are drawing a particular object – say, a figure in a studio – from observation, a visual measurement process known as 'sight-sized' drawing is commonly taught. The artist holds a pencil at arm's length, moving the thumb along it to intercept the rays of light travelling from the object to the eye. With the aid of a series of triangulated measurements, the appearance of the object is plotted more or less reliably onto the drawing. This is very helpful in developing the feeling that the artist can reach out to take hold of whatever is before them.

Meanwhile, if we are drawing objects in relationship – say, buildings in a street – the standard system by which to establish the space they

Thomas Harrison, *From Andrew's Flat, Singapore*, 2016, pencil on paper

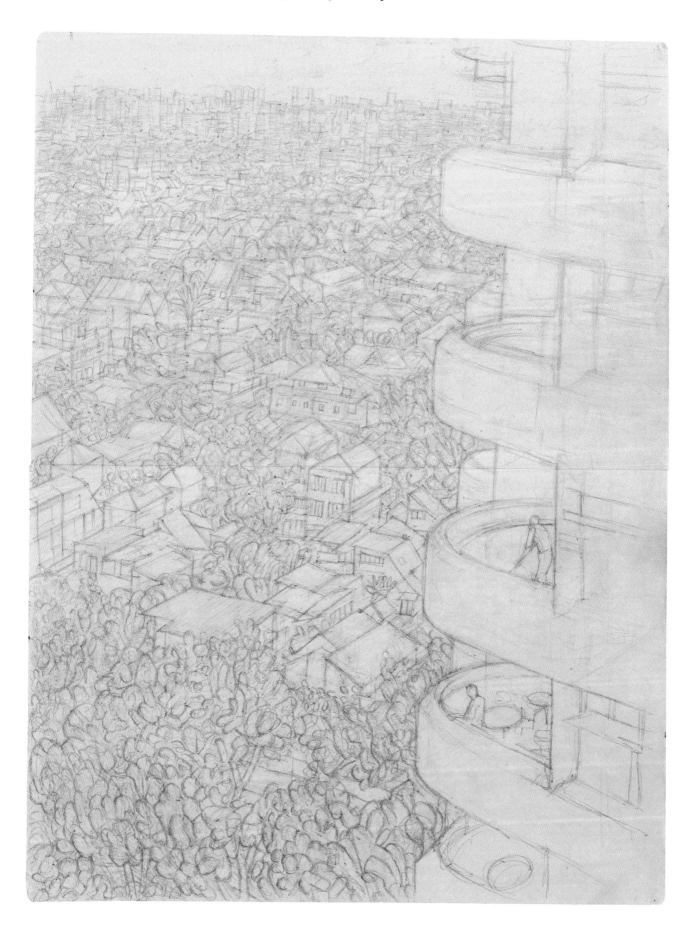

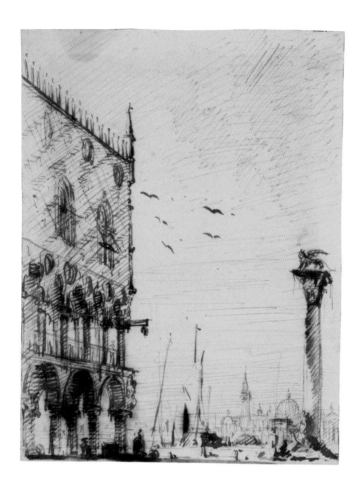

Caitlin Stone, *Inside the Pantheon*, 2015, pencil on paper

Above:
CANALETTO
Venice: The Piazzetta, looking towards San Giorgio Maggiore,
c. 1723–4, pen, ink and pencil on paper, 23.2 x 17.8 cm (9¼ x 7⅛ in.)

This is one of six drawings of St Mark's Square, Venice, done for a set of paintings completed in the mid-1720s. The column of St Mark, right, has been enlarged; the top aligns roughly with the receding roof-line of the Palazzo Ducale on the left, while in the distance San Giorgio has been stretched to show its portico.

Rosie Vohra, untitled (sketchbook, China), 2014, mixed media

Caitlin Stone, *Building*, 2015, pencil on paper

Caitlin Stone, *City*, 2015, pencil on paper

occupy is perspective. This system has five simple rules that may be reliably employed:

> Each set of lines that is physically parallel will appear to recede to the same vanishing point.
>
> Any set of parallel lines that is physically level with the viewer will appear to recede to a vanishing point at the viewer's eye level; when the viewer moves, the vanishing points will move with them.
>
> Parallel lines that are inclined uphill away from the viewer will appear to recede to their vanishing points somewhere directly above eye level.
>
> Parallel lines that are inclined downhill away from the viewer will appear to recede to their vanishing points somewhere directly below eye level.
>
> All lines that are aligned parallel to the viewer's picture plane – horizontal or vertical – will not be affected by recession to a vanishing point, and so will appear undistorted by perspective.

If we look straight ahead, verticals remain vertical and will not go to a vertical vanishing point. But if the picture plane is set to look up or down, then the viewer will start to experience the influence of vanishing points either above their heads or beneath their feet. Similarly, all horizontal

Michael Chance, *The Monastery*, 2013, graphite on paper

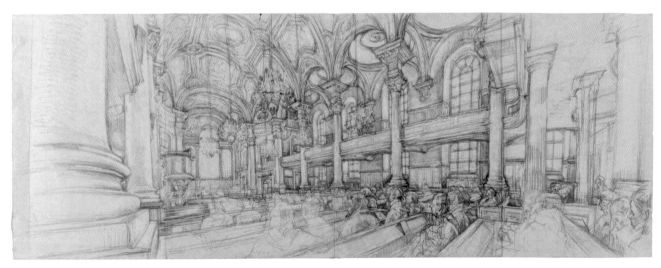

Martin Shortis, *St Martins in the Field*, 2013, pencil on paper

planes that are parallel to the flat picture plane will remain horizontal in the picture. Horizontals at eye level always remain horizontal, whatever the picture plane used.

Curve or stretch

These 'rules' are reliable, but they may also face challenges. As I became interested in perspective, I noted that guides to the system are careful to limit the field of vision to an 'eyeful' – whereas in drawing from life you may follow your curiosity in all directions. The immediate visual experience when looking across a wide angle of view is of curvature. As the eye moves, it encounters the subject in differing alignments.

Take, for example, the experience of drawing a large building standing near at hand from observation. If you place yourself in front of the building and look along its wall, the account you make of your immediate visual experience will – because your head is turning – end up describing a curve of increasing velocity. What is level becomes inclined, and what you understand to be straight is curved and pulled in various directions. Cumulatively, our vision roughly describes the inside surface of a sphere.

When we draw on a wider picture plane, the image stretches as we move away from the centre of vision. A counter-intuitive effect develops in the picture, whereby parts of the subject that are nearer to us end up smaller than more distant – but more stretched – areas. Drawing a large subject that needs to be kept coherent therefore creates particular sets of demands not encountered if you keep to smaller subjects. The main difference is that rather than looking from outside at something, the viewer is actually held by the space depicted. When I started drawing bigger spaces, the certainties of measurement learned within traditional perspective became a problem. I discovered that to draw exactly what I saw in each part of the view – an 'eyeful' – and then to link up these narrow cones of vision made the straight space appear curved. I was moving things, redrawing endlessly to follow the movement of the eye. At the end of it all, the space and volume of the subject eluded the drawing. I needed to find a way to translate this curved reality into my flat drawing in a way that held it together. Sight-size drawing was to be avoided, and the relationships of scale and proportion were of limited use when working like this.

Eventually, I found that a straight stick of about 70 cm (approx. 28 in.) held in the picture plane could be used to extend the perspective of the central portion over a much wider field. This was very helpful in drawing architecture. It kept the space of the picture coherent, and as a result what I was seeing changed from an immediate and ultimately curved experience to an oblique but flat plane. The benefit of restoring a flat picture plane in this way is that the five simple rules of perspective may again be reliably employed. Vanishing points can be found and used like tent pegs. They will pull out the space, tie in the viewer and stabilize the picture plane.

Simple freehand geometrical constructions can be used both in drawing and in life to analyse and depict coherent structures and spaces. These geometrical constructions were employed by the masons and architects who made and designed the buildings we draw, and their use leads us directly to the anatomy of these structures.

The Point of Perspective *Martin Shortis*

WHERE: *indoors, with a view of a built-up area*
WITH: *2 sheets of acetate or clear vinyl • tape • 3 or more fine, semi-permanent marker pens of different colours • a straight stick or ruler, ideally 1 metre (approx. 3 ft)*

Perspective is a system that unites space. When we draw with perspective we are using objects to express space; space becomes the most important thing and objects become secondary. This exercise will help you to understand perspective and vanishing points, how to predict distortion and how vanishing points can be used to portray a particular perspective.

+ *Find a window (the larger the better) with a view of some buildings which you wish to draw. Choose a position where things recede away from you – avoid drawing the view head-on.*

+ *Attach a piece of acetate or clear vinyl to the window, or draw directly onto it. The architect Lutyens used small pieces of soap to draw on glass.*

+ *Position yourself close enough for your pen to touch the window. You will need to keep your head at the same 'viewpoint'; it can help to rest your chin or forehead on a piece of furniture.*

+ *Draw your view, paying particular attention to the orientation of physically horizontal lines. Attach the second sheet of acetate or vinyl over the finished drawing.*

+ *Drawing onto the second sheet, extend the lines to their*

vanishing points. To do this, you will need to extend the lines out so far that they cross over with other, parallel extended lines, i.e. the top and bottom lines of a window. This cross section is known as the 'vanishing point'. You should end up with numerous vanishing points – one for each set of parallel lines. Use different colours for different sets of lines to avoid confusion.

If the vanishing points are beyond the edge of the sheet and window, you might need to extend the lines onto the wall. If so, try using pins connected with string, or take the drawing and place it on a larger sheet of paper – you can stick several sheets together if required. Notice where the groups of parallel lines meet. Hopefully, you will find that all the vanishing points end up at the same level – which should be the same as your eye level.

This exercise demonstrates that a vanishing point is not something real, but is created by our viewpoint. Vanishing points position the viewer and show their particular perspective as opposed to a generalized view.

You may need to try this several times to make it work. Keep practising and don't worry if your drawing is 'bad'. This exercise will help you to see and think about space in the built world, and to develop your spatial imagination.

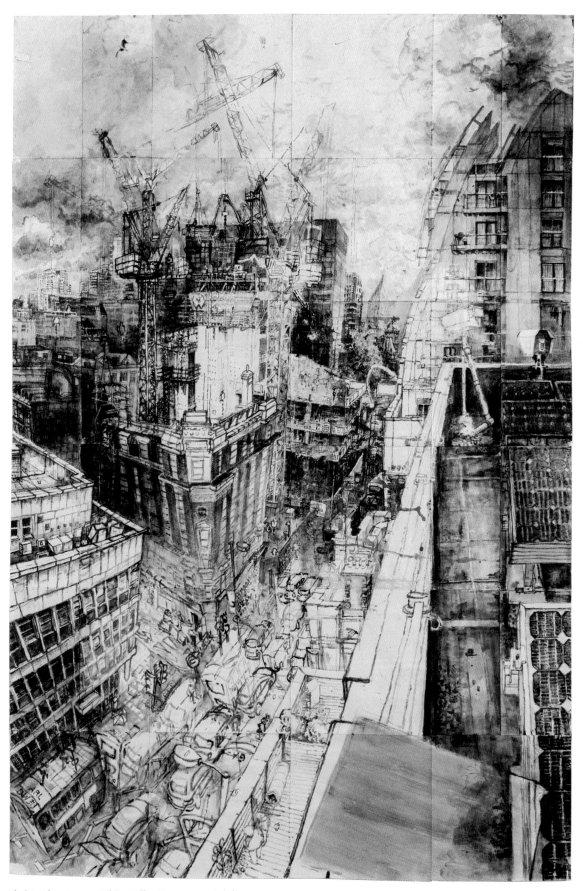

Christopher Green, *White Collar Factory*, 2008, ink on paper

Other People's Terrain *Mark Cazalet*

How might drawing in foreign lands and unfamiliar parts
of town be creatively invigorating?

Why have so many artists across the centuries felt compelled to go into
other people's terrain to draw? Why leave the safety and comfort of the
studio? What can the chaotic environment of the street offer an artist except
compromise and aggravation? In *Street Haunting* (1927), Virgina Woolf offers
us a succinct writer's explanation: 'It is always an adventure to enter a new
room, for the lives and characters of its owners have distilled their atmosphere
into it, and directly we enter it we breast some new wave of emotion.'

The premise might seem straightforward, but the implications are far
from simple. Those 'owners' might be in distant countries, or they might
be our fellow citizens in some unfamiliar part of town. We might choose to
travel far and experience much inconvenience – not to mention bed bugs
and incomprehensible behaviour – or find similar obstacles closer to hand
in our own backyard. The unexpected possibilities and problems that arise
are worth considering, either way.

Abroad

In truth, travel may not always turn on encounters with other people, nor
even with tourist 'sights'. In 1983 I was in Russia on an art school trip.
Wanting to explore the city alone, I went to the Moskva Pool. At that time,
this was the world's largest open-air circular public baths; nowadays, the
Cathedral of Christ the Saviour stands at the site. On that February evening
the temperature differential between the water and winter air caused
a dense cloud of condensation to float over the surface. Unnervingly,
swimming in that vast space, I could only see a metre beyond my hands.
Figures loomed in and out of focus, or were only discernible by booming
voices through the mist. The missing tiles on the floor of the pool seemed
to be shifting black forms, slithering irregularly beneath me. It was a
rubicon experience, and resulted in my first attempts to draw in colour
from memory. I learned that what compels us to draw may not happen at
a time or place where we are able to act on that impulse. Furthermore,
it was apparent that the experience was as much about capturing smells,
sounds and the experience of diminished visibility as anything tangible.

Travel, then, may stimulate us into drawing in fresh ways. In 1914,
Paul Klee became deeply unhappy during a stay in Hammamet, Tunisia,
when travelling with his friends Hans Macke and Franz Marc. He believed
that in drawing the clichés of sand dunes, camels and the mosque's dome

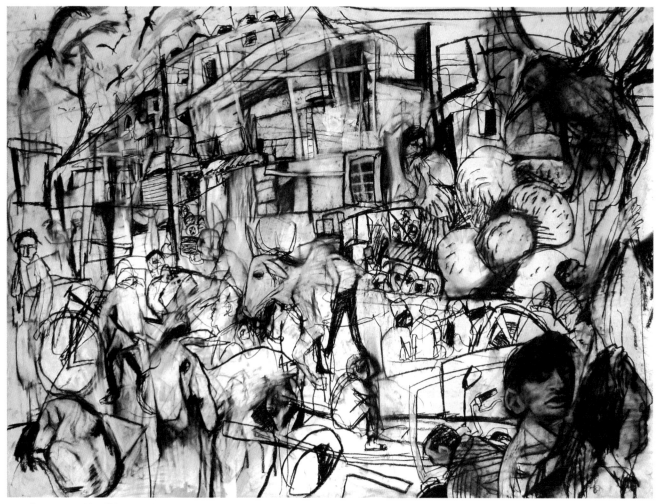

Jonathan Farr, *Old Delhi*, 2012, charcoal on paper

he was dealing only with the superficial signs. When he gridded his picture plane and placed colours together, they produced the effect of the heat and atmosphere. Sometimes one has to push beyond the literal motifs in order to find the essential subject.

It is natural, though, to start with observation. Observational drawing in foreign cultures has been catalytic for artists from Turner and Delacroix to Matisse, often enabling them to find what eluded them at home. Traditionally, artists have followed the illogical and reckless stratagem of arriving raw, with a thin knowledge of local customs, social realities or even language, and audaciously beginning to draw a society they cannot reasonably understand. This was my own modus operandi when I walked the roads of Baroda, West India, at the beginning of an eighteen-month scholarship there in 1989. Shamefully, my initial creative months were full of the utterly banal touristic superficialities. The sudden jolt of the unfamiliar does, however, in time break down habitual inhibitions and the constipation of studio-bound introversion.

So who benefits from this trade and how? Postcolonialism has made us more aware of its pitfalls – of exoticism, cultural appropriation, transgressions and rank misreadings. An aphorism with which most travellers can concur when it comes to the behaviour of the majority of one's fellow nomads is that travel narrows the mind. Far from the encounter holding up a mirror to ourselves, we import and apply all our prejudices, partiality and presumptions. For artists, this may unintentionally produce acute portraits not of the destination but the place of origin. Edward Burra's magnificent watercolours of 1930s Harlem come right to the edge of presenting stereotyped caricatures

Below, left:
PAUL KLEE
Motif from Hammamet, 1914, watercolour and pencil on cardboard, 20.3 x 15.7 cm (8 x 6¼ in.)

Of his time in Tunisia, where he visited Tunis, Hammamet and Kairouan, Klee wrote, 'Colour possesses me. There is no need to try to grasp it. It possesses me. That is the meaning of this happy moment: colour and I are one. I am a painter.'

Below, right:
EDWARD BURRA
Harlem, 1934, watercolour and bodycolour on paper, 55.3 x 41.9 cm (21⅞ x 16½ in.)

A photographic memory enabled Burra to set down his impressions of the places he travelled to – Marseille, Paris and here, Harlem at the height of its cultural Renaissance – once he had returned home to England. A lover of jazz and black American culture, Burra sought to record the energy of urban life in the New York neighbourhood.

Carl Randall, *Mr Kitazawa's Noodle Bar (Ink Study)*, 2016,
Indian ink on paper

Joe Goouch, *woman and child*, 2011, etching

of the African–Americans he depicted in the bars and streets of New York; what
the images reveal is the repression and parochialism of interwar Britain. But
Burra's vision is redeemed by the ingenuous eye he employs, democratically
recording the squalor infused with the dignity, vitality and the heroic cultural
aspiration of the people in it. He doesn't romanticize the poverty: violence and
sexuality are luridly omniscient. Then again, perhaps the real subject is his
love of jazz and theatre. Are the people merely contingent actors?

Is it sufficient to record landscapes and vistas unencumbered by the
pressing socio-political realities of the people there, who are staged like
a crowd of non-speaking extras filling a Hollywood set? The great tradition
of topographical painters such as Edward Lear, Thomas and William Daniell
and even Turner rarely engaged with the lives of the people represented.
In 1947, John Minton spent a month in the then-lawless, cocaine-smuggling
island of Corsica. The resulting text and images, worked on with Alan
Ross and published as *Time Was Away: A Notebook in Corsica*, has a richly
refracted set of concerns. Minton lovingly portrayed the young men and
boys to whom he was attracted, but he also captured crowded public buses,
slums and desolate, isolated communities. I think we have a conflicted

brief when we draw abroad: part 'us', part 'them'; part autobiography, part documentary. And maybe these strands are necessarily inseparable.

Nearer home

In his early twenties, around 1882–3, Georges Seurat visited an area dubbed *la zone*, a hinterland of Paris between the *banlieues* of Courbevoie and Saint-Denis that was frequented by rag-pickers and people who lived from scavenging. It would have been simple to portray the pathos of marginal urban lives in the style of his hero Jean-François Millet – epic figures tied to meagre subsistence labour. Instead, Seurat created gaseous surfaces woven with arced lines, a fog of febrile suggestibility. We grope in the visual plane of the resulting drawings, unable to secure a perspectival grip (I think of my immersion in that misted Moscow pool), and it is deeply unnerving. As Bridget Riley put it, Seurat's drawings present us with 'an experience beyond our visual grasp.' Seurat epitomizes the artist as urban wanderer, searching out the hazy no-man's land beyond our routine experience. He conjures a place that reverberates with lonely desperation but visually enchants, an oxymoron of degradation and mystery. Drawing can point us in both directions; it is the ideal medium for mixed messages.

Prunella Clough made day-long walking trips through redundant, semi-industrial areas. She took photographs and made notes, but in the studio these were radically condensed and obscured; her lyric evocations were inspired by the most quotidian of stains, joins, debris and haphazard arrangements. Her drawings and paintings are like words on the tip of the tongue that stubbornly resist resolving into clear accounts, but that nonetheless taint the mind with reveries of metaphysical worlds – puzzling suburban miniatures.

Stepping out in this way, I particularly relish the economy of materials and improvisatory techniques that drawing on the street necessitates. A small

GEORGES SEURAT
Courbevoie: Factories by Moonlight,
1882–3, conté crayon on paper,
23.6 x 31.2 cm (9⅜ x 12⅜ in.)

Two tall, dark smoke stacks and a glowing moon emerge from Seurat's sheet. The paper texture, picked up by the soft conté crayon, effectively communicates the smoky haze of a winter's night on the industrial outskirts of Paris.

Other People's Terrain *Mark Cazalet*

Geraint Evans, *Edgeland*, 2015, charcoal on paper

Mark Cazalet, *To Timbuktu; Tramp Ship up the Niger*, 2009,
chine-collé linocut

Overleaf: Rebecca Harper, *Along with the Stream of Buffalo*, 2013,
gouache, watercolour, glitter and charcoal on paper

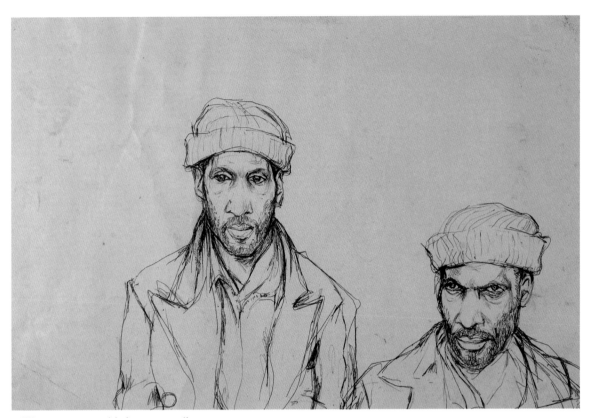

William Stevens, untitled, 2007, pencil on paper

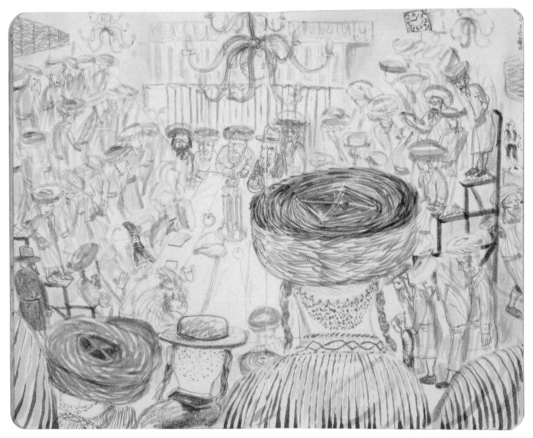

Mark Cazalet, *Toldos Aharon Shabbos Tish, Meah Shearim,*
Jerusalem, 2005, felt-tip pen and graphite on paper

bag of kit allows me to move fast. The pragmatic need to reduce one's media often forces the most versatile graphic response: I opt for light-hued felt-tip pens to wash an immediate design, conté and graphite sticks for dense tonal shadow and strong marks and aquarelle pencils for colour. The street produces an ever-changing kaleidoscope of shifting forms whose effects have to be rendered directly. Indelible markers compel one to seize Cartier-Bresson's 'decisive moment', an instant when all the permutations of movement, spatial depth, mood and unified composition of the surface crystallize.

The street offers endless narrative possibilities. It can be a stage for projected personal visions or for a formalist set of abstract concerns. One approach is to look onto the street below without being part of it. I am moved by the alienation of Edward Hopper's lonely New Yorkers; the naked woman sitting on the bed of her single-room apartment, craning to see what is happening outside without revealing herself. The humidity and loneliness there is as dense as any barometric reading. We are drawn into empathy and yet also into a strange voyeurism of her voyeurism. Hopper brilliantly shows the double-edged nature of drawing on the street: we are compelled to stare, to look beyond the conventions of polite acceptability, but to be so placed puts the artist-*flâneur* in danger of prying, of losing objective distance, of becoming themselves a player in the tableau. I may draw the world as a stage populated by sideshow stories, but these are real lives. When I stand still and look for hours, profound insights into seldom-seen private worlds often take shape – and this triggers a causal responsibility that implicates you and me.

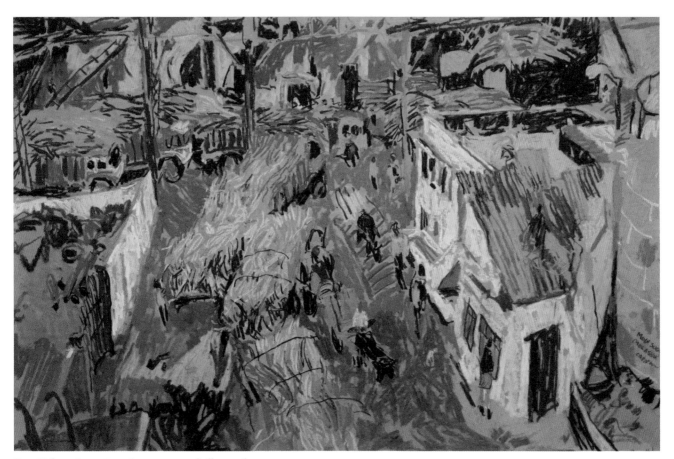

Tyga Helme, *Sugar Cane Factory*, 2014, chalk pastel on paper

Night Drawing: Letting Go *Mark Cazalet*

WHERE: *outdoors, then, later, indoors*
WITH: *black or dark-coloured paper and gouaches, pastels or coloured pencils*

Prepare some paper with a dark ground – a diluted wash of dark-coloured ink or watered down acrylic paint – or use black or dark paper. Select a range of colours you'd like to work with and lay them out so you don't have to think about your palette later. Leave this to one side.

Go into a quiet garden or wood at dusk. Don't draw, just sit and stare at the rapidly changing colours, space and shifting tones. Above all, listen as night takes over from day. Allow at least twenty minutes of meditative acclimatization, firmly putting away any distracting thoughts or plans as to what you will draw.

Then, go back to your studio or wherever you like to work. Draw your experience of your complete encounter from the garden onto the paper. Think about perceptions of space and sound rather than form or how things really looked. Make considered marks to build up your surface. Work with economy rather than detail.

This approach can allow you to be less self-conscious in your drawing and less focused on the final outcome. As the poet Rumi said, 'Put your thoughts to sleep, do not let them cast a shadow over the moon of your heart. Let go of thinking.'

Holly Mills, *Untitled 1*, 2018, pastel, conté and charcoal on paper

Holly Mills, *Untitled 2*, 2018, pastel, conté and charcoal on paper

Laura Footes, *Memory of Bedford Square at Night*, 2013, ink, biro and black chalk on paper

Charlotte Ager, *Private Night Park*, 2018, charcoal, ink and gouache on paper

Covering the Ground *William Feaver*

What a walker in a landscape may come to know by drawing in it.

Crouched in the ineffectual shade of a young olive tree, I reached for my sketchbook and began to make what I could of the slopes opposite. I was in Tuscany: there were cypresses lined up like random exclamation marks and somewhere nearby cicadas zithered. Where to start? Given the heat and the relentless pressure of the sun on the back of my neck, I needed to get the drawing done promptly, and that meant dotting and dashing to set down the essentials. Nobody was about, it being midday – but a dog tethered outside the villa below barked querulously enough to remind me that landscape drawing is marginally intrusive and that places can never be simply picturesque.

To sketch summarily is to go one better than the codified flatness of a map: to quicken, therefore, and to frisk the scene. A simple, rapid response of this kind may be enough, if the aim is to produce some sort of moving personal response. But by its very nature, drawing in the landscape also demands walking it and staying with it. Forays like this one to Tuscany are all very well, but reiteration – year in, year out – has more to it.

For me, the better place to return to is – and has been for decades now – a subject that literally draws me in. It is Spartylea, high in the North Pennines in the tail end of Northumberland, a hamlet that for hundreds of years, until two or three generations ago, lay in the heart of a lead-mining area. Waste heaps and washing floor reservoirs survive; hill farming lingers below the grouse moors. A terrain composed of limestone, peat and clumps of sparty rushes encourages one to imagine that timelessness has intervened. Yet, as my sketchbooks testify, things do alter: obviously through the seasons and, less markedly, through climate change. The rowan growth rate is now phenomenal and summer birdlife – skylarks, peewits, swallows and all – seems busier than ever.

Drawing in these parts is daily exercise. For me, along with the dog, it's a matter of going time and again up the Drag, the old packhorse route to Hexham, or south to Byerhope, where there are still red squirrels in the Scots pines, or, on the other side of the valley, along the claggy Black Way past the notorious whitewashed redoubt of 'Dodgy Don', who is currently serving time. Turning towards the long, sheltering shoulder of Killhope, where the counties of Durham, Cumbria and Northumberland meet, there are sublime distances to appreciate – panoramic, demanding a double-page drawing – while nearer and lower, at one's feet, are the Robson and

Georgina Sleap, *The river in the rain*, 2011, pencil on paper

Archer farms, Elpha Green and Low Shield, each a cluster of buildings and sycamores enclosed by hay fields and sheep grazing. Drawing also serves as an excuse for taking a breather. Sheltering under drystone walls, wind flapping the pages, it's not long before the vast harmonies of the Dale rebound onto paper: its high horizons magnifying the clouds, its ever-changing narrative of light and shadow flitting over familiar slopes.

In such circumstances most drawings do little more than mark time spent, failing to get beyond over-familiarity and the mannerisms induced by numbed fingers. Yet even the scattiest may be appreciable as something grasped: the scars of burnt heather softened as summer progresses, the patterning left when the baler has passed and, from mid-August, the daily spectacle of guns travelling in 4x4 convoys to quell the grouse. You learn, when drawing, to look out for the mail van delivering unachievable broadband special offers and Philip the quixotic milkman travelling untold miles to deliver three times a week to isolated households.

Sitting there, watchfully, you tell yourself that without drawings in hand, the eyes wouldn't operate so intently. That said, a good drawing then seems so sudden.

William Feaver, *Tedham, Allendale: Winter*, 2011, ink and wash on paper

Naomi Trevor, *View from the Olympic Park, Southwest*, 2015, pastel and charcoal on paper

Katie Brookes, *Sun over Hammersmith Beach*, 2013, pencil on paper

Meg Buick, *Viewpoint*, 2013, pastel on paper

Constanza Dessain, *Notes on an Unfinished Landscape*, 2012, etching

Fraser Scarfe, *Tree at Kensington Gardens*, 2013, black pen on paper

Ann Dowker, *Drawing from the Ramasseum, Upper Egypt, Luxor*, 2018, charcoal
and chalk on handmade paper

Being Present *Tyga Helme*

WHERE: *somewhere outdoors*
WITH: *a stack of 8 x 8 cm (3¼ x 3¼ in.) squares
of paper*

*This exercise encourages you to be more involved in the
looking process, by taking away the pressure of where
your drawings are going and what they will end up like.
You can use any subject, but it works well on a street or
in a wooded landscape.*

*Prepare a stack of small squares of paper and locate
a view, vista or scene that you would like to draw from.
Take the first square and without too much thought,
start from your initial point of interest and draw it.
After three minutes, turn over the first square and start
on the next, allowing the eye to move up, down or along,
wherever it is most drawn. You might be interested in
the minutiae of the bark on a tree in one square and the
whole shape and silhouette of the same tree in another,
or the fern that was to the right of that tree's roots in
another.*

*Continue to draw on the squares, always turning over
the last one before starting the next so that you cannot
refer back to your previous drawing. You might spend
a few seconds on one square and a few minutes on
another. Some squares might be densely filled, others
complete with just a few marks.*

*If you like, you could walk or move around between
squares and draw the same view from a different angle.
If your interest moves on, then you must take a new
square. This exercise is about being intensely present
in your looking and mark-making. You could go through
ten or twenty squares.*

*At the end, the squares can be put together as a whole.
Different senses of place and space might be conveyed;
you will be able to see where your eye naturally travelled
and what you reacted to.*

Tyga Helme, untitled, 2014, ink on paper

Max Naylor, *Thorpeness*, 2012, ink on paper

Finding and Making in Open Country
Daniel Chatto

The high intensity of an encounter with landscape in all its unruliness.

Let me describe a certain experience of drawing in open country. There are as many ways to engage with landscape as there are artists, but this illustrates one possible path.

When Constable began his career as a landscape artist, he would often walk out early with boyhood friends who were setting off hunting. As they walked the land together, he had a sense that they were all engaged in a shared activity: while they stalked game, he was stalking his perfect subject. Both activities form a link with the land that is ancient, even primal. You may experience this just walking in the landscape, of course, but it is heightened by the sense of purpose and connection of which Constable spoke: the attention paid to every curve of the land and every structure of vegetation. You can set out on such walks and find places equivalent to those he found, places that you can return to in different weathers and seasons. Each time you will see more clearly, and your work will become more intense, freer.

So, you have found a subject and must now find the spot where you will make a base camp – moving in smaller and smaller circles, just as a dog makes its ridiculous circular bed. You hit upon the perfect location – say, a patch of higher, drier ground, or a fallen trunk for a better view. Now you can set out from this base to see your subject up close and also in the round. You cannot possibly draw a tree, for instance, with any knowledge or feeling if you haven't seen its patterning of lichens and the texture of its bark, and you will not be able to understand its form and growth until you have walked around it and seen it revolve in space.

Now you are ready to start drawing. The internal tension is palpable, the paper pristine. This is the moment to just start putting the subject down loosely, arranging the major elements as you want them to balance on your paper – enough air to feel the weather and volumes around the larger subjects, enough earth to thoroughly explore the distances and rhythms of the landscape. This is not the time to worry about how you should make the marks – you are free of rules and there is no 'should'. Do not be overwhelmed by the plethora of nature's forms and textures. The mark you make, for instance, for a clump of windblown grasses a couple of feet in front of you, and the mark placed inches above it

Gideon Summerfield, *A Refugee's Dream*, 2017, monotype

on the paper to stand for part of a tree trunk that stands solidly twenty feet further away may be broadly similar – one heavier and more upright than the other – but you do not need to consciously direct this. You must simply look very hard at the subject, experiencing it intensely, with the attention of a hawk, and intend that your marks depict each distinct object. Unconsciously, your hand will sculpt the weight and rhythm of the two forms. Your individual mode of depiction will take care of itself.

You have started, and the broad balance of the drawing begins to take shape. There might be something hidden behind one of your nearby masses that has a rhythm that will look good in the drawing – so you move to see it and incorporate it onto your page. Perhaps a range of hills to your left is finer than what is directly in front of you. Haul them round and put them into your horizon. Wait for the sky to evolve, and when clouds form whose rhythms most express what the atmosphere of your work intends, work like crazy to get them down on paper. A swift's arcing flight around a tree must be recorded like lightning. It makes you more aware of the huge volume of air that the tree's canopy encompasses and links it to the canopy of the sky; it also warns you that it is now afternoon, and insects are on the wing.

Soon, you will find yourself able to work on a larger scale, with big sheets of paper weighed down with whatever stones or fallen branches lie to hand – then you will start to walk around in the space of your drawing, with all worry about mark-making disappearing. If, however, you still feel

Above, left:
LEONARDO DA VINCI
A *Stand of Trees* (recto), *c.* 1500–10, red chalk on paper, 19.1 x 15.3 cm (7⅝ x 6⅛ in.)

Here, Da Vinci has made use of both the sharpened point and the broad, flat edge of a piece of chalk, depicting a cluster of trees effectively with very minimal materials.

Above, right:
FRANK AUERBACH
Tree at Tretire, 1975

Auerbach made a number of studies of this tree from the upstairs window of a house in Tretire, Herefordshire, describing its 'canopy that holds up the wild sky' – here built up from the earth using layered, forceful marks.

that you are not working with the freedom you would like, try using a more forceful medium. I like using earthy materials like chunks of sanguine (red earth), charcoal made from vine, oak or willow, or ink made from oak galls. These materials are direct – they are a bit messy and come from the world you are depicting. You can't be fussy with them; they come in big lumps, or make blots that can't be rubbed out.

You continue to work your way over your big sheet of paper. It may have been blown away a couple of times and need more rocks to weigh it down. You now need to work on the sky and perhaps the upper part of the trees – but you can't crawl over your drawing to work on its top or you will harm it, so you walk round to the far side of the paper and work looking over your shoulder. You will be drawing upside down and in reverse and your marks will be clumsier, but they will also be freer and more vigorous. You might have to work on them a little once you are back at home, in order to harmonize the whole thing.

You are nearly finished. Now is the time to bring your focus onto the drawing itself and see what it needs, not what nature is shouting at you to include. By this time you are exhausted, your senses are befuddled by weather and work, you have no idea whether your drawing is good or trash – you will find that out over the course of the next few days, once you have

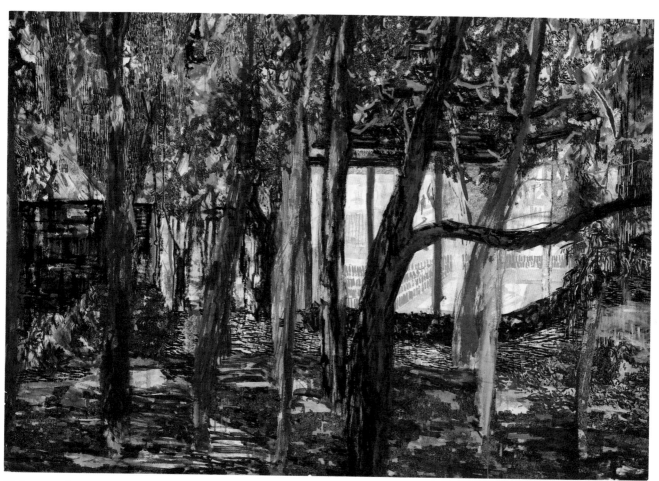

Kathryn Maple, *Leaving the City Behind*, 2013, watercolour on paper

Kate Kirk, *Regent's Park*, 2015, pencil on paper

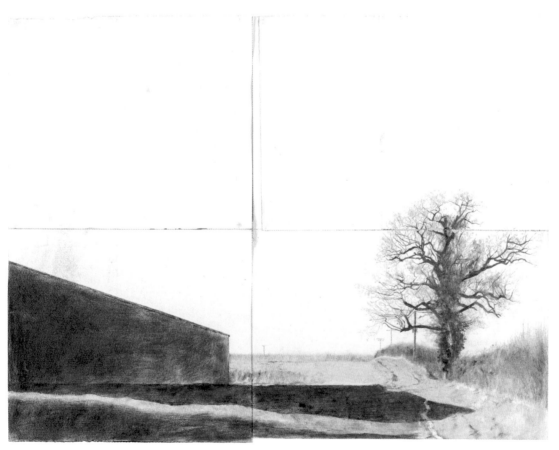

Pollyanna Johnson, *Tree*, 2016, graphite and charcoal on paper

come to see it less emotionally. But what a supreme experience of nature you have had! Not quite the shamanistic connection of a Neolithic artist, but you have moved mountains (or at least hills), stopped the sky in its tracks and – briefly – turned the world upside down.

You were likely dissatisfied at many points in the process. You may have worked on for much of the time with little hope that your drawing was much good, but this dissatisfaction is perhaps necessary and important. Nobody who is quietly – or worse, noisily – pleased with their work is ever going to create anything worthwhile.

Try to free yourself from undermining self-criticism, but never from dissatisfaction with what you have achieved – you will only get better. Experiment to find mediums that help you to be forceful, not facile. Spend time working only with them, and you will begin to draw more powerfully and indeed to see more, and more clearly. It is the power of vision that we are dealing with.

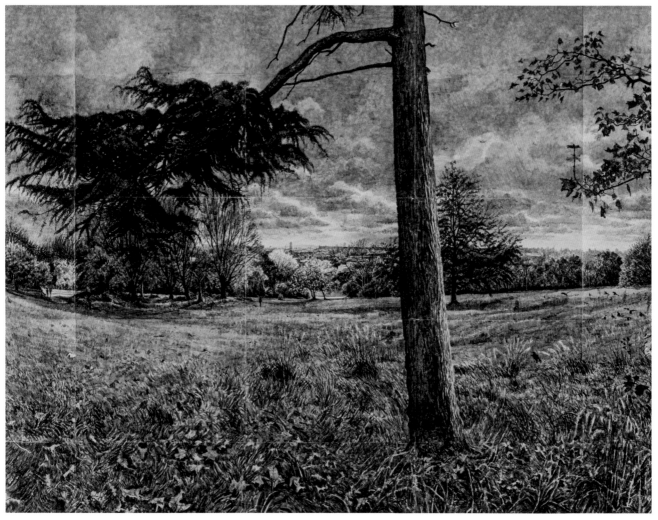

Christopher Green, *Alexandra Park, Autumn*, 2008, ink on paper

Overleaf: Olivia Kemp, *Though the Way is Lost*, 2014, pen on paper

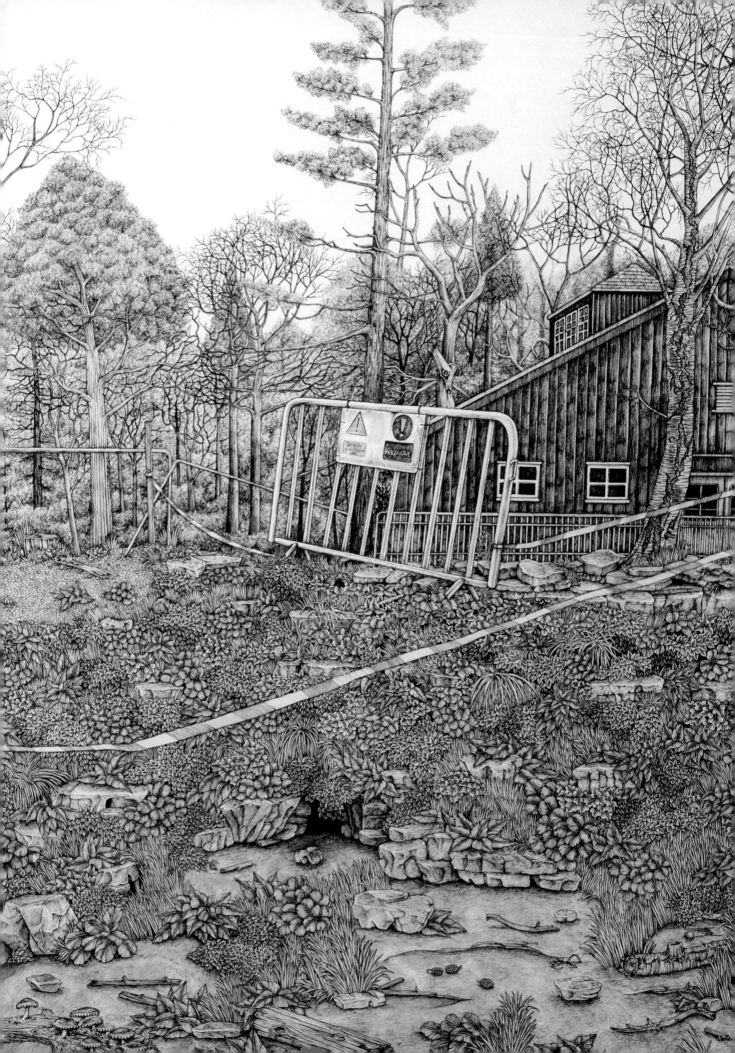

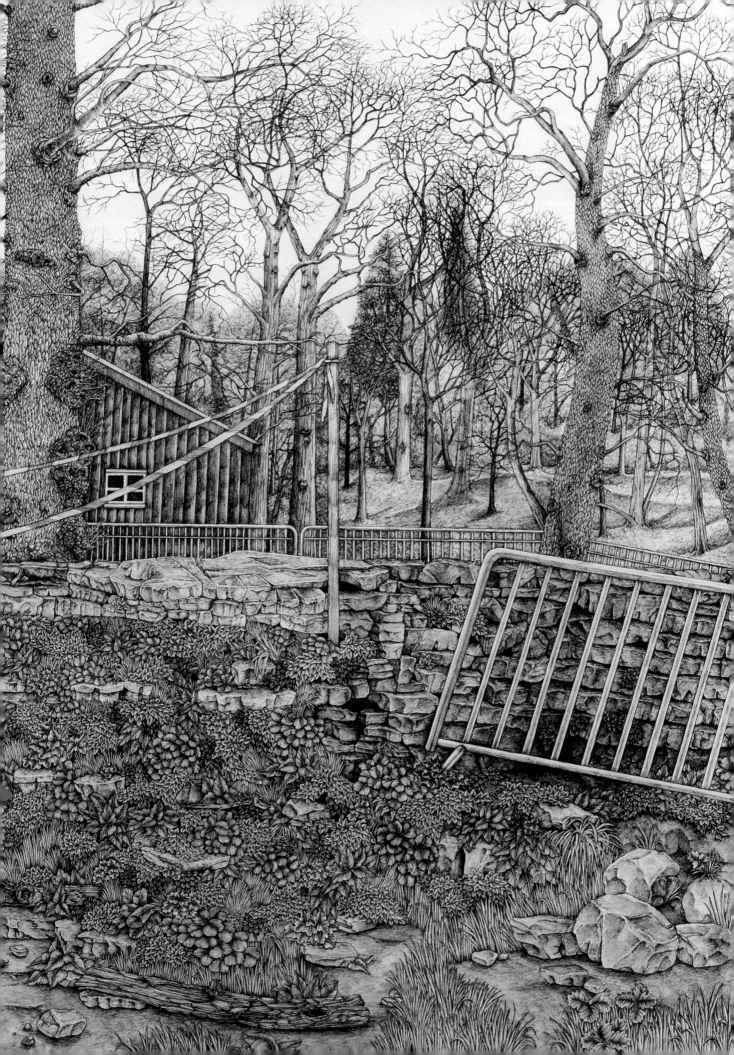

Oak Gall Ink *Daniel Chatto*

WHERE: *a wood with oak trees, then a kitchen*
WITH: *a large pan (not iron), iron nails*

First, find your oak galls. The galls you are looking for are perfectly round, hard, woody marbles as light as corks, which grow in clusters on oak trees. In England, 2017 was the best year for oak galls for a decade. Pick them when they have a little hole in them – this means that the harmless gall wasp has emerged.

Fill a good-sized casserole dish or large saucepan up to a couple of inches from the brim with galls and cover them with water. They will float buoyantly, so weigh them down with a smaller pan on top. Make sure not to use iron pans.

Bring the water to the boil and simmer the galls for up to six hours, replenishing the liquid until you have about half a pint of golden brown ink.

Pour off the liquid and keep some as your palest ink: this is what Van Gogh used in his reed pen and ink landscapes.

Then, put a few rusty old nails into the remaining ink for twenty minutes or so. It will become a darker, warm brown. Within an hour you should be able to decant some beautiful Rembrandtian dark browns. After about two hours you should try to save a most beautiful purple-brown colour, which Constable used for his blots.

You can leave the remaining ink to steep with the nails until you achieve a wonderful, intense blue-black. This amazing ink has been used for writing and drawing since at least Anglo Saxon times.

JOHN CONSTABLE
Study for Jaques & the Wounded Stag,
1834–6, pen, bistre and watercolour,
14.9 x 10.7 cm (5⅞ x 4¼ in.)

The soot of burnt wood is boiled to produce bistre, used here as a wash. The colour varies depending on the type of wood – in the eighteenth and nineteenth centuries beech, which produces a translucent grey-brown colour, was commonly used.

Daniel Chatto, *Landscape with Field Maples*, 2015, sanguine on paper

Nature Up Close *Clara Drummond*

Engaging with nature by way of the single, intensely observed specimen.

It is not clear how Albrecht Dürer made the drawing known as *The Large Piece of Turf* (1503). Did he spend hours drawing it outside in situ, or did he piece it together in his studio and study it there? Either way, the perspective that he gives us is one that we could only have if we were lying in the mud, eye level to the grass roots. That is how close *The Large Piece of Turf* brings us to nature – and it reminds me why drawing from nature transforms the way we see the world. We need only to drop down on our knees and look closely to encounter an extraordinary landscape of miniscule mosses, busy insects and abundant growth.

The Large Piece of Turf is a work of such intense observation that it seems to contain everything one needs to know and feel in order to portray nature. Nothing is generalized, everything is observed with attention, each blade of grass is seen as if for the first time – and most of all, possibly, there is a searching desire to better understand the subject. This intensity of looking creates a luminosity and clarity, a brightness of seeing.

In his *Four Books on Human Proportion*, published in 1528, Dürer wrote:

> Life in nature makes us recognize the truth of these things, so look at it diligently, follow it, and do not turn away from nature to your own good thoughts.... For verily, art is embedded in nature: whoever can draw her out, has her.

A print of *The Large Piece of Turf* hung in the hall of the Berlin apartment where Lucian Freud lived as a young child. The clear light and mesmerizing detail of Dürer's studies of nature can be seen in Freud's early paintings and drawings. So too can the seeking quality, the way he looks at fur, feathers, skin, leaves, petals and fruit with an almost forensic gaze. Nothing is boring; everything is drawn with a sort of hunger. Freud never perfects or composes his subjects: he depicts a dead monkey lying awkwardly on the table; a chicken, a cactus, a heron are all drawn unceremoniously, in jagged detail. And so it makes us look again, in the same way that Dürer makes us see such an everyday and unspectacular thing as a lump of turf as a sort of miracle.

On a quest to draw the wild plants and grasses of Suffolk described by the eighteenth-century poet and amateur botanist George Crabbe, I visited the Herbarium in Cambridge. Here in this library of the field, the wood, the mountains and the marsh, there are preserved, between slips of paper, plants that lived up to 315 years ago. The wild plants that I drew would

Opposite, top: Clara Drummond, *Standing Horse, after Stubbs*, 2015, black chalk on prepared paper

Opposite, bottom: Ondrej Roubik, *Okapi*, 2012, pencil on paper

Clara Drummond, *Cambridge Herbarium: Colchicum
Autumnale*, 2016, pencil on paper

have lived for only a matter of weeks in the summer months before drying
up, scattering their seeds and then dying back into the earth. Yet here they
were in front of me on the desk, unchanged, suspended in life through the
seasons and the years, carrying the secrets of their species.

I drew the tall Sweet Vernal Grass and the bulbous Meadow Saffron.
Then, mark by mark, an oxlip grew across my page, creating another life of
sorts. Using a microscope to distinguish the delicate roots and veins of the
leaves, I drew at a slow pace, corresponding to the speed at which the plant
grew from a seed that germinated in 1935, unfurling from seed to standing
bloom in minute motions.

While working in the Herbarium I often thought about the work of
Georgia O'Keefe – about how she saw flowers as marvellous things that
were frequently over-seen, about her desire to make people notice them
by depicting them on a scale that made them strange and unfamiliar. She
pioneered new ways of seeing the world, and brought to our attention the
extraordinary things in nature that we could find all around us if we only
took the time to look:

> When I found the beautiful white bones on the desert I picked
> them up and took them home...I have used these things to say
> what is to me the wideness and wonder of the world.

Above, left:
ALBRECHT DÜRER
The Large Piece of Turf, 1503,
watercolour and tempera on paper,
40.3 x 31.1 cm (15⅞ x 12¼ in.)

Minute attention has been paid to this
small pocket of grasses and dandelions,
depicted in all their natural disorder
with such care that it seems possible to
identify each individual plant growing
in the clump of earth.

Below, right:
LEONARDO DA VINCI
Star-of-Bethlehem, Wood Anenome & Sun Spurge, c. 1505–10, red chalk, pen and ink on paper, 19.8 x 16 cm (7⅞ x 6⅜ in.)

Blades of grass growing among the wood anemones indicate that these studies were probably drawn in place, rather than from specimens. The lush, swirling foliage of the star-of-Bethlehem gives the sheet a sense of air and movement that connects it to the outside world.

I believe that drawing and the forms found in nature are deeply connected. Whether early humans were drawing on the walls of caves or carving images, shapes or patterns into bone, one has the sense that their first impulses to create were in direct response to the natural world.

In 2014 I worked as Artist in Residence in an exhibition called 'Discoveries', which brought together objects from several fields including zoology, geology, anthropology, scientific instruments and classical archaeology. Drawing for the exhibition made me realize that artists and scientists share a capacity for sustained close observation of their subject and an ability to give form to what they observe. Although the ultimate purposes are different, both processes lead to discovery. Many of the objects in the exhibition were unfamiliar to me and therefore very revealing to draw, but it was the fossils that proved to be the most exciting: inconceivably ancient, extinct and extraordinary.

When one is drawing something from nature, its internal logic reveals itself to you gradually, and one becomes conscious of the unity, order and symmetry that underlies all natural forms. I felt this most acutely when drawing the fossil of an ichthyosaur, a dolphin-like creature that once swam through prehistoric seas. As I drew each fragile rib, bone and delicate vertebra, the long-dead animal's sinuous form appearing on my page seemed quite alive, in mid-movement, opening a brief window onto the ancient past.

Leonardo da Vinci wrote:

Though human genius in its various inventions with various instruments may answer the same end, it will never find an invention

Cheri Smith, *In Sulphur Lands*, 2018, pencil and pastel on paper

Gabriela Adach, *Study of Chickens in Pignano*, 2018, coloured pencil on paper

Kathryn Lloyd, *Lycaon*, 2013, graphite and oil bar on greaseproof paper

Jack Fawdry Tatham, *The Durian and Her Hedgehogs*, 2017, etching

more beautiful or more simple or direct than nature, because in her inventions nothing is lacking and nothing is superfluous.

If we leave the ordered world of the museum and the herbarium to work outdoors, we have less control over what we see or find. Wild plants and animals may either hide or reveal themselves. Yet through drawing them, we can get closer to what is often overlooked and only partly understood.

Elizabeth Frink's sculptures of birds make one acutely aware of the artist as a receiver of something raw, untamed, transcendent and full of force. The process of transformation is perpetual in the natural world, and Frink's work harnesses the transformative potential of drawing and sculpture to portray it: men become birds, animals become warriors, horses' heads become fossils, birds fall from the sky and the possibility of life and death is ever present. Like the unknown artist who created the prehistoric Lion-man of the Hohlenstein-Stadel, Frink combines the human and the animal. In this way, she allows the human part of her to recede so that she is more receptive to the animal. She goes to nature, she gets under the skin of her subject and becomes less separate from it. I feel that artists who do this, such as Frink, Freud and Dürer, are able to truly draw their subject.

Above, left:
LUCIAN FREUD
Rotted Puffin, 1944, conté and coloured crayon on paper, 18.4 x 13.3 cm (7¼ x 5¼ in.)

The disheveled feathers of this dead bird are formed of carefully, intensely observed lines. The play of textures – smooth beak and bone against bedraggled feather – and the awkward angle of the bird's head combine to create a compelling, disquieting image.

Above, right:
ELIZABETH FRINK
Eagle, 1966, charcoal on paper, 75 x 55 cm (29⅝ x 21¾ in.)

Frink invokes a range of texture and motion using her chosen material: broad, looping strokes create wings and tail-feathers, while the smaller, softer feathers on the eagle's limbs and head have their own smudged idiom. The specifics of eyes and claws are created using the sharp point of the charcoal.

They show us that it is through drawing that we can experience this intimacy with nature.

Once, when I was in Norfolk, I found a fledgling bird that had been struck by a car. It lay lifeless in my hand, its downy feathers and small wings completely still. I brought it inside and laid it on a table near the window. At first I drew the darks and lights of its soft grey plumage – it was hard to create a feeling of weight and form, as the light body barely pressed against the paper it was laid upon.

So much of what was characteristic and particular to the fledgling seemed to reside in the details: the miniature feathers that encircled its eyes, the fall of light on its diminutive beak, the delicate structure of its legs. But when I drew too much detail, all sense of life and movement was lost. So I endeavoured to balance the swift marks that described the tilt of its head and the exact arc of its wing with the slow and careful drawing of each tiny feather and claw. I drew the fledgling and rubbed it out dozens of times.

As the light faded I decided to stop. Looking at the drawing, I could see that there was something of the fledgling in it, but it was only one perspective, just a fraction of the experience of looking at the young bird. I was reminded that when we look at nature we only see one side of things; that the whole is so hard to capture that it requires us to look, not once, but many times. Fragment by fragment we build up a picture of something more truthful. Tomorrow, I told myself, I must try again.

Above: Clara Drummond, *Fledgling*, 2017,
pencil on paper

Right: Olivia Kemp, *Gannet, Juvenile*, 2014,
pen on paper

Overleaf: Christopher Green, *Alexandra
Park, Winter–Spring*, 2008, ink on paper

Paper Concertinas *Clara Drummond*

WHERE: *outdoors*
WITH: *large (A1, or approx. 23 x 33 in.) sheets of paper, graphite stick and coloured crayon*

Drawing is a very direct way to immerse yourself in the natural world. It gives you time to pause, to look closely and to become aware of the sounds, smells and sensations of being in and surrounded by nature.

For this exercise, first make three paper concertinas: take a sheet of paper and place it horizontally on a flat surface in front of you. Fold and then tear it into three long strips. Then, take each strip and fold it into a simple concertina of six equally sized pages.

+ *Looking Up: Make six quick, two-minute drawings of whatever you can see above your head. Drawing from right to left or left to right, let each drawing flow from one page to the next in one continuous drawing rather than six separate drawings.*

+ *Looking Down: Make six quick, two-minute drawings of the ground. You may want to start with what is directly by your feet and draw outwards from there. Try to be aware of where you are in relation to what you are drawing.*

+ *Looking Near and Far: Make six longer, five-minute drawings using both a graphite stick and a coloured crayon. You may want to keep the graphite as your light and the crayon as your dark, or just use them intuitively. First, anchor yourself by drawing something that is fixed and close by, such as your own feet or the base of a tree trunk. Draw outwards from there. Try to use the whole height of your page to draw what is far away, up close and what is in between. Avoid placing the horizon in the centre of your page.*

THINGS TO CONSIDER
Vary your marks to describe different textures. Use the side of your graphite stick or crayon as well as the point.

Think about the fall of light. Try to capture the darkest shadows, the lightest points and everything in between.

Remember movement – whether it is shifting clouds or branches blowing in the wind, the natural world is rarely completely still. Allow your marks to shift and change to reflect this.

Hopefully, by the end of the hour you will see that the natural world is endlessly complex and varied, and transforms completely depending on how you look at it and where you are in relation to it.

Jenny Smith, *Holland Park*, 2012, watercolour, ink, graphite, chalk, oil pastel and charcoal on paper

Kathryn Maple, *A Tropical Flurry*, 2013, watercolour on paper

INNER SPACE

INNER SPACE Introduction *Julian Bell*

A drawing is a set of marks that someone has made. This last section of *Ways of Drawing* discusses relations between that set and that someone. Its emphasis is neither on art nor on nature, but on the qualities of personal experience. However, if we ask what we mean by 'someone' – by an individual, by a person – the answers are in flux. In this section introduction, as in the two previous, I want to suggest that thinking about formats of imagery could help to illuminate the issue.

In the twenty-first century, the principal frame in which we experience imagery is the screen. We deal with backlit rectangles of visual information. There is an indefinite supply of these and we can pass them before us more or less as fast as we like. The centre ground of our visual experience has probably become the smartphone screen, which is smaller than the average handheld book and of course far smaller than a wall.

The formats in which we experience imagery tend to cast us, as viewers, into distinctive roles. The spectator facing a picture on a wall is implicitly in public space, one upright body shouldering others and prospectively in communion with them. Looking down at a book held in my hands, I am more nearly in the privacy of a dream or contemplation, my social potential temporarily annulled. The digital screen, this more recent frame, cuts across the categories of private and public. It sets us, as it were, within *spongiform* space. Multiple *you*s and *me*s become porous to one another, stuff flows through, but no panorama is available. Rather than arriving at public overviews or at private insights, what we chiefly experience is slippage: we move neither above nor through, but sideways, via a succession of windows that keep passing out of sight.

In any format we have options to play, invent and express ourselves. Screens have massively enlarged these possibilities. Not only has almost all the world's historic imagery become easily accessible online, but just about everyone is now a photographer, and every edit and posting could be regarded as a small artistic act. We should remember, however, that while any format may mould us for as long as we interact with it, no single format wholly defines us. Our potential is not exhausted by the movements of our fingertips, nor those of our arms, nor yet those of our legs. We are creatures inhabiting several different scales at once.

Thomas Harrison, *From Claude's Flat*, 2016, pencil on paper

KEITH TYSON
Studio Wall Drawing, A Beautiful Circuit, 2002, acrylic, ink and collage on paper, 151.8 x 121.3 cm (59⅞ x 47⅞ in.)

Tyson's Studio Wall Drawings began as sheets pinned to the artist's studio wall, discarded when they became too cluttered. They sit somewhere between sketchbook and diary – a record of visual ideas and interests made without the concerns of a 'finished' work.

CY TWOMBLY
Delian Ode 10, August 1961, pencil, wax crayon, coloured pencil and ballpoint pen, 33.6 x 35.2 cm (13¼ x 13⅞ in.)

Throughout his career Twombly developed a highly idiosyncratic visual language, working and reworking, erasing and smudging his marks to create an archive or repository of impressions across his sheets. This work was, as the title suggests, made while visiting the Greek island of Delos.

Predominantly, the types of graphic activity discussed in this book use arm muscles. And in some senses these activities become refreshing and even therapeutic for us, in a culture so accented towards the digital and hence towards the less-embodied. People who feel that they have left their bodies behind while working online sign up for drawing 'workshops' – 'work' being here regarded as something fine and admirable – in which to explore the joys of gestural marking, or perhaps the sweat and shivers of *plein air* observation. Meanwhile, the art world has become fond of saluting 'the object' as an aesthetic desideratum – the obdurate, emphatically material exhibit that simply refuses to be digitized.

Screen-to-sketch relations aren't simply reactive and oppositional, however. There are underlying assumptions shared by digital systems and large swathes of contemporary art production that can be traced back before the advent of the Internet. In 1968 the American art critic Leo Steinberg characterized a new form of address to the viewer, which he saw as emerging in works by Marcel Duchamp in the 1910s and fully arriving in Robert Rauschenberg's *Combines* – the ramshackle, over-painted assemblages of found urban materials that Rauschenberg began to exhibit in the 1950s. Whereas the hitherto dominant easel painting had presented the standing viewer with a pictorial world that was meant, likewise, to stand up, the new work exhibited by Duchamp or Rauschenberg was 'no longer the analogue of a world perceived from an upright position, but a matrix of information conveniently placed in a vertical situation.' The title of Steinberg's essay borrowed a term from printing – 'The Flatbed Picture Plane' – to name this kind of work; but a still more telling connection was made when he wrote of Rauschenberg's art as standing 'for the mind itself – dump, reservoir, switching center, abundant with concrete references freely associated as in an internal monologue.'

In this model for art, then, something is presented to the viewer – be it a framed rectangle, a multimedia 'combine' or some other form of installation – that is meant to correspond to the artist's 'mind'. A 'mind' in this sense is a horizontal, passive receptacle – a printer's 'matrix' or flatbed, or indeed the hardware that is its etymological equivalent, a motherboard. What fills that waiting container is 'information' – stuff from the world outside that could potentially be quantified and digitized. At the same time, on some plane distinct from either container or content, there is an operator, selecting what to slot into the exhibitable frame. This operator-artist presents the viewer with a certain 'take' on the world, and in so doing demonstrates a detachment from the internal 'dump' of information. The operator asserts 'I am an artist, I am in control' – even while the presented selection may itself proclaim 'This happens to be my mind, this happens to be my world. Crazy, isn't it? Sad!'

This sort of model has informed a great deal of artistic production in the half-century since Steinberg first aired his argument. During this cultural phase (call it 'postmodernism', if you will), the activity of drawing has been tugged in opposing directions. Some operators of the late 1960s – the Conceptualist Sol LeWitt, for instance – valued line drawing as a demonstration of conscious mental control: in this they sided with artistic idealists such as the sixteenth-century followers of Michelangelo,

or the late eighteenth-century Neoclassical movement. But the insistence on pure linearity and clean form implies a detachment from the material, which could convert into a hands-off attitude towards making physical objects at all. One outcome of this has been the artist-as-executive, who outsources the production of their exhibit to hired fabricators. From this, one might conclude that drawing is in fact a mere optional tool in the artist's equipment, to be relegated to the margins of art education. This conclusion was influential – and it was partly to counter the resulting dearth of drawing in art and art education that the Royal Drawing School was founded in 2000.

In the years since, drawing has acquired a fresh profile and visibility in the art world. Nowadays there are many gallery spaces, publications and websites that offer a welcome forum to this primary mode of visual thinking. At the same time, much of what we encounter in these spaces proceeds on Steinbergian principles. Two characteristic rhetorics dominate contemporary exhibition or presentation drawings. There is the fastidiously finished, exquisitely equalized working-out of an often provocative or counter-intuitive premise; or there is the proffered sample of graphic frailty, with its in-quotes 'badness' and stab at graffito-like poignancy. Both offer a decent political formula for an age of anxious, quasi-porous personas, and in some hands they generate exciting and affecting work. But they ignore the broad centre ground of artistic effort: that terrain between the immaculate and the cackhanded, in which drawers simply struggle earnestly to *see better*. Insofar as this is a book for drawers themselves, that middle ground of experience matters. It reminds us that the interplay of mark-maker and materials cannot be reduced to a presentation of information-filled windows.

We cannot ignore the upright, two-legged animal that each of us prospectively is – and the muscular, gravity-aware imagination that comes with that state. To exclude evidence of effort – of revision, correction and improvement – is also to exclude the dimension of time. There are so many wonderful drawings – from Leonardo's and Rembrandt's to Picasso's – that lay bare an archaeology of marks and so tell stories about the difficulty of envisaging things adequately. Sequential narrative drawing is a flourishing art, given the vitality of animation and of graphic novels; but the single sheet in which one can read a whole narrative of thought seems currently an under-demonstrated form. Reading – immersing one's attention in an imaginary space – implies a further dimension, that of depth. It implies that some encounters with sheets of markings may be more profound than others, and that these humanly fashioned items – these visual fictions, if you will – may touch, in ways that words cannot, on some aspects of truth. Exhibition catalogues like to claim that the provocative-yet-polished exhibition drawing is 'questioning reality'. When we go deeper into drawing, we may begin to be questioned *by* reality.

Drawing, in other words, is a set of practices that exceeds in potential what its present public profile might suggest. It will likewise exceed anything that this book can demonstrate. We hope, at least, to enlarge the discussion.

At the outset of this section introduction, I stated that when we look inwards, we inevitably enter a flux. That flux is represented in this section of the book by a diversity of personal testimonies, each of them surprising, each allowing and encouraging its readers to consider what their own

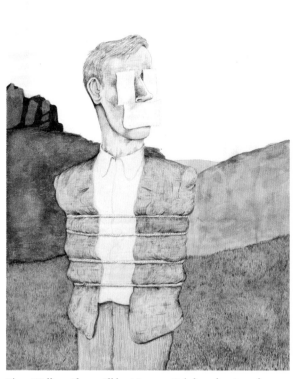

Liam Walker, *Alec on Ilkley Moor*, 2016, ink and watercolour on paper

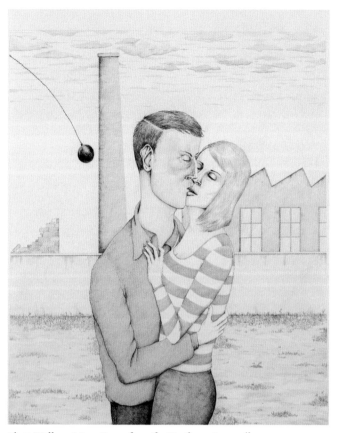

Liam Walker, *A Love Scene from the North*, 2016, pencil on paper

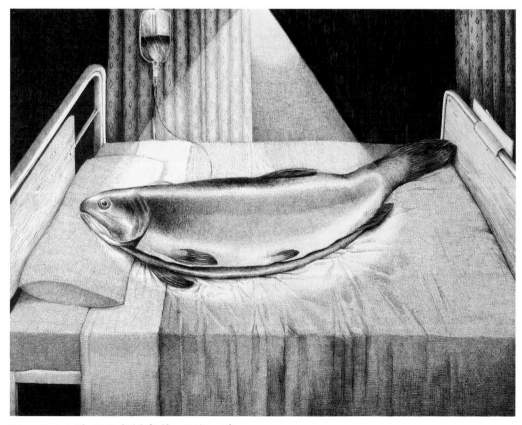

Laura Footes, *The Gutted Fish (Self-portrait 2006)*, 2013, pen on paper

Caitlin Stone, *Eyeball*, 2015, pencil on paper

Justine King, *Golden I*, 2013, pencil and gold leaf on paper

Overleaf: Gabriela Adach, *Locomotion*, 2018, coloured pencil on paper

testimonies might be. The first voice is that of the calligrapher *Ewan Clayton*. Informed by an understanding of Chinese brush traditions, he shows ways in which drawers might rethink the customary Western oppositions of 'body' and 'mind', 'line' and 'space'. He is followed by a lucid account of the experience of drawing during illness, by the illustrator, comics artist and graphic novelist *Emily Haworth-Booth*. Her analysis of her encounter with the chronic neurological condition known as ME likewise finds ways to cut across familiar categories – in this case, those of 'imagination' and 'observation'. *Catherine Goodman*, the School's Artistic Director, explores another form of dialogue between outer and inner worlds, discussing the unforeseen exchanges to be found in drawing from film stills. Then, in an invigorating essay, the painter *Sarah Pickstone* moves over several aspects of drawing, all of them converging in its capacity to move – across time, history and lived experience, across artistic modes and between one person and another. *Sophie Herxheimer* talks about communication from the perspective of a multi-disciplinarian who has always readily slipped between words and imagery, setting us an example of how to weave one's own personal cultural tapestry. Finally, the Bengal-born painter and sculptor *Dilip Sur* offers a radically poetic understanding of drawing, setting it in a framework that is at once metaphysical and lyrical.

Stroke, Body, Space *Ewan Clayton*

Mark-making, whether drawing or writing, as at once
a physical and a poetic process.

I am a calligrapher by profession, but increasingly I have become interested
in issues of embodiment. As a result, I have become involved in exploring
and teaching drawing as a 'somatic' process.

'Somatic' is an adjective drawn from the Greek word *soma*, which holds
body and mind together as one indivisible substance. So if, for instance,
I use the word 'write' in a somatic sense, I am thinking both of the process
of originating meanings, words and spellings in the mind, and of the
process of turning them into a physical substance and structure on the
page in ink and letters and visual arrangements. I am seeing both as a single
process in which all aspects of 'writing' are intimately interconnected,
so that they may not be teased apart without distortions emerging.

Thinking of drawing as a somatic process, therefore, means viewing
it as something that is born from the whole body and the body's various
ways of understanding and being in the world. I can learn about the world
through drawing, but equally my experience of being in the world can
change my drawing. In a life class I can learn about space, for instance,
by giving myself experiences that widen my peripheral vision: I can
physically walk around the room while deliberately attending to objects
and space in the corner of my vision. Or I can stay in one place but work
with my gaze, at one moment broadening it to the furthest edges of the
room using a kind of panoptic attention and at another focusing in on one
single object in the mid-range of my visual field. I can exercise that muscle
of attention by repeatedly moving from one to the other gaze over a series
of minutes. When I return to drawing the model, I will most likely bring
that new experience with me, and my drawing will be changed!

Drawing for me is, at one level, very similar to writing: it is not only
a visual event but also a tactile and kinesthetic and spatial experience.
I am sure it is so for most people, but it is the tactile and kinesthetic that
give me my particular sense of relationship with the subject, sensing the
movement within forms, the rhythms of their connecting parts, the way
a body may allow or resist gravity flowing through it and my own body's
response to or understanding of that.

Calligraphers hold that within a single stroke there are three
moments, each of which reveals something about our sense of presence
and connection – or, as a martial artist or healer might say, our sense
of extension. They are the moment you engage with the surface; the way

Rosie Vohra, *One Fine Day in the Middle of the Night*, 2014, gouache on paper

Left:
HASHIGUCHI GOYO
Kamisuki 髪隙 *(Combing the Hair)*,
1920, colour woodblock print on mica
ground, 44.8 x 34.8 cm (17¾ x 13¾ in.)

Here the woodblock has been cut very
finely, to depict strands of the woman's
hair as she brushes it – part of the
ukiyo-e tradition revived by Goyo.

Below:
REMBRANDT VAN RIJN
*Landscape with a Farmstead (Winter
Landscape), c.* 1650, brown ink and
wash, black chalk on cream antique
laid paper, 6.7 x 16 cm (2⅝ x 6⅜ in.)

Sparing brushstrokes build up this
evocative landscape. The lines become
finer as they sweep across and up the
page, creating a convincing impression
of the fence receding into the distance.

Right:
KATSUSHIKA HOKUSAI
Soshu Shichirigahama 相州七里濱
*(Shichirigahama Beach, Sagami
Province)*, 1831, colour woodblock oban
print, 24.3 x 36.4 cm (9⅝ x 14⅜ in.)

Shichiri-ga-hama rises in the
foreground of this print, with Mount
Fuji echoing its shape in the distance.
The trees and foliage draw a line
between one mountain and the other,
tying the composition together.

you sustain connection with it as it builds energy, attention or excitement; and the way you disengage or lift the pen off the page. Of course, it is also quite possible to lift the pen off the page and not lose your sense of connection to its surface – somehow, one's hand and pen circle around like a swallow above a pond in the evening light, swooping down to the surface time and again without breaking the momentum of flight.

As a calligrapher I am concerned with marks – their rhythms, their gestural qualities, what they look like on the page – but also with what they feel like in the body as we make them, and the different kinds of energy we can bring to them. I think the Chinese tradition of both calligraphy and painting can lend us insights here. In traditional Chinese texts, seven brush strokes are thought to characterize a calligrapher's repertoire. In the classic text *A chart of brush manoeuvres* (*Bizhen tu*), Lady Wei, a calligrapher in the Western Jin dynasty (265–316 CE), writes:

> The horizontal stroke is described as like an open array of clouds
> that drifts slowly across the sky for a thousand miles;
> the dot is like a falling rock, crashing down a mountain;
>
> the vertical stroke has the growth of a strong vine stem;
>
> the downward stroke, from right to left, is like an ivory tusk
> in its luminous smoothness and curvature;
>
> the sweeping stroke from left to right should rise and fall with
> the orgiastic energy of an ocean wave or rolling thunder;
>
> the hook is like an animal's claw or a rooted pine;
>
> the bent diagonal stroke has the energy of an arrow about to be
> released from a sinuous bow.

The point here is that the above strokes are described not in terms of their visual form alone but in terms of movement. A slow, drifting, gentle movement, in the case of the cloud; a surprisingly quick, strong and forceful movement with the hint of a curve in the case of the dot, like a falling, bouncing rock. These images combine the visual with the felt:

> The eighth stroke is the empty stroke of the invisible Tao
> – felt space.

In the Chinese tradition, this feeling about the forces within the forms goes back to the origins of writing itself, in divination ceremonies held in late Shang China. The cracks in the bones of ritual burnt offerings were read as signs of emerging forces at work in the universe. Over the generations soothsayers came to read the shape of these 'answers' in predictable ways. From the start, characters in East Asian writing systems were likened to the physical signs of nascent realities. Writing in China was recognised as an expressive medium from the first century CE onwards, and by the eighth century a critical literature around its aesthetics had developed.

I have noticed how these formal descriptions of movement can be related to formal thinking about movement in our own time. The epithets I have used to describe movements in traditional Chinese brushstrokes,

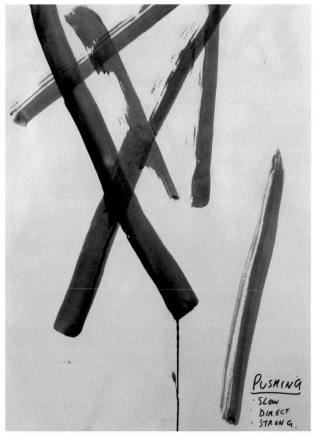

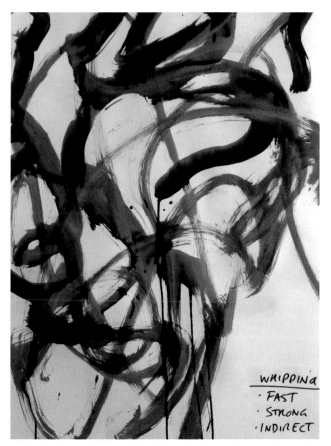

Fraser Scarfe, *Pushing*, 2018, Indian ink on paper

Fraser Scarfe, *Whipping*, 2018, Indian ink on paper

'drifting', 'quick', 'forceful', were drawn from the analysis of movement
made by Expressionist choreographer and dance and movement theorist
Rudolf Laban (1879–1958). It may be because I had forebears who were
connected on the one hand to the craft community set up in the 1920s
by the typographer and stonecarver Eric Gill and on the other to Laban
that I not only found my way into lettering, but also found myself drawn
to issues of bodily movement.

　　Gill's tradition was linear and two-dimensional. This may be why I am
so fascinated by the opposite; by how to create space within the picture plane,
how to make it feel full rather than empty! Even in two-dimensional work,
this is the challenge. Letters, like drawings, really only come alive when the
spaces within and around them are felt spaces. The knack is to see the space
and line simultaneously as you create them. To see them as one thing and
not as two; feeling the space while being aware of the line. Among twentieth-
century artists, Matisse spoke of this as seeing colour or light. Of his
drawings, he wrote 'they generate light; viewed in poor light, or under indirect
lighting, they contain, in addition to the sensitivity and flavour of line,
a luminosity and tonal values that obviously correspond to colour.'

　　Matisse seems to have embodied an almost calligraphic approach and
sensitivity in his drawing practice. He would apparently synthesize multiple
studies into a felt, kinesthetic awareness of the subject. To a visitor who
was puzzled by a large sketch of a woman's face drawn on a door, Matisse

remarked 'I did this drawing blindfolded. After working with the model all morning I wanted to see if I had really possessed her. I had someone blindfold me and lead me to this door.' He described how he built this embodied, spatial awareness:

> These drawings are always preceded by studies made with a less demanding instrument than a pencil or a pen, a charcoal stick, for example, or a stump so I can simultaneously consider the model's personality, her human expression, the quality of the light surrounding her, the atmosphere, and everything that only a drawing can express. And it is only when I feel that I have been depleted by this work, which may last several sittings, with a clear mind, that I can let my pen run free with confidence. I then have the definite feeling that my emotion is being expressed by means of plastic writing. The moment my emotion-filled line has modelled the light of the blank sheet, albeit without removing any of its stirring whiteness, there is nothing more to add, and nothing to alter. The page is written, no correction can be made. If it is inadequate, all I can do is give it another try, as if it were a matter of acrobatics.

This description is akin to the experience of making a piece of calligraphy – an art, that, like Federico Garcia Lorca's description of the emotional intensity, *duende*, in music and dance, 'needs a living body to interpret it, because they are forms that live and die perpetually, raising their contours over an exact present.'

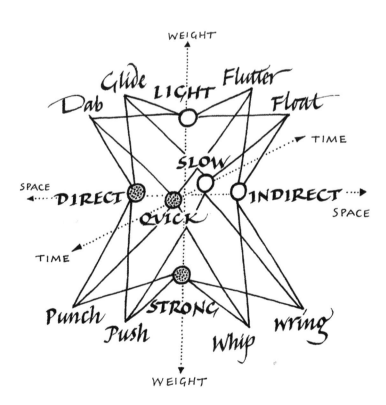

Ewan Clayton, Laban's 'eight efforts' adapted for drawing practice, 2019

Right:
HENRI MATISSE
Girl's Head I, 1950, Chinese ink on
paper, 20 x 27 cm (7⅞ x 10¾ in.)

The apparent simplicity of Matisse's
spare, elegant ink drawings belies the
careful balance of black line and white
sheet – in the artist's words, the 'art
of balance, of purity and serenity.'

Below:
HENRI MATISSE
Drawing with a bamboo stick
(in progress), 1931

Here, Matisse is shown sketching out
his mural *The Dance* using a stick of
charcoal attached to a bamboo pole.
The implement allowed him to recreate
his smooth, sweeping line on a much
larger scale; his gestures, too, are
enlarged, here extending his arm
to create one of the three arches.

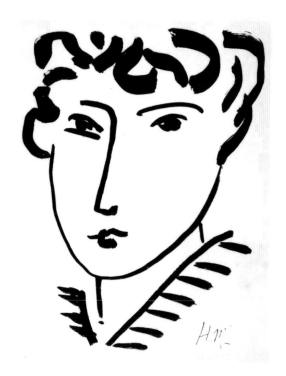

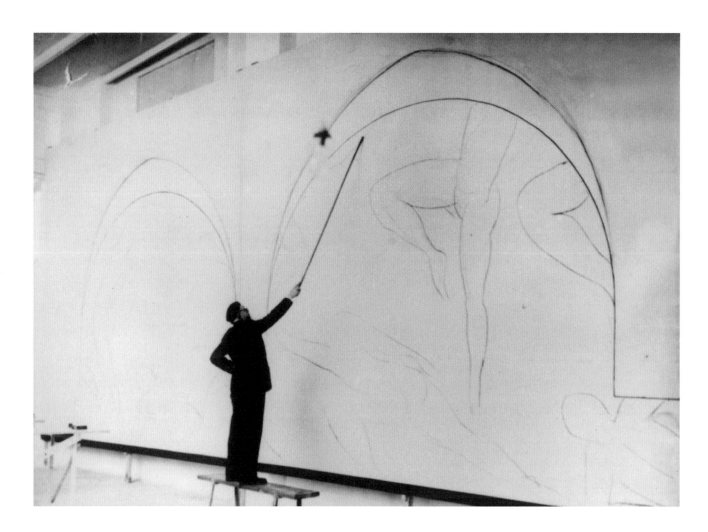

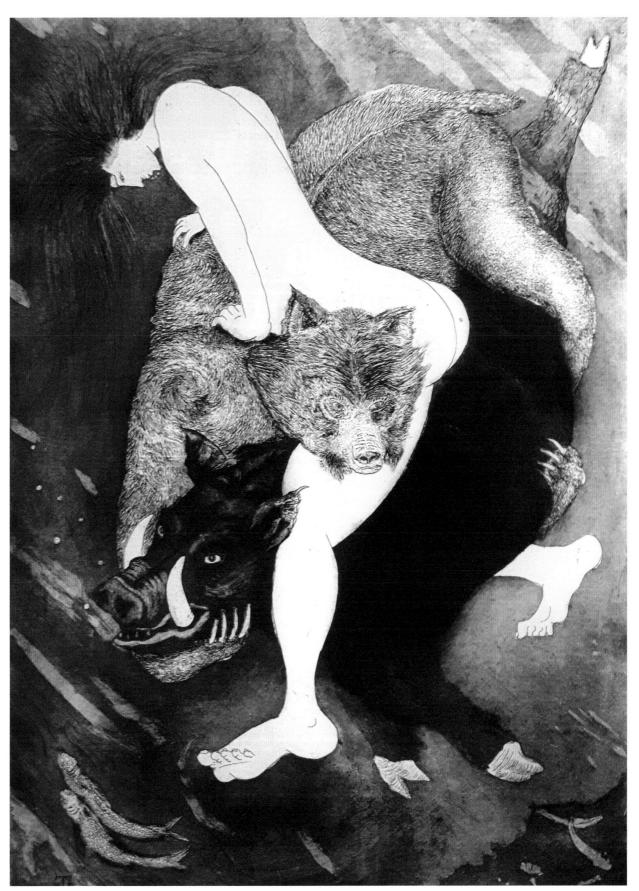

Jack Fawdry Tatham, *Among the Bearded Bear*, 2017, etching with aquatint

Warm Up: Touch and sensation *Ewan Clayton*

WITH: *the drawer's hands*

This is a brief exercise to help you sensitize your hands and sense of touch before you draw.

Wake up your hands by rubbing the palms together, round and round and round, generating some heat. Rub the backs of both hands and around your wrists, and allow your fingers to slide in between each other.

After about twenty seconds of this activity briefly pause and notice the sensations in the palms of your hands. Then shake your hands as if you are shaking water droplets off the ends of your fingertips. Do this ten times. Then pause again and sense what is happening in your palms: they may be tingling slightly; they will certainly feel more alive.

Sit with that sensation for a moment, then simply extend your arms down towards the ground and imagine ink or water streaming through them into the earth. You could continue to imagine that flow coming through them and out through the tip of your drawing instrument as you begin to draw. It is as if the ink or colour is flowing through you from your feet upwards and out. This may help you to bring more of your body and its senses into your drawing.

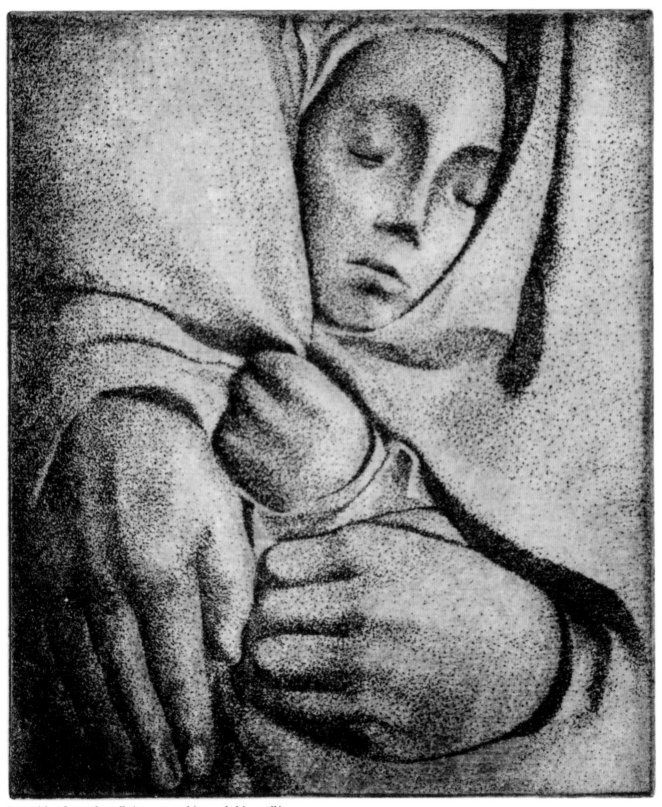

Kate Kirk, *After Käthe Kollwitz*, 2015, etching and chine-collé

Graphic Medicine *Emily Haworth-Booth*

Experiencing the fallibility of your body, and how drawing might help to address that experience.

I stopped drawing when I first became unwell with ME (Myalgic Encephalomyelitis, or Chronic Fatigue Syndrome). Getting dressed, eating, moving from one side of the room to another was difficult enough. Why on earth would I attempt anything beyond that?

But convalescence is boring, and eventually I reached for my sketchbook. I started making slow observational sketches of what I could see from the sofa. The folds of the curtains around the living room window, my dog snoring on a cushion, my husband reading on his iPad. One of my most disturbing symptoms was what is sometimes called 'brain fog'. This is like being drunk all the time – but with only the disorientating aspects of drunkenness and none of the good ones. Reading and writing sent me into a spin. Drawing, however, became a kind of anchor that I could drop to ground myself, to reassure myself that I was 'here', that reality was solid, vivid and encompassing.

The act of making observed drawings of my immediate surroundings was symbolically important – reminding me to stay present, rather than worrying about my illness. But its usefulness went beyond this; did it also, perhaps, perform a medicinal function? There are several schools of thought about what causes ME, and even what it is; that is part of its slipperiness. One theory, which my own experience supported, is that it is a condition related to the over-activation of the sympathetic nervous system – also known as 'fight or flight', the crisis mode in which perceived dangers trigger a series of hormonal and physiological changes in the body. In other words: anxiety made my symptoms worse. By helping me to stay present and focus on what was physically in front of me, much like observing one's breath in meditation, the act of drawing helped me see that most of the 'danger' to which my body had been responding was imagined or remembered, rather than embodied in the actual reality of my immediate circumstances. This perceptual shift, as well as the concentrated quiet of the act itself, noticeably reduced my anxiety and slowed down my breathing and my heart rate, activating my parasympathetic nervous system: the 'rest and digest' mode which, acting as a kind of brake to the sympathetic nervous system, allows healing to take place.

As I recovered enough energy to venture back out into the world, my drawings began to shift paradoxically inward, from the directly

Emily Haworth-Booth, extract from *Are you comfortable sitting like that?*, 2016, pencil, ink and digital processes

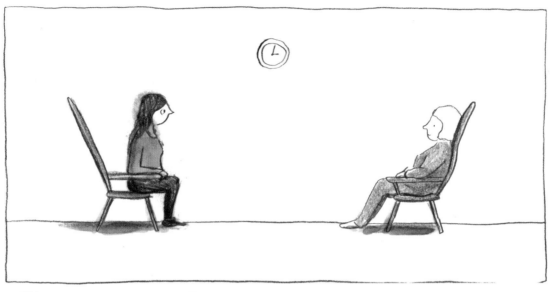

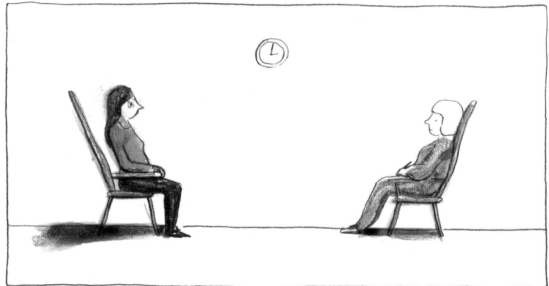

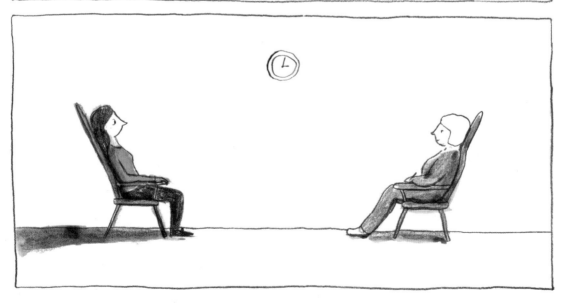

observational into something that lay between memory, imagination and observation. I think the reason for this may be that while ME is absolutely real for the person experiencing it, it has few outward signs and clinical markers, which makes it difficult to diagnose and is one of the reasons it is known, along with many other chronic and mental health problems, as an 'invisible illness'. This means that sufferers can feel very isolated: the reality within is at odds with their surface appearance.

One of the most frustrating elements of my own experience was that well-meaning people kept telling me how well I looked, when inside I felt anything but. Similarly, doctors were telling me over and over and again that there was nothing wrong with me, when at the same time my own body was telling me that this was not the case.

The somatosensory cortex, the place in the brain which processes our experiences of pain, is disproportionate to the places where the pain is coming from on the body. So an injury to the lips or fingertips, for instance, may be felt as far greater than it would logically appear to be if it were measured with a ruler or described verbally as a 'pinprick to the finger'. (After all, a prick to the fingertip was enough to send Sleeping Beauty to sleep for a hundred years!) Likewise, *logically* my verbal descriptions of how I felt, whether to friends or at the doctor's office, contrasted with my physical appearance and undermined their truth. If I drew pictures of how

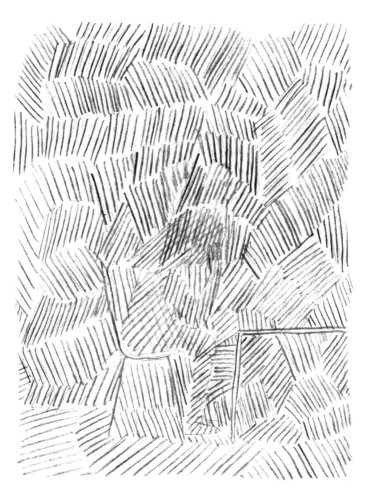

Emily Haworth-Booth, *Untitled*, 2014, pencil on paper

Pia Bramley, *Who Is This Who Is Coming?*, 2014, carbon paper line

Richard Burton, *Uniform*, 2009, ink on paper

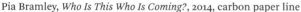

I felt, would their reality be less contestable? I could remake my physical appearance in drawing, so that it became one with my inward self.

Making these drawings quickly became an essential way of expressing my feelings about my illness, and after a good drawing session I had the relief and endorphin rush I've also experienced after, for example, a yoga class or particularly useful psychotherapy session. The comparison with psychotherapy isn't random: the process of allowing thoughts and memories to bubble up from within and then interpreting or making meaning from them afterwards is common to both practices. In *Aspects of the Novel*, E.M. Forster famously wrote, 'How can I tell what I think till I see what I say?' He was talking about writing, but as I drew I started to understand better how I felt, and although the drawings may have begun from 'I'll show them!', they were ultimately more useful as a way of showing myself what I was saying. Metaphors began to emerge, many of which I wasn't aware of until I began to draw. I drew myself inside a glass box and sharpened my sense of the specific kind of isolation I felt. I drew my body as an assemblage of a mass of small lines, like lead shavings, or as a contour of dashes, and saw that I felt I was disintegrating and dissolving.

I believe that this kind of drawing, though apparently 'imaginative', is in fact deeply observed. It may not have perspective, foreshortening and correctly proportioned limbs, but it can only come about through intent observation of the self and the inner landscape, through a kind of listening

to the internal body. There is a school of drawing in which one is taught to hold up a stick and measure forms, to ensure that they are placed on the paper in correct relationship to one another. It may be argued that my kind of therapeutic drawing is just as 'correct' – that it requires just as much focus and concentration to be accurate and true, although the accuracy is more subjective and the outcome looks so very different. The question of whether practical familiarity with the *outward* sort of observational drawing might prepare the mind, hand and eyes for making the *inward* sort of drawing may even arise. Is there any crossover in the skill and sensitivity required? Certainly the observational drawings that I made of my surroundings while convalescing put me on the path, and gave me some of the skills and confidence to venture into deeper internal territory when the time came.

As I found in my sofa sketchbook, conventional observational drawing is no doubt also therapeutic in its own right. The kind of non-verbal focus it brings may allow us to access what is known as 'right-brained thinking' – the kinds of mental process through which we can come up with more creative solutions to problems, or achieve a meditative state that promotes healing throughout the body. But 'graphic medicine' in particular, the term for the telling of our medical stories through drawing coined in 2007 by the medically trained artist Ian Williams, offers something that neither

Lilly Williams, *Clouds*, 2014, charcoal on paper

Jessie Makinson, *Pink Perfume II*, 2012, watercolour on paper

objective study of the physical world, nor simply writing or talking about our symptoms can: a kind of blood-letting; an almost primal purging of unpleasant, painful feelings.

A drawing of myself on the page, a drawing of my pain – both of these place the illness outside me, making it small and manageable, as though perhaps I have some control over it. It is a tangible entity the size of my little finger, rather than an unknowable diffusion of sensations moving through my body. This kind of drawing is really a form of naming, which we know is powerful as a way of containing and controlling things. Through drawing we can name the unnamable, the pain and confusion that are beyond language but no less real. Drawing also offers the possibility of manipulating and changing something on the page more easily than something that's inside your own body. You can draw the pain, as a big black cloud perhaps, and then you can draw it again, smaller and smaller, until it's gone.

A drawing can become – *is* – a real thing. Draw the simplest outline of a figure on a page and add a dot for an eye, and you have brought another person into the world. To me this magical, conjuring aspect of drawing is one of its most exciting qualities. In my own eyes, the drawings that I was making had demonstrable power.

When I started to get better I wanted to make sure I'd never forget what had happened. Drawing my story in the form of a graphic memoir became a way of assimilating the lessons learned, understanding them within the context of archetypal story structure – because of A, B happened, and C is how I dealt with it – and lastly, recording them. Attempting to revisit and redraw those sensations of illness and disintegration, I have seen that the power of drawing can also be dark. Making one of these drawings can transport me back to the depths of those moments, and even momentarily return the symptoms. They have a kind of eerie power over me that I am learning to respect.

Lilly Williams, excerpt from *The Woman Who Turned into a Chair*, 2014, charcoal on paper

Craig Harper, untitled, 2013, pencil

Irene Montemurro, *Self-portrait with Strawberry*, 2018, ink on paper

Drawing Me, Drawing You *Emily Haworth-Booth*

WHO: *with a sitter or someone observed in public*
WITH: *several sheets of paper*

This exercise, which uses a model as the basis for a self-portrait, can help unite two ways of image-making – observational and imaginative drawing – and can reveal how they support each other.

If you don't have access to a professional model, you could ask a friend to sit for you for ten minutes, or do this exercise in a cafe or public space and base your drawing on a member of the public.

Draw the model's pose from observation, making sure to fit their whole body on the page rather than cropping the figure to draw just, for example, the face. As you draw the model, simultaneously incorporate everything you know and remember about how you look: your body size and shape, face shape, features, hairstyle, the clothes you are wearing today. Try to integrate your own features right from the beginning, rather than sketching the model first and then superimposing yourself at the end. The idea is for the model's pose to supply the basic anatomical architecture, with your

own features providing the specific details that will bring the character – you – to life.

To take this exercise further, create a mini-sequence by making two further drawings of your character standing up from their chair and then walking away. You could either work from the model again or from imagination.

If you enjoy this, your sequence can continue indefinitely – keep drawing your figure, now purely from imagination and memory, and see where 'you' might like to go next. Work intuitively to expand the sequence across multiple pages or frames. You could explore wish-fulfilment, fantasy, the darker sides of your character or the simple joy of mundane acts.

This exercise allows you to take ownership of an observed image, but also to become the author of your self-image and your own story. You become a character that comes to life on the page.

Liam Walker, *The Deal*, 2016, pencil on paper

Drawing from Film *Catherine Goodman*

Great films, like great paintings, can be a rich resource
for visual ideas.

Drawing from film takes place in semi-darkness. There is a sort of privacy
and freedom in this darkness; but drawing in a group of six or more can
also foster a feeling of community and shared experience.

Anyone can choose a frame and stop the film for five or six minutes.
Either you choose to draw the full composition or you select a detail;
you might find yourself drawing compositions that you would not
necessarily have chosen, or that you would not naturally want to draw.
What the genius eyes of film directors such as Satyajit Ray, Federico
Fellini or Andrei Tarkovsky give us – in much the same way that a great
painter might – is a fully formed composition. By using the director or
cameraman's eye, there is a sense in which compositional choices are
made for you. Some people are more attracted to drawing portraits of
people, others to large, panoramic landscapes. The experience can be
quite playful: you have to compromise and accept being taken out of
your comfort zone. By the end of the film, you will emerge with a cache
of images and ideas. Sometimes you will find that the most stimulating
images are those with which you were least comfortable at the time,
and these can feed into your wider artistic practice.

Tarkovsky makes many references to great works of art in his films,
and often uses a leading image: Piero della Francesca's *Madonna del Parto*
(*c.* 1460) in *Nostalgia* (1983), or Leonardo da Vinci's *The Adoration of the Magi*
in *Mirror* (1975). In *Solaris* (1972), he uses Pieter Bruegel's *Hunters in the
Snow* (1565) – but he transports the scene into space. There is a moment in
Mirror which shows a person's back as they look out onto a lake, and again
you get the sense that Tarkovsky is thinking about Bruegel.

I approach drawing from film very much as though I were standing in
front of a large Veronese or Titian canvas: I make an imaginative leap *into* the
painting or the screen and imagine that I am drawing from life; the surface
disintegrates and so does the idea of it being a projected image. Drawing
from film engages you in looking at fictive life rather than actual life. It is
very important that the frozen scene is projected onto a wall or screen on
a scale much larger than one could experience on a television, so that those
drawing from the film can make the imaginative leap necessary to walk
around in the space along with the characters in the film. The illusion of
reality is closely connected to the scale and quality of the projected image,
and because the image is unframed, in a sense it is unbounded.

Catherine Goodman, *Charulata*, 2018, oil on paper

Catherine Goodman, *Arabian Nights*, 2018, pen on paper

During the five or six minutes in which you draw, you will find that you continue to engage imaginatively in the life of the film. There is a sense in which the image continues to live – it was moving in front of your eyes until a few seconds before and will move again shortly – and this becomes tangible as you draw.

The imagination sometimes lingers on in our waking moments, whether from a day or night dream. In a similar way, the emotion and narrative of a film and the feeling of being invested in the story and characters you are drawing can bring the tale to life. It is as though you were drawing Little Red Riding Hood right in front of you.

Drawing from film allows you to draw subjects you wouldn't otherwise come across. Strange images not found in daily life, such as the monkey on horseback from Werner Herzog's *The Enigma of Kasper Hauser* (1974), are offered directly from the imagination of the director – it is like dipping into their unconscious. In Víctor Erice's *The Spirit of the Beehive* (1973), a mobile cinema brings *Frankenstein* to town, and the monster is so real to the children watching it in the village hall that he becomes alive to them, and they begin to look for him in everyday life. I often feel like this after drawing from film – the images linger on and I find that the characters reappear on my way home.

VÍCTOR ERICE
Still from *The Spirit of the Beehive*,
1973

In this shot, the furrows ploughed
into the stark Castilian landscape
draw all eyes – and the two
young figures in the foreground
– towards the shed in which Ana,
the protagonist, meets an escaped
Republican soldier.

Catherine Goodman, *Pillow Fight* (drawing from *The Spirit of the Beehive*), 2018, pen on paper

Overleaf: Laura Footes, *Absolution and Eternal Refuge* (inspired by Bulgakov's *The Master and Margarita*), 2013, watercolour and ink on paper

Imagination and Observation *Catherine Goodman*

WHERE: *indoors or outdoors, somewhere you are interested in drawing*

In his book Poetry in the Making *(1967), the poet Ted Hughes wrote on the important connection between imagination and the physical world: 'Maybe my concern has been to capture…things which have a vivid life of their own, outside mine.' While this connection informed his process as a writer, the same can also be said of drawing imaginatively.*

This exercise uses observational drawing as the starting point from which to develop your imaginative drawing skills.

First, choose a subject for your observational drawing. Draw an interior or exterior space; it could be industrial, a cityscape or a landscape, a view inside a room, outside the window or in the open air – anything that interests you which can be drawn from direct observation. Try not to consider how the piece will develop in your imagination at this stage.

When you begin your drawing, take time to look carefully at what you see directly before you. Resist the temptation to rush this part of the session, and focus instead on engaging with your subject.

The second part of this session encourages you to trust your imagination. Looking at the drawing you have just made, begin to allow things to happen. Without self-editing, start to introduce elements

to your drawing which come to you through your imaginative life:

+ *Draw the drawing you have made from life again and allow a person or people to inhabit it.*

+ *Draw your drawing again a second time; this time, add inanimate objects to the scene. Try not to second-guess the new elements you include in your drawing, and be open to the direction in which your imagination takes you. The objects can be any scale or orientation.*

+ *Continue as before, this time adding animals to the scene.*

You can re-draw your original observational drawing as many times as you like, including a new, imaginative element in each drawing. If you prefer, you can add all of these elements – figures, objects, animals – to the same drawing at once.

Your drawing or drawings will evolve as you continue to re-draw without self-consciousness, thinking imaginatively and learning to trust your mind's eye.

The key to this game is not to edit your imagery. Allow anything to happen and keep the exercise going for about an hour – leave the drawings and when you revisit them, keep the ones that interest you, that have some life, and discard the rest.

Perienne Christian, *Concave*, 2011, pencil, watercolour and ink on paper

Walk the Line *Sarah Pickstone*

An exploration of drawing's capacity to move – across time, personal experience and artistic modes.

In her story *Street Haunting*, published in 1927, Virginia Woolf takes the narrator for a walk through the wintry streets of London at dusk to shop for a pencil. The protagonist walks and looks and lets herself be drawn into what she sees. Her imaginative self meets memory and history and makes an arc of time, set against contemporary Oxford Street and the Thames, 'rougher and grayer than remembered.'

I love the sense in this story of watching through time, and I imagine myself drawing a line with the pencil that Woolf has tucked behind her ear on her return from the stationers. Perhaps drawing can be similar to Woolf's idea of 'street haunting' – a saunter of discovery, inhabiting the lives of others. When we leave our day-to-day activity behind to walk, to draw, 'the shell-like covering which our souls have excreted to house themselves, to make for themselves a shape distinct from others, is broken, and there is left of all these wrinkles and roughnesses a central oyster of perceptiveness, an enormous eye.'

Drawing itself is a kind of empathetic story-telling. What kind of human narrative are we observing? What attention is paid to line and mark, atmosphere and light, to setting? Perhaps this is not the sort of story that has a linear trajectory – a beginning, middle and end. The beauty of drawing is that you can play with the space of a page and disrupt its sense of time.

Like many artists of the early twentieth century, Woolf understood that breaking the rules of narrative often comes out of an expressive necessity. Similarly, it can be surprising to explore how we perceive time through drawing. A line in itself reveals a narrative – the lines of Louise Bourgeois and Van Gogh tell of different ways of seeing. Nature, too, has an underlying pattern – a narrative of the laws of science. Many of the things we see are the repeated forms of nature – the hair at the crown of a head, which looks like a rose, which looks like a celestial constellation. We can draw stories across subjects; everything is connected.

Imagine the weather and the tone of a drawing; the shadows from the lights of the city, slanted and visceral; the mood and the time. The shape of the gaze; the fact that the eye meets bricks and looks through glass. Imagine the character of your subject: the sexual, psychological

Sara Anstis, *Feast*, 2018, charcoal, dry pastels and grease pencil on paper

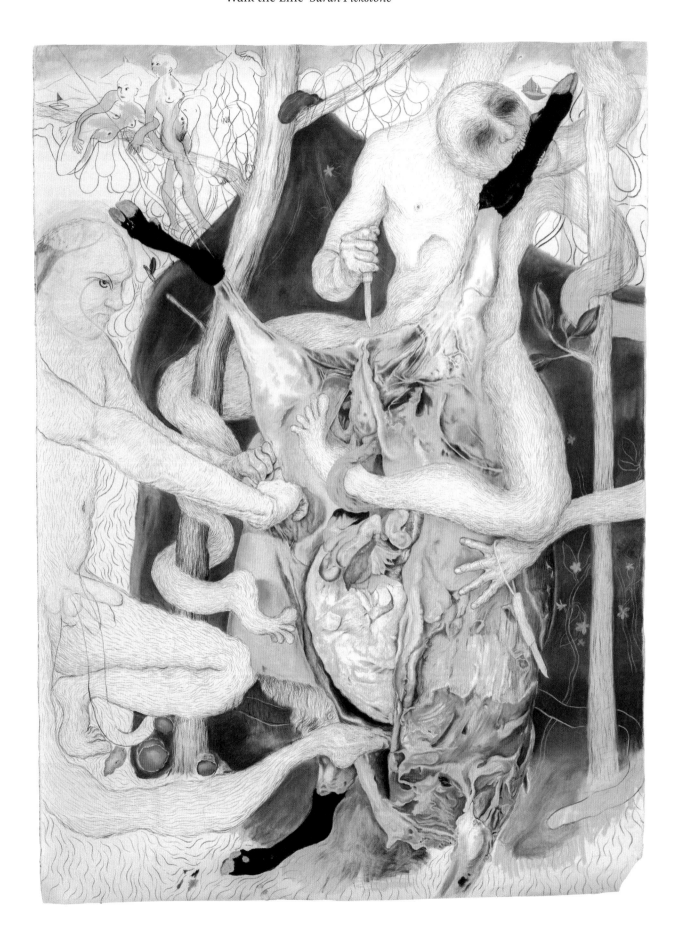

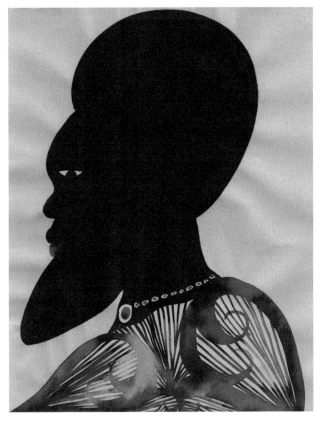

CHRIS OFILI
Untitled (Man Afromuse), 2006,
watercolour and pencil on paper,
45.7 x 30.5 cm (18 x 12⅛ in.)

Ofili's ongoing series of *Afromuses*
are each made in one sitting, using
watercolour paints – a quick, liberating
process that the artist has described
variously as a warm up to a day's work
and an exercise in beauty.

PABLO PICASSO
Weeping Head (VI), Postscript of Guernica,
1937, graphite, gouache and colour stick
on tracing cloth, 29.1 x 23.1 cm
(11½ x 9⅛ in.)

Guernica (1937) cast a long shadow over
Picasso's art. He produced a number of
'postscripts', among them this affecting
image of a weeping woman, witness to
the horrors he had depicted.

Opposite, top:
LOUISE BOURGEOIS
10 AM IS WHEN YOU COME TO ME
(detail), 2006, 20 etchings with
watercolour, pencil and gouache on
paper, each 38 x 91 cm (15 x 35⅞ in.)

This multi-part work consists of twenty
musical score-sheets depicting the
hands of Bourgeois and her assistant,
Jerry Gorovoy, who began work at 10 am
each day. It records something of their
long creative partnership; the hands
are arranged differently on each sheet,
painted in reds and pinks of varying
intensity.

and emotional atmosphere of your drawing. The eye sees from vantage
points of experience and history both communal and personal. Whose
history are you drawing from? Perception faces psychological challenges
and our own prejudices without even being aware. What you can see is
only ever half the story. In 1937, a decade after Woolf published *A Street
Haunting*, Picasso was drawing images of the horrors of Guernica – he
knew all about the backs of things and the sideways glance; that a head
could be drawn in profile with two eyes one atop the other. He could
draw a scream and violence in the line of a large, comedic cartoon head;
I find these drawings of the horrors of war very affecting.

Draw things that affect you. It is usually best to do what you like –
to draw things that appeal and not worry about being cool. It is also
best not to pretend to be interested in things you are not, or to worry
about the conventions of acceptability. Drawing is also about desire –
a desire to understand, to record, to consume bodily; to love and hate,
and to show others how much we love and hate the things in our world;
to see and be seen. This is no pathology or twisted craving, but a human
need to meet one another. It is also about being able to be the 'other'
and understand the 'other'.

To draw is an incredibly freeing process; to become more than one
thing. As Woolf's narrator observes, 'what greater delight and wonder can
there be than to leave the straight lines of personality...to feel that one is

Daniel Blumberg, untitled, 2016, coloured pencil on paper

Jessica Jane Charleston, *Sex Chat*, 2017, chalk pastel and gouache
on paper

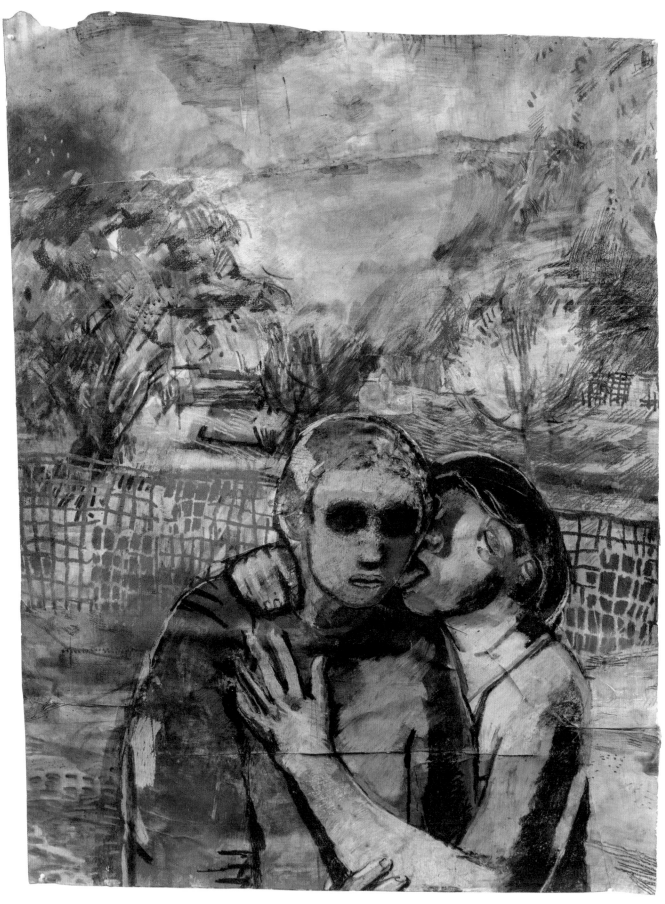

Joana Galego, *Not Breathing*, 2017, mixed media on paper

Sarah Pickstone, studio wall with studies for *An Allegory of Painting*, 2018

not tethered to a single mind but can put on briefly for a few minutes the bodies and minds of others.'

Drawing can be everything – there are rules to be broken. Technique is a useful tool, but never an end in itself; it is all about the attitude that you provide for yourself, the questions you ask with your drawing and then the practical question of how to begin. It just requires that pencil.

I try not to force things, and try (very hard...) not to struggle. It requires a lightness of touch, but is an exact pursuit; you need precision and to give your whole attention to the moment. The best drawings have a specificity to them, where the subject has been well-seen in a particular way. I like to draw from something in front of me, but there is no hierarchy of style or subject matter here. Observational drawing is no more 'true' than an abstracted response to the visible world. Photography and Einstein challenged the idea of a classical ideal in Newtonian space and time. Agnes Martin's beautiful drawings of light and landscape both internal and external are drawn equivalents for this reality as much as Turner's.

An open, imaginative approach is key. Keep your mind's eye open for connections to other seemingly random images, and trust yourself. There is no correct way – it is important to develop your own sense of what you want in a drawing; to take responsibility. When you reach a degree of confidence, your unconscious mind can provide rich, interesting and

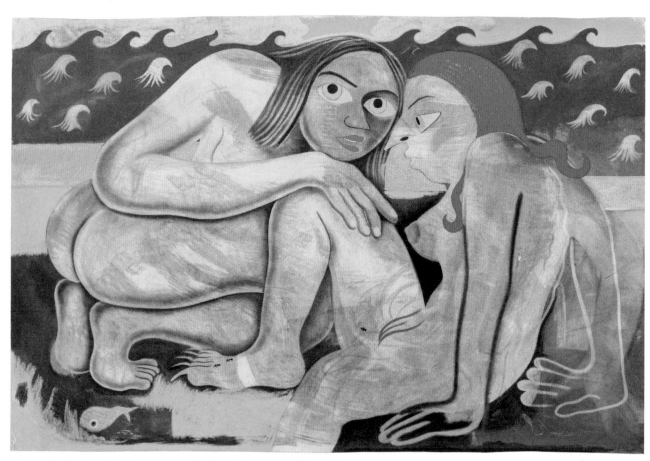

Sara Anstis, *The hanging rings are removed allowing the two out of the netting, and the lusty maids have found their favourite*, 2018, soft pastel on paper

AGNES MARTIN
Untitled #11, 2002, acrylic and graphite on canvas, 152.4 x 152.4 cm (60 x 60 in.)

Martin marked out her lines on gessoed canvas before applying colour quickly and deliberately, making works that, in her own words, 'are light, lightness, about merging, about formlessness, breaking down forms.'

Sarah Pickstone, *Disegno after Angelica Kauffman*, 2017, watercolour on paper

Dorry Spikes, *Santería, Santa Marta – Cuba*, 2017, coloured pencil on acrylic wash

sometimes miraculous drawings. But it is practical to set up a framework, which is why students often work with a model or an arrangement of objects. Exploring with different media can also be fruitful.

Often, things happen – mistakes, coincidences – and it is helpful to pay attention, and instead of thinking things are wrong or bad, to see your page as an interesting experiment. Sometimes, a drawing only seems any good with hindsight, especially awkward drawings. You cannot judge it as you go along, and you can't be perfect; all you can do is take the action to draw. Nurture the drawings you make.

Drawing can play an active, political role as well as a personal one. I love the way that drawing passes right through dialectical boundaries and remains a common language, a primal form of communication. You can be light on your feet and open to humour while drawing about heartbreak. For me, drawing is more synthesis than analysis; more felt than understood.

Open the door, take a walk with that pencil from behind your ear, and begin.

Sarah Pickstone, *Woolf Thinking*, 2010, watercolour on paper

Sarah Pickstone, *Smith Study*, 2011, watercolour on paper

Poetry Drawings *Sarah Pickstone*

WHERE: *outdoors*
WITH: *a poem or poems of your choice*

+ *Pick a poem – don't overthink it.*
 Trust the process.
 Perhaps think about the art you like and pick a poem
 from the same place and time. The twentieth century
 is rich in poetry that reflects the visual arts – perhaps
 Cubism in Paris or Abstract Expressionism in the US
 would be good places to start. Interested in Modernism?
 William Carlos Williams wrote a great poem in response
 to a painting by Juan Gris, called The Rose is Obsolete.

+ *Pick a tree – don't overthink it!*
 Keep trusting the process.

+ *Think of a figure, a person, yourself.*
 Sit down in front of your tree – preferably a public tree;
 it is more risky drawing in public. Just draw it any old
 way. Think about the character of the tree: the root
 system beneath, the structure of the branches, the back
 of the tree, what the ground might look like to that bird
 up there.

+ *Now add the person. It could be the narrator of the*
 poem; it could be you. Imagine them standing with or in
 the tree. Draw a passer-by. It doesn't need to be a whole
 figure. It could be just a head, a hand, a hat – but a body
 part is good. Think about the attitude of the poet or
 the figure. Are they in a good mood? You can share the
 responsibility with your poet; collaborate with them...

+ *Re-read your poem. Does an image come to mind?*
 An animal? Weather? Colour? Mood? Try and draw
 your embarrassment, your shame, your humour.
 Good drawing has less to do with accuracy than with
 emotional honesty. Has your drawing caught a sense
 of place?

+ *Make several of these drawings, working quickly.*
 Don't judge your work just yet. Trust in the process.

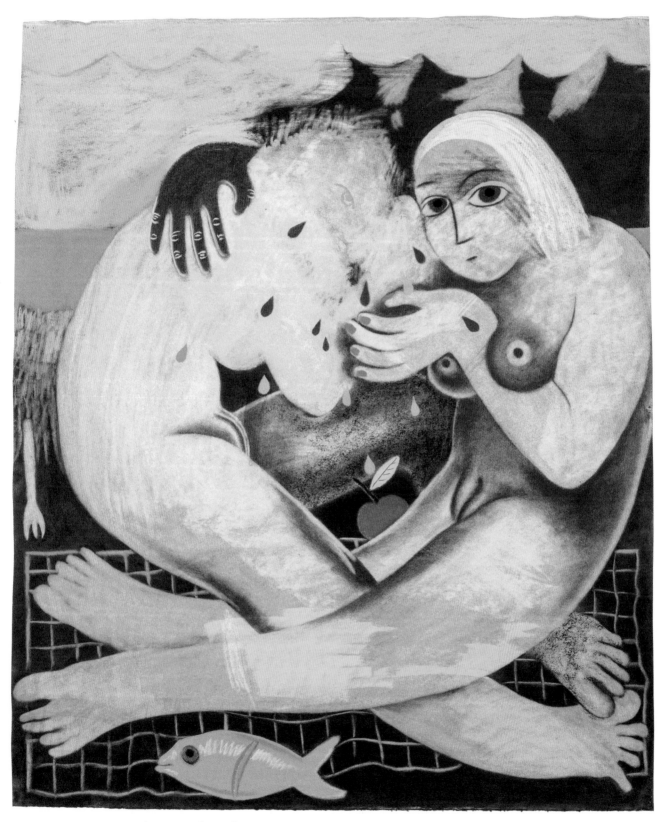

Sara Anstis, *Sitting eating crying*, 2018, soft pastel on paper

Text and Image: Where two rivers meet
Sophie Herxheimer

Working in the terrain between words and images, and finding a way to tell stories using both.

If the Sun and Moon should doubt

They'd immediately go out.

WILLIAM BLAKE, AUGURIES OF INNOCENCE

These words, painted by my mother in a rush, in looping blue gouache on a scrappy sheet torn from a layout pad, were slid under my bedroom door on the first morning of my O-level exams. So you see: my mother, William Blake, spontaneity, confidence and poetry are all entangled and spur me on my creative path. They compete fiercely for light and space with the greedy brambles of reality.

In this essay concerning the marriage of drawing with text, where words might be drawn and have pictorial weight, I want to look particularly at my own inspirations towards such duality. Part of this discussion stems, then, from having had to make a horrible choice: to attend art school for painting at the expense of wielding language.

Two hundred years after Blake, I too grew up in Lambeth, part of South London that stands over the river from the established order but near enough to throw the odd metaphorical stone. The textiles created daily by my mother, Susan Collier, and my aunt, Sarah Campbell, were formative influences on my work. They painted original designs in gouache in a studio in our house, first for Liberty and eventually for their own company, Collier Campbell. They broadened the scope and possibilities of printed cloth with their brushwork and ingenuity; from them I learned about colour, instinct, observation and graft.

I always reveled in mixing words and pictures. As a child, one of my favourite things to do was to make up rhymes and draw. I'd injure myself trying to sew pages together into books with satin thread. Anyone looking at my work can see the influence of many masters: I've worn my retinas thin on the linear flourishes of Matisse and Picasso, the textures grappled onto paper by Van Gogh. Like many artists, I continue to look hard at the

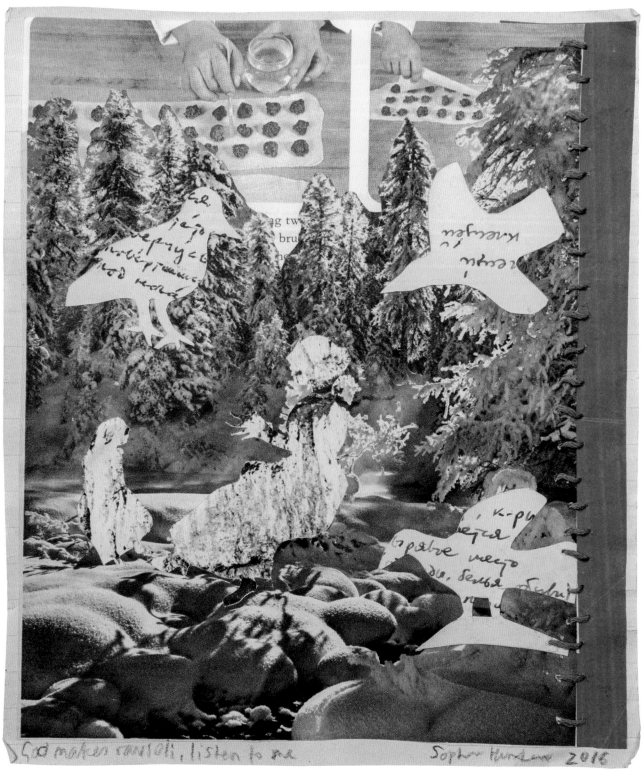

Sophie Herxheimer, *God's Ravioli and the Russian Birds*, 2016, collage

outer and inner worlds and at art: ancient, contemporary, global. I am perhaps even more assiduous as a poetry reader!

Many artists and poets have held up helpful signposts in the terrain where words and images meet and combine; here are a handful of them...

I've already mentioned William Blake, who created his own mythology and a new way of printmaking. He was both imaginative and practical, epitomizing duality in all his creative outpourings: innocence and experience, heaven and hell, image and text. His work creates a tension between grounded local observation and a freely wandering and visionary inner life; it teeters between the everyday and the unfathomable in a way I find strangely easy to relate to.

The work of Shikō Munakata is so alive that it challenges its own material. Self-taught and original, his woodcuts show subjects caught in flights of Japanese characters as animated as bird-crowded branches in the wind. Text and image, inextricable from one another, become one synchronous thing. I admire him for making the unyielding wood he cut into as fluidly responsive as air or water.

Charlotte Salomon painted a 750-page book of her own life, marrying words – often songs – with her gouaches. In *Life, Or Theatre?* she created a work that is truly synesthetic, with colour, language, sound and texture all leaking visceral reality from each page. She began the project in response to her family history, in which her own mother and many of her female ancestors had committed suicide. She painted to find her own voice and save her own life – though as soon as she'd finished it, she was found and murdered in the occupied France she'd fled to in 1938 from her home in Berlin.

Artists who harness their voices to the world as it changes, sometimes violently, seem to use that energy to create objects of extraordinary power

SUSAN COLLIER and SARAH CAMPBELL
Design stamp and hand-painted design for a panel-printed skirt, 1981

Collier-Campbell's hand-painted pattern designs were printed to retain their brushmarks and painterly feel, deliberately leaving traces of the handmade in the mass-produced.

Rosie Vohra, *Eleven Pots and a Snake with Breeding Wings*, 2014, monoprint

Lindsey Mclean, *Pepsi*, 2014, oil pastel on paper

Below, left:
WILLIAM BLAKE
Songs of Innocence and Experience:
London, c. 1825, relief etching with
watercolour and gold, 15.7 x 14.1 cm
(6¼ x 5⅝ in.)

A young child leads an old man along
what is recognizably a cobbled London
street; the 'chartr'd street' of the
accompanying verse. In the margins,
a small figure warms its hands at a fire
– despite the cheery blue background,
the images and verse offer a bleak view
of life in contemporary London.

Below, right:
ALICE NEEL
Untitled (Alice Neel and John Rothschild
in the Bathroom), 1935, watercolour on
paper, 30.5 x 22.9 cm (12 x 9 in.)

This small painting of Neel and her
lover positions the viewer as almost
a voyeur, looking in on a scene from
the domestic life of the artist. The frank
intimacy of the piece is such that it was
considered too risqué to show until
over a decade after the artist's death.

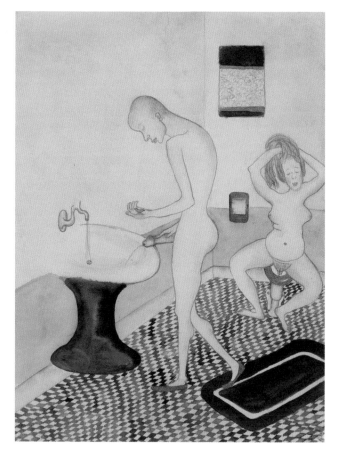

Opposite, top:
SHIKŌ MUNAKATA
The Hawk Princess (Taka no onna),
1958, woodcut on paper, 40.6 x 31.1 cm
(16 x 12¼ in.)

Individual character strokes are
echoed by the sharp, vigorous lines
of the background in this piece.
Munakata worked quickly, usually
cutting straight into the woodblock
rather than producing preliminary
sketches.

Below, right:
VARVARA STEPANOVA
Building, circle, run, beetle, grave, snake-
like, soft feathers, 1919, watercolour on
paper, 15.5 x 10.7 cm (6⅛ x 4¼ in.)

Stepanova produced several handmade
poetry books, including *Poison* (1919),
from which this sheet is taken. The
words are painted directly onto
the page, over and around brightly
coloured shapes; the interaction of
colour and line echoes the contrasts
and harmonies set up in her poetry.

whose urgency persists even in the comparative lulls that may follow.
An abiding influence on me has been the work of the Russian Futurists.
They made little books out of scraps of wallpaper and cheap rubber
printing sets, including poems by Mayakovsky and Khlebnikov and wild
drawings by Larionov, Stepanova, Goncharova. These works are towering
lessons in collaboration and inventiveness. How I would love to have been
handed one of their hastily stapled books at an underground station in
Moscow in 1919!

Humans are made to communicate, and part of this drive means
making things. Drawing is the primal act of making. My daughter, aged
eighteen months, stood at a little easel and drew the outline of a cat.
Her triumph was complete when she drew its eyes: 'Now it can see me!'
she announced. She created dialogue, and thus vanquished loneliness.

Making things, making things up, is part of our endeavour to tell
other people what we've seen and heard. In crazy times, whether personal
or political, we will use whatever is 'to hand'.

I made puppets for my children when they were small, and it turned
out that the scale of them pleased my autistic son and helped him to
learn to speak. One puppet was a green frog who, in the story we all made
up, drove a green bus around a green pond. A friend's child was at the
table when Mr Frog was showing off about his bus. 'You're not real, and
you haven't got a pond!' he shouted fiercely, looking the frog squarely

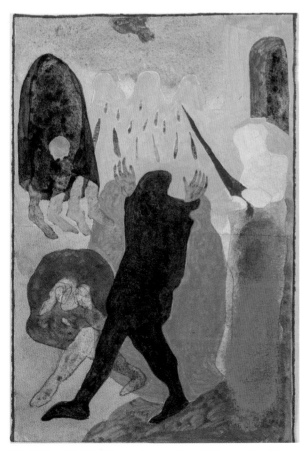

Ella Walker, *Untitled, Red socks swords and drips*, 2018, paint
and pigment on paper

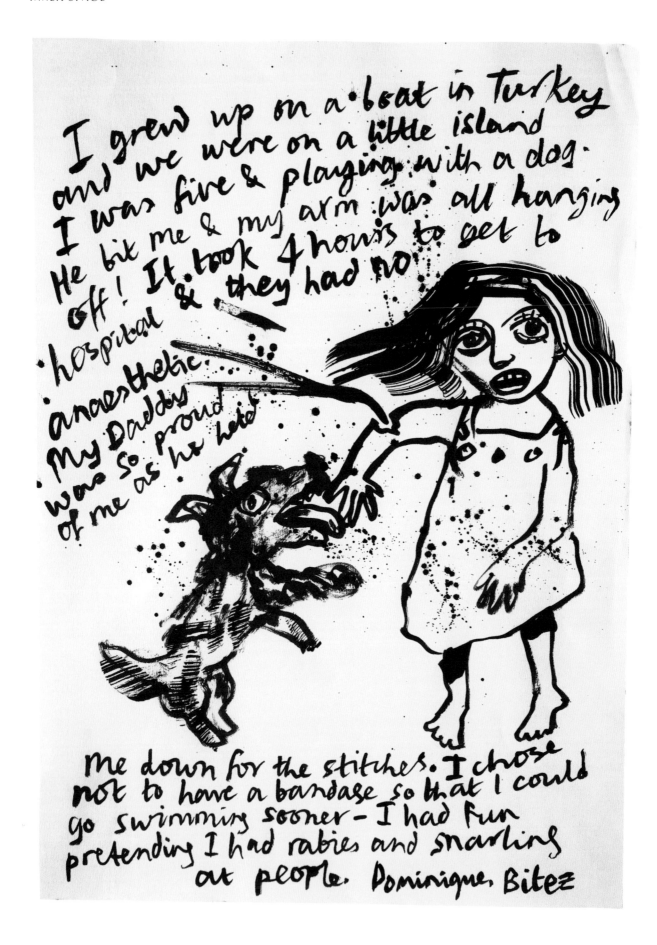

I grew up on a boat in Turkey
and we were on a little island
I was five & playing with a dog.
He bit me & my arm was all hanging
off! It took 4 hours to get to
hospital & they had no
anaesthetic.
My Daddy
was so proud
of me as he held

me down for the stitches. I chose
not to have a bandage so that I could
go swimming sooner - I had fun
pretending I had rabies and snarling
at people. Dominique Bitez

in his glass marble eyes. He couldn't help but believe in the frog even as he shouted at him. We are creatures of imagination, and imagination is as practical a tool as reason. If you use them together you will find a way through any pond you care to mention, real or pretend.

In 2004, I fell into an idea-pond that has grown into a body of work which in some ways defines my practice as an artist-poet. An ocean of ink... *Stories Collected Live in Ink* began with a project called 'Feast', at a primary school. At the culmination of my residency, I sat in a shed on the school's vegetable patch and listened to people tell me their recipes, with the aim of making a school cookbook. Almost at once, I got sidetracked into the rich territory of the stories that went with the dishes.

Since then I've developed a technique of 'live listening': writing and drawing that can be applied to any person, whatever their age or background. Food, a universal theme, is still a great way in; but as I have been commissioned to collect stories in many contexts, I've learned to tailor open-ended questions on many subjects.

I always have a photocopier and a helper so that each fresh drawing can be immediately reproduced for the narrator, who becomes a temporary collaborator. Each person is listened to and seen, and has their words encapsulated with new brevity and drawn for them. The ensuing document is a witness to their experience.

Doing this work tipped me further into poetry, and I made a series of collages in ghost-conversation with the poet Emily Dickinson, whose poems offer themselves like small, oblique ladders in and out of gigantic thoughts. Her 'envelope poems' are amazing visual fragments, in which the script is as much drawing as poem. The works I made in response to hers are also fragmentary objects: stitched, cut-up collages using photographs from a 1930s flea-market tourist book of Switzerland. The daunting vastness of the Alps seemed a good mirror for Dickinson's interior landscape. The book that emerged from this, *Your Candle Accompanies the Sun*, is like a duet for Emily Dickinson and I, in honour of the female artist who must spill her big universe from a kitchen table.

Sophie Herxheimer, *Dominique's Dog Bite* from *Stories Collected Live in Ink*, 2017, ink on paper

Image and Text *Sophie Herxheimer*

WHERE: *indoors, with friends*
WITH: *poetry books • printed images • interesting coloured or textured materials • photocopier • scissors • paste or glue*

Find an anthology of contemporary poetry, open it up and photocopy it at random up to three times.

From the three poems you land on, choose the one that seems richest or most appealing to you.

Make a collage in response to the poem, bearing in mind the mood, tone, rhythm, texture and colour of the language the poet has used. Ask yourself:

+ *Is it a heavy or light poem or both at once? Does it make you feel happy, horrified, excited, confused, belligerent – or what else?*

+ *Are there distinct colours in it? Does it suggest a palette?*

+ *Is it even and formal or ragged-looking, e.g. what shape is it on the page?*

+ *Does it shout, whisper, instruct, show, exaggerate?*

+ *Are there distinct images in it and if so, what are they doing?*

When you have made a visual, weight-for-weight equivalent to the poem, read the piece again next to your collage.

Now, swap collages with a friend or fellow student and write a poem using their collage as a prompt.

Carry on doing this all day, until you have enough pages for a book or a very long line of poetry bunting!

This exercise could lead to a performance, the discovery of a poet whose work you didn't know or simply a new way to make things and be inspired.

Sophie Herxheimer, *Kitchen Sink*, 2017, papercut

Sophie Herxheimer, *Dung Beetle Poem*, 2017, collage

Dorry Spikes, untitled (sketchbook), 2017, watercolour and coloured pencil

Being Drawing *Dilip Sur*

A radically poetic framework for understanding drawing and personal practice.

Poetically man dwells on this earth.

FRIEDRICH HÖLDERLIN

Drawing is, in essence, the primordial unfolding of the self. It is living existence; an active creative process that is central to all my visual enquiry and exploration. It is where the beginning begins: a unknown, mysterious world that is always turning, evolving and forming in process. Emerging there, in life's wonder and quest, is manifold variation: germinating, revealing and growing within – a living organism. Drawing is never predictable and it never begins and ends in the same way. Always a new beginning!

Far away in the distant...often, as a child, I found myself standing alone in front of an empty wall with no one around, or on the wet sandy soil in front of our house, under the big mango tree, during the long-lasting monsoon season. Then, in a sudden, awkward, restless movement, my desperate scratching of lines would begin across the wall with a piece of broken brick or a found coloured stone. Or my trembling hands would plough through the soft wet earth with a bamboo stick or a piece of broken clay pottery. And images would appear in quick succession – a cow here, a bird there and a house, then the sun, the moon, the river, a man, a goat, a rice store, a fish, a basket, one after another.... They would appear and disappear equally with mere caprice – and then all would be wiped away, to start again! Thus began my life of drawing: not knowing anything, getting lost in a world of which I knew nothing. An unknown world....

It was one early spring morning, the sun was glowing and we were all outside under the open sky – I remember it vividly. It was before I had started to learn the alphabet and I was sitting with some older students who attended my father's tutorials, to which I had to follow him every day. Having nothing to do, I was disturbing the students by taking their books to see what was inside them – mainly to find out whether there were any pictures. In the middle of their lesson, I was called in a soft voice to come close, and my father, taking the slate quietly, drew a lotus with a chalk pencil. Passing the slate to me, he asked me to draw a lotus on the other side. Entertained, I started – and then asked him if I could see the lotus that he had drawn once more. At that point he said 'of course you can, but you do not need to see it – you have seen the lotus so many times! So try it...think of it and

Dilip Sur, *Journey to Ur*, 2015, ink, pastel and charcoal on paper

Being Drawing *Dilip Sur*

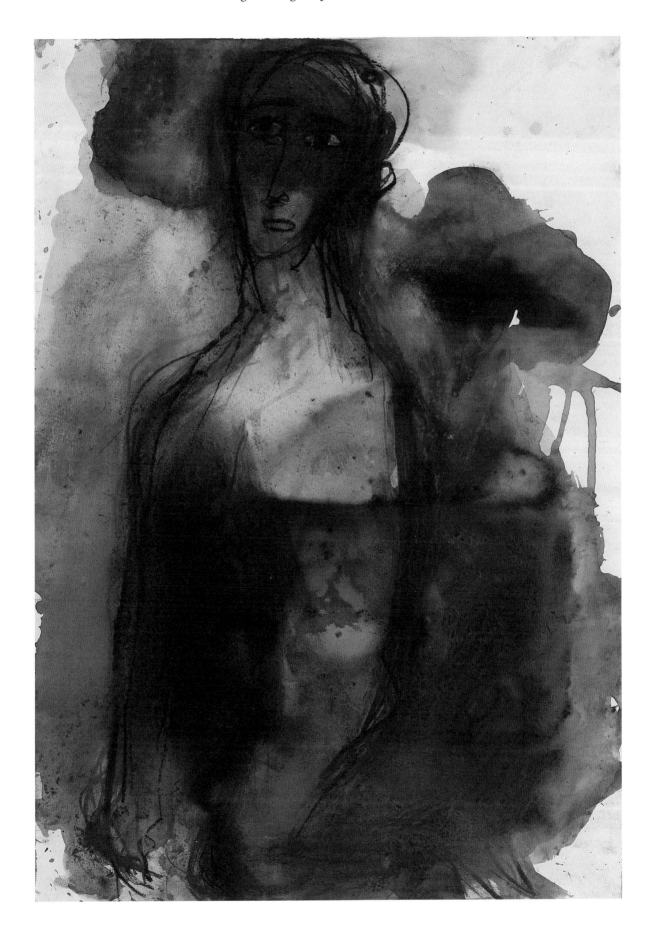

ROCK CARVING
Jebel Jassassiyeh, Qatar. Photograph
by Peter Dowley

Jebel Jassassiyeh, a rock art site near the
sea, has a number of carvings of boats –
including this one, a plan image of
a vessel with oars. The age of the
carvings is unclear, though the area is
thought to have been populated before
the eighteenth century.

draw it. Doesn't matter if you cannot draw it the first time. You can try again!'
Perhaps without my knowing, there began my first lesson in drawing.

Arriving at art college was truly the beginning of a new world for me in
many ways, and there, amid everything, some essential aspects of a creative
life came to light. Firstly, I came to recognize the absolute value of work –
the active working process, through conscious study and questioning – and
to comprehend the real meaning of serious labour. Secondly, I realized the
need to enquire, examine, explore; to really look into and grasp the world
that is in front of us, and to discover the other world that is inside us.
Thirdly, I found that I needed to create my own visual language – and it was
with this that I would later, finally, learn to create my own world. But for
that realization, I first had to walk the walk of life in the world outside.

CAVE PAINTING
Chauvet-Pont-d'Arc Cave, Ardèche,
France. Photograph by Raphael
Gaillarde

Deer, herds of mammoths and bears
were all worked from the rock of the
Chauvet caves, some over 30,000 years
ago. The images are often sited in
harmony with the contours of the rock,
and some have been etched or incised
into the surface.

Opposite, top right:
REMBRANDT VAN RIJN
The Abduction of Ganymede, 1635,
pen and brown ink wash, 18.3 x 16 cm
(7¼ x 6⅜ in.)

Instead of depicting the classically
beautiful youth desired by Zeus as
his cup-bearer, Rembrandt offers
a radically different interpretation
of this myth: his Ganymede is a
squirming, frightened child, carried
off untimely from what appears to
be his distraught parents below.

Drawing is drawing life. It is the story of creation. The journey begins:
a new world appears in the clearing, revealing new dimensions to the meaning
of life itself. Drawing is the first visual expression of the human mind – the
primal sign in the process of forming a rich visual language, a grand narrative
that evolves from a desperate scratch or mark on clay or on bark, on the rock
or the cave wall. The beauty of being shines forth in this human striving, so
vibrant and so living that it touches our spirits deeply. The drumming waves
of their heartbeat dances in our blood. We celebrate life! Throughout
the whole of humanity's history, drawing remains our richest unwritten
manuscript – the incomplete and continuous autobiography of life on earth.

Life, entwined in the practice of drawing, is deeply connected with
selection in every step. It is this that affects the creative being essentially,
by creating value: the central object of life. Value is the prime matter, the
substance of being. The greatest of all selections is a life that has true value
– that is, in the realization of one's own creative becoming. Absolute care is
necessary in selection; it should be rooted in the consciousness of reason.
This is where the transformation begins – a transformation through work.
There is revealed our self-creation; our true identity.

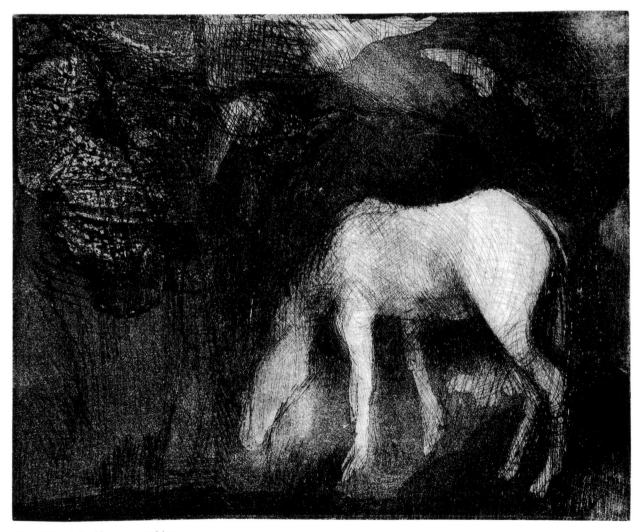

Naomi Grant, *Lycidas*, 2011, etching

Jane Cheadle, *Robin Hood Gardens*, 2014, chalk and charcoal on paper

Naomi Grant, *Lycidas*, 2011, etching

Joshua Bristow, *Pyramid in the Landscape, Castle Howard*, 2017, monotype

Drawing is living. It is through this experience of living, working and re-evaluating that 'life' has become the subject of inquiry in my practice. Life, with its endless potential and infinite possibility; the living history that exists in time past, with all its complexities and its highs and lows, always deeply concerns me. Life – this very life – the beauty of this existence! The wonder of all! How did it appear? What happened? Why? Is there a reason? A chance! A happy accident! A mystery! Finding no concrete answer, the only way forward that appears to me is to give a meaning to this wondrous existence through work; through trying desperately to connect, to relate and to create a relationship with the whole existence of the living world. This very living cosmos! The infinite beyond, from which we all appear and of which we all are a part. And how it is so – all – only for once! And it is in this that finally we celebrate the creation, in creating a world that is ours with full effort – a reflection of this existence. Being aware that it may be minuscule or insignificant; but still, a simple mark is meaningful – as being here – as a living presence within it – as breathing.

It is the experience of my drawing practice that led me to teaching, and I find both equally creative and inspiring. In teaching I can share my experiences, identifying with the problems that students face in their different stages of drawing practice. During my years of teaching, there have been many incidences that have inspired me to continue. What I value most is the students' development through strength of study, inquiry and self-

Dilip Sur, *By The River*, 2016, earth pigments, pastel, charcoal, ink and acrylic on paper

discovery; finding confidence and freedom to explore new ideas and create their own worlds.

Everybody can draw, as everybody can write. I have full confidence in this. Learning to draw is more exciting and enjoyable if our minds are free from all preconceptions that might hold us back. The only criterion is to have the will to do – the love to do – and to give the time to germinate, to grow within and to let flower!

To draw is to concentrate, to contemplate and to identify oneself with the subject that is in front of us – a life, a landscape or an apple. It is to know, to enquire, to relate, to discover a new higher existence within oneself and have the courage to take risks, make mistakes and journey further without fear. Drawing begins with an inquiry into the existence of being – into the subject in front of us, which is always new; a study to understand the phenomenon from inside, to examine how it originated, formed and is constructed. To acquire knowledge, to know the process, the truth, that creation has to evolve through time in and by itself. There begins a relationship with the subject, and it is there that imagination and ideas take their root. A contemplation; an interpretation of the world through creative exploration – where the spirit takes its leap into the unlimited, the infinite, the elevation of being – the poetical – the universal!

Pollyanna Johnson, *Long Grass*, 2016, graphite and charcoal on paper

The Air around a Figure *Constanza Dessain*

WHERE: *around the threshold of a building*

When we draw something with enough conviction, the paper around our subject becomes air and the page becomes an inhabitable space. The most evocative drawings demonstrate not only what can be seen but also something of the invisible qualities of a place. A viewer may be able to sense its weather, its emotional atmosphere, its smells or sounds. I am thinking particularly of the dry, barren wind that blows through Goya's Witches *series, or the hushed, sunlit rooms in which I imagine Ingres's sitters.*

This is an exercise for thinking about the non-visual information in a drawing. It sets out to make us more aware of the 'invisible' atmospheric qualities in the drawings we make of the world around us.

Position a model in the doorway of a building, on the threshold between the outdoors and the interior. They can face either way – you may wish to try both.

Draw the figure twice: first, situate yourself inside the building and draw the scene before you, looking through the doorway to the world beyond. Then, move outside and draw the figure from the other direction, looking back into the place where you had previously been sitting.

In each of your drawings you will depict two distinct environments. Observe the quality of light in each space. Is it artificial lighting inside and dusk outside? Is there a dark hallway compared to a bright street curb?

As you draw, consider the different temperatures, smells and sounds in the interior and exterior. How did it feel to sit in each space? How might it feel to be a figure crossing from one space into the other?

Trust your marks to absorb these perceptions without consciously illustrating them.

Sophie Charalambous, *The Church in the Mountains*, 2009, watercolour on paper

Overleaf: Melissa Kime, *Technicolour Joseph and the Amazing City Bankers*, 2012,
gouache, watercolour and pencil on paper

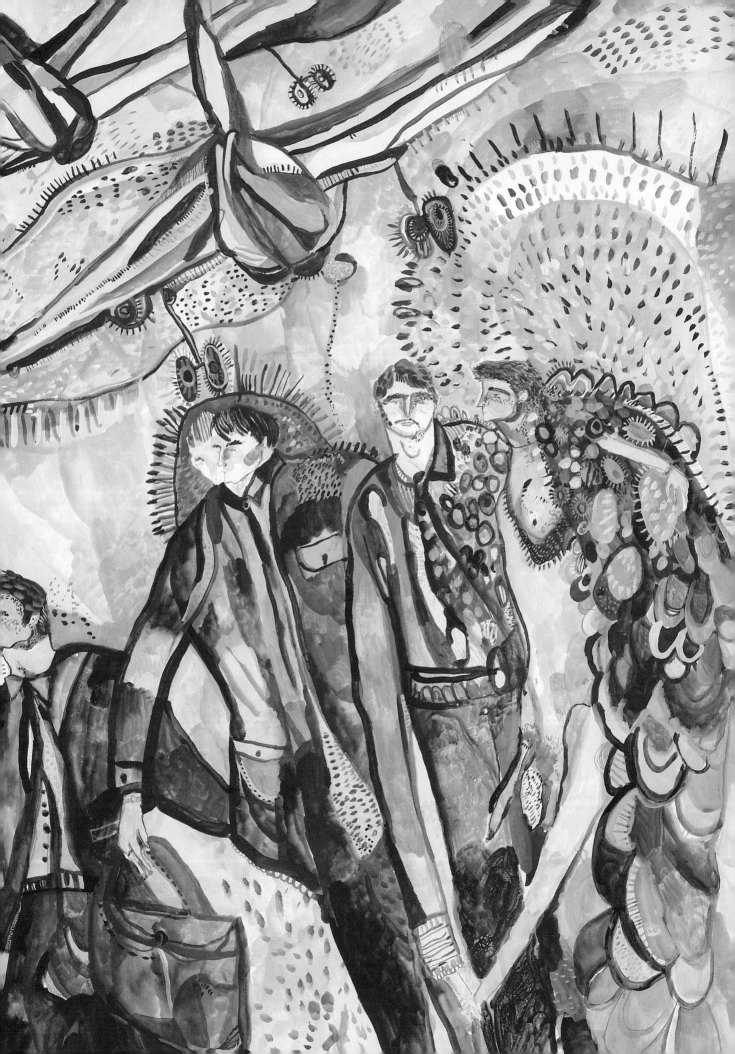

Gideon Summerfield, untitled (sketchbook), 2017, coloured pencil

THE EDITORS

JULIAN BELL was born in 1952. A self-employed painter throughout his adult life, he has worked on pub signs, murals and portraits alongside the narrative, panoramic compositions that have dominated his exhibitions. Since the 1990s, he has also been teaching – at Goldsmiths College, City & Guilds of London Art School and Camberwell College of Art – and writing about art for journals such as the *London Review of Books*. Thames & Hudson have published his books *What is Painting?* (2nd edn, 2017) and *Natural Light: The Art of Adam Elsheimer and the Dawn of Modern Science* (2023).

JULIA BALCHIN joined the Royal Drawing School in 2010 and was appointed Principal in 2021. She has curated exhibitions in London and New York at Christie's, Blain Southern and Buckingham Palace and has collaborated with the Royal Collection, British Museum and the Courtauld. A curator and art historian, she maintains her own artistic practice as a way of seeing and thinking. She studied Fine Art and History of Art at the University of Leeds, later returning to set up fine art publishers and commercial gallery Paper Scissor Stone. She has lived in Holland, Australia, Mexico and Spain, and now lives and works in London. She draws every day.

DR CLAUDIA TOBIN is a writer, curator and academic specializing in modern and contemporary literature and the visual arts. Her recent books include *Oh, to be a Painter!* (2021) and *Modernism and Still Life: Artists, Writers,*

Dancers (2020). She has contributed to major exhibitions and projects exploring the relationship between writers and artists, including at the National Portrait Gallery, Tate Gallery, and the Fitzwilliam Museum. She frequently works with contemporary artists, curates the Royal Drawing School's Creative Conversation series, and was commissioned to establish the School's environmentally conscious Green Drawing programmes. Claudia has held prestigious fellowships in the United States and across Europe, most recently at the Harvard University Center for Italian Renaissance Studies (Villa I Tatti) in Florence. She teaches English literature and visual cultures at Cambridge University and is a Senior Research Associate at the Intellectual Forum, Jesus College.

THE CONTRIBUTORS

MARK CAZALET attended Chelsea and Falmouth Colleges of Art before being awarded two postgraduate scholarships with The French Government at the École des Beaux-Arts, Paris, and at MS University Baroda, West India, with The Association of Commonwealth Universities. He has completed large-scale glass and painted works for many ecclesiastical settings including Worcester, Manchester and Chelmsford Cathedrals. His studio practice is based around drawing, painting and printmaking, usually concerned with landscape themes. In the spring of 2012 and 2013 he was artist-in-residence at the Josef and Anni Albers Foundation in Connecticut.

DANIEL CHATTO studied English at Oxford University and Art at The City & Guilds School of Art. His work is founded in painting from life in a wide range of media from fresco to oil, wax, egg, gum and glue tempera, and he teaches the making and use of these traditional paints in contemporary practice. He shows at Long & Ryle in London.

EWAN CLAYTON is a calligrapher and lettering artist who lives and works in Brighton, Sussex. He holds a part time position as Professor in Design at the University of Sunderland. For twelve years he worked as a consultant to Xerox PARC, the research lab in California that developed much of the digital technology underpinning the world of digital communications and mobile computing that we know today. He grew up in and around the craft community founded by Eric Gill at Ditchling, Sussex. Ewan's book *The Golden Thread*, a history of writing, was published in 2013.

MARCUS CORNISH studied Sculpture at Camberwell School of Art, followed by an MA at the Royal College of Art. In 1993 he was elected to the Royal Society of British Sculptors. He won a scholarship to India to study the work of Ayanar Potter Priests, and a Henry Moore scholarship to pursue ceramic art. He was artist-in-residence at the Museum of London in 2005–6, and official tour artist with the British Army in Kosovo and on a diplomatic tour to Eastern Europe with HRH The Prince of Wales. His work has been recognised in a number of national and international awards and covered in *The Times*, *Independent* and *Sculpture* Magazines.

CONSTANZA DESSAIN studied Social Anthropology at Cambridge before going on to the Byam Shaw, Central St Martins. She worked as an art teacher for TeachFirst before starting The Drawing Year at The Prince's (now Royal) Drawing School in 2011. She completed the Royal College of Art MA in Print in 2018, where she was awarded the Desmond Preston Prize for Drawing. She has shown with Bosse and Baum Gallery, Our Autonomous Nature and the Embassy Tea Gallery and teaches at Falmouth University and the Royal Drawing School.

LIZA DIMBLEBY (lizadimbleby.com) began drawing and painting while studying in Moscow and completed a doctorate in Russian thought at the University of London in 1996. She joined The Drawing Year at The Prince's (now Royal) Drawing School in 2003 and has taught there since 2005. Her book on walking and drawing in cities, *I Live Here Now*, was published in 2008. She lectures at art schools and universities in Scotland and England and has led drawing talks and walks in Glasgow, London, Moscow, Paris, Orkney and Siberia. She lives and works in Glasgow.

ANN DOWKER is a painter, draftsman and printmaker. She taught at Chelsea School of Art and the Byam Shaw School of Art for ten years, is a freelance tutor at The National Gallery and has tutored at the Royal Drawing School since it was founded in 2000. She printed for many years for and with Leon Kossoff and was involved in curating his show at the National Gallery. Ann has exhibited with Theo Waddington, Angela Flowers and Art Space Gallery and has been in many mixed shows. She now works between London and Egypt.

CLARA DRUMMOND studied Modern Languages at Cambridge University before completing The Drawing Year at The Prince's (now Royal) Drawing School in 2005. She was awarded First Prize in the BP Portrait in 2016 and is the author of *Drawing and Seeing: Create your own sketchbook*, published by Kyle Books in 2018. In addition she was awarded the Bulldog Award by the Royal Society of Portrait Painters and the Young Artist of the Year Prize by the Society of Women Artists, and has been exhibited five times in the BP Portrait Award Exhibition at the National Portrait Gallery. Other group shows include the Jerwood Drawing Prize and the Garrick Milne Prize. Solo shows include 'Kingdom' at Galeribox, Iceland, and 'The Paper Museum' at Two Temple Place, London. Most

recently, she had a joint exhibition with Kirsty Buchanan, 'The Unsung Muse' at the William Morris Society, London. She teaches at galleries and festivals and The Royal Drawing School.

WILLIAM FEAVER, for many years the art critic for *The Observer*, is also a painter and has curated exhibitions ranging from Tate retrospectives of Michael Andrews and Lucian Freud to John Constable at the Grand Palais, Paris (2003). His book *Pitmen Painters* (1988) was adapted by Lee Hall for an awards-laden play of the same name, and he staged a related exhibition in Vienna. His other publications include *When we Were Young: Two Centuries of Children's Book Illustration* (1977), *Frank Auerbach* (2009) and *The Lives of Lucian Freud* vol. 1 (2019) and vol. 2 (2020), the first volume of which was selected as a Book of the Y ear 2019 by the *Guardian* and *The Times*.

CATHERINE GOODMAN is a painter and Founding Artistic Director of the Royal Drawing School, which she established with HRH The Prince of Wales in 2000. She is based in London and Somerset. In 2002 she won First Prize in the National Portrait Gallery BP Portrait Award. She is represented by Marlborough Fine Art and has had numerous solo exhibitions, including 'Portraits from Life' at the National Portrait Gallery (2014) and 'the last house in the world' at Marlborough Fine Art London (2016). She exhibited at Hauser & Wirth Somerset following five months as artist-in-residence at the gallery in 2018, and at Marlborough Gallery New York in 2019.

EMILY HAWORTH-BOOTH is an author–illustrator who teaches courses on comics and graphic novels at the Royal Drawing School and regularly runs workshops at schools, universities, literary festivals and hospitals. Emily's picture book *The King Who Banned the Dark* was a Guardian Children's Book of the Month and shortlisted for the Waterstones Children's Book Prize 2019. She won the *Observer*/Comica/Jonathan Cape Graphic Short Story Prize in 2013 and is working on a longform graphic memoir about climate change, chronic illness and romantic comedies. Her comics have appeared in publications including the *Observer*, *Miss Vogue* and *The Inking Woman*, Myriad Editions' groundbreaking study of over 250 years of Women Cartoon and Comic Artists in Britain.

TYGA HELME was born in 1990 and studied Fine Art and History of Art at Edinburgh College of Art and the University of Edinburgh. She is a draftsman, painter and printmaker, and her work is made exclusively from life. She studied on The Drawing Year at the Royal Drawing School in 2014 and was awarded the International Institute of Fine Arts residency in India. She now teaches at the Royal Drawing School.

SOPHIE HERXHEIMER is an artist and poet. She has held residencies for London International Festival of Theatre, Southbank Centre, The National Maritime Museum and Transport for London. Her work has been shown in settings from Tate Modern to her local allotments, The National Portrait Gallery to a 48-metre hoarding along the sea front at Margate. She has illustrated five fairy tale collections, and made and collaborated on many artists' books. In 2019 she received of a Hawthornden Fellowship. Her book *Velkom to Inklandt* (2017) was an *Observer* poetry book of the month and a *Sunday Times* Book of the Year. Recent books include *60 Lovers to Make and Do* (2019) and *The Practical Visionary* (with Chris McCabe, 2018).

EILEEN HOGAN is a painter. She has exhibited widely in Europe and America, including solo shows at the Imperial War Museum and the Garden Museum in London. In 2019, a retrospective of her work at the Yale Center for British Art, New Haven, was accompanied by a monograph, *Personal Geographies*, jointly published jointly with Yale University Press. She is a Professor in Fine Art at Camberwell, Chelsea and Wimbledon Colleges, University of the Arts London and a Trustee of the Royal Drawing School.

TIMOTHY HYMAN RA has exhibited widely, including nine London solo exhibitions, and his paintings and drawings are in public collections including Arts Council of England, Royal Academy, The British Museum and Deutsche Bank. He was elected RA in 2011. Trained at the Slade School of Fine Art, he has taught there part time since 1979, and in many other art schools and museums. He has a long connection with India, especially Baroda. He was lead curator for Tate's Stanley Spencer retrospective (2001), and co-curator of 'British Vision' at the Museum of Fine Arts, Ghent (2007). His publications include *Bonnard* (1998), *Sienese Painting* (2003), *Bhupen Khakhar* (2006) and *The World New Made: Figurative Painting in the Twentieth Century* (2016). In 2011–12, he was artist-in-residence for Maggie's Cancer Caring Centres.

DR IAN JENKINS was Senior Curator in the Department of Greece and Rome at the British Museum, where he specialized in classical sculpture, including its reception. His publications include *Archaeologists and Aesthetes in the Sculpture Galleries of the British Museum, 1800–1939* (1992), *Greek Architecture and its Sculpture* (2006) and *The Parthenon Sculptures in the British Museum* (2007)

JOHN LESSORE was born in London in 1939. He studied at the Slade from 1957 to 1961, and in Italy on an Abbey Minor travelling scholarship. His chief teachers were his mother, the painter Helen Lessore, and Tom Monnington. John was a co-founder of the Royal Drawing School in 2000 and a Trustee of The National Gallery, London, 2003–11.

He taught from 1965 to 1999 at the Royal Academy Schools and from 1978 to 1986 co-ran the Life Room at Norwich School of Art with John Wonnacott. His work is in private and public collections including Tate, The British Museum and the Royal Academy. Major commissions include a double portrait of Jeremy Dixon and Edward Jones and a group portrait, *Six Paralympic Athletes*, both in the National Portrait Gallery. He lives and works in London, East Anglia and France.

ISLEY LYNN is a playwright. She modelled at the Royal Drawing School from 2001 to 2016. Her play *Skin A Cat* won Pick Of The Year at Vault Festival 2016 and was nominated for four Off West End Awards, before touring nationally. Her adaptation of *War Of The Worlds* in collaboration with Rhum And Clay sold out for a five-week run at New Diorama Theatre in 2019. Isley was the 2014 Script6 winner at The Space with *Bright Nights*, and her monologue *What's So Special* was performed as part of *The Get Out* at The Royal Court Jerwood Theatre Upstairs (2014). She is a graduate of the Royal Court Young Writers Programme (2012) and Royal Court Invitation Studio Group (2013) and her work has been supported by the National Theatre Studio and Cottesloe Theatre, Hightide, Soho Theatre, Lyric Hammersmith, the Tricycle, Theatre Royal Stratford East, Ovalhouse, Criterion Theatre and the Orange Tree Theatre.

ORLANDO MOSTYN OWEN is a painter. He studied at the École des Beaux-Arts, Paris, and participated in Valerio Adami's annual summer colloquiums at the Fondazione del Disegno, Lago Maggiore. He worked in Paris for ten years, exhibiting with Deborah Zafman and Galerie Polad-Hardouin and founding the International Bongo-Bongo Brigade with Humberto Poblete Bustamante and Andrew Gilbert. He has received numerous prizes, among them the Prix de Dessin at the Academie des Beaux Arts, the Prix de Peinture Paul Louis Weiller and the Prix Grace de Monaco in Monte-Carlo, and was selected as a representative of Italy for the 2011 Venice Biennale. He has curated various shows and exhibited extensively in Paris, Berlin and London. His work is in numerous private and public collections.

ISHBEL MYERSCOUGH studied at Glasgow School of Art, and painted in Glasgow for two more years before moving to the Slade School of Art in 1993. At the end of her studies Ishbel was awarded a travel scholarship to New York, and after returning to England to show her work, was invited to participate in the artists programme run by Robert and Susan Summers in Connecticut. She now lives and works in London. She won the National Portrait Gallery BP Portrait Award in 1995 and has since completed two portrait commissions for their collection. She was represented by Anthony Mould for 20 years, having several exhibitions with him, and is now represented by Flowers Gallery.

THOMAS NEWBOLT was born in 1951 and studied at Camberwell School of Art from 1970 to 1974. He has exhibited at Roland Browse and Delbanco (1974–7), Browse and Darby (1977–2007) and now at Piano Nobile Fine Art. Thomas was artist-in-residence at Trinity College, Cambridge University, 1979–81, and Harkness Fellow at the University of Virginia, 1981–3. He has taught at Camberwell, University of Wisconsin at Milwaukee, Anglia Ruskin University (Cambridge School of Art) and the Royal Drawing School. In 2019 he worked with Mexican painter Roberto Parodi on a tribute to José Clemente Orozco, which took place at the Museo del Palacio de Bellas Artes and Antiguo Colegio de San Ildefonso in Mexico City in December 2019.

SARAH PICKSTONE is a painter who lives and works in London. She studied at the Royal Academy Schools and the University of Newcastle. She won the Rome Prize for painting, spending a year at the British School at Rome, which had a big impact on her work. In 2012 she won the John Moores Painting Prize, for which she had been a runner-up in 2004. In 2014 Daunt Books published *Park Notes*, an anthology of collected writings with her paintings. Sarah's work is shown internationally, including recently in Shanghai, Seoul, Basel, New York and Italy. 'An Allegory of Painting' – a large painting installation made in response to the painter Angelica Kauffman – was commissioned by the Royal Academy as part of its 250th celebration in 2019. Teaching is an important part of her work.

MARTIN SHORTIS is Head of the Print Room at the Royal Drawing School, where he also teaches. He studied at the Ruskin and Royal Academy Schools, where he concentrated on large commissioned drawings working on the spot. He has taught since 1992 and continues to draw outside and around London.

DILIP SUR studied Painting and Sculpture at the Government College of Art in Calcutta before completing his MA in Painting at the College of Art in New Delhi, India and continuing his postgraduate education in Painting at Byam Shaw School of Art (UAL) in London. He has received national and international awards such as the British Council Charles Wallace Trust Fellowship, and has exhibited internationally, including solo exhibitions at the Grosvenor Gallery in London, the Guild Gallery in Bombay and the Schoo Gallery in Amsterdam. He has been teaching Drawing at the Royal College of Art since 1996 and is currently also a tutor at Imperial College London. He has previously taught at Cheltenham and Gloucester College of Art and at Kings College London, Byam Shaw College of Art and Chelsea College of Art in London. In 2011 he collaborated with Mike Figgis on the project 'Just Tell The Truth' at the Royal Opera House.

FURTHER READING

Any internet search or bookshop browse will uncover a great many 'How to...' books covering specific areas of drawing. For particular forms of practical help, look through their illustrated pages and see what suits your individual needs best.

Texts that deal with the art of drawing more broadly, as this book seeks to do, are harder to find. For this reason, we include here some books that may currently be out of print; in all cases we have given the original publication date.

Major historical–theoretical surveys of the art include:
Deanna Petherbridge, *The Primacy of Drawing* (2010)
Philip Rawson, *Drawing* (1969)

A couple of manuals by art educators have proved helpful, over the decades, to many kinds of would-be drawers:
Betty Edwards, *Drawing on the Right Side of the Brain* (1979)
Kimon Nicolaides, *The Natural Way to Draw* (1941)

Artists with powerful personal interpretations of drawing make equally valuable reading:
Josef Albers, *The Interaction of Color* (1963; revised edition 2013)
Avigdor Arikha, *On Depiction* (1995)
John Bensusan Butt, *On Naturalness in Art* (1981)
John Berger, *Berger on Drawing* (2005)
Jeffrey Camp, *Draw* (1994)
Paul Cézanne, *Conversations*, ed. Michael Doran (2001)
Francis Hoyland, *Greek Light: On drawing from the past* (2014)
Andrew Marr, *A Short Book about Drawing* (2013)
Henri Matisse, *Ecrits*, ed. Dominique Fourcade (in French: 1972)
Musa Mayer, *Night Studio: A Memoir of Philip Guston* (1988)
John Ruskin, *The Elements of Drawing* (1859)

Many contributors to this volume have gained from reading texts by writers who may not themselves draw, but whose insights are particularly stimulating to the visual practitioner. Here are some of these texts:
Gaston Bachelard, *The Poetics of Space* (1958)
Charles Baudelaire, *The Painter of Modern Life* (1859)
Walter Benjamin, *The Arcades Project* (1982)
G.K. Chesterton, *Charles Dickens* (1906)
Georg Wilhelm Friedrich Hegel, *Aesthetics* (1828)
Martin Heidegger, 'The Origin of the Work of Art', 1937 and 'The Question Concerning Technology', 1954, in *Basic Writings* (2008)
Louis Kahn, *Essential Texts*, ed. Robert Twombly (2003)
Jean Newlove and John Dalby, *Laban for All* (2004)
Georges Perec, *Species of Space and Other Pieces* (1974)
Michael Podro, *Depiction* (1998)
Rainer Maria Rilke, *New Poems* (1907–8)
Rebecca Solnit, *Wanderlust: A History of Walking* (2014)
Leo Steinberg, *Other Criteria* (1972)
Junichiro Tanizaki, *In Praise of Shadows* (1933)
Andrei Tarkovsky, *Sculpting in Time* (1986)
Marina Warner, *Forms of Enchantment* (2018)
Virginia Woolf, 'Street Haunting', 1927

Inspring conjunctions of word and image can be found in the works of William Blake and Shikō Munakata, and also in the following:
The World Backwards: Russian Futurist Books 1912–16, ed. Susan Compton (1978)
Emily Dickinson, *Envelope Poems*, ed. Jen Bervin and Marta Werner (2013)
Charlotte Salomon, *Life or Theatre?* (1941–43; first published 1981)

Finally, there is the endless stimulus to be gained from looking at books that reproduce work by remarkable drawers. Numerous artists have been cited in the essays collected here, but further recommendations include any collections you may be able to find of the drawings of Guercino, Adolph Menzel, Alberto Giacometti, Saul Steinberg, Kiki Smith and the cartoonist Carl Giles.

PICTURE CREDITS

Jamie Stenhouse, *Bonnie*, 2017, pencil on paper

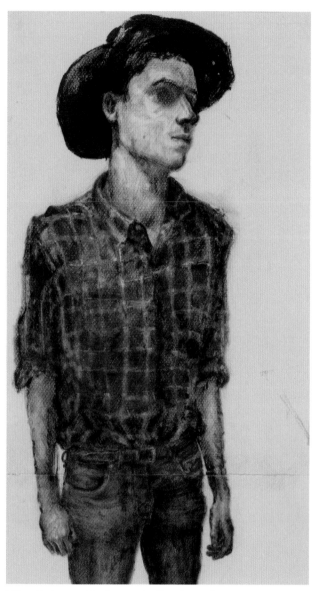

Oliver Bedeman, *Cowboy*, 2008, oil and pastel on paper

ACKNOWLEDGMENTS

We have arrived at this book after a journey that was long but also full of rewarding encounters. Throughout, we three editors have been sustained by the engagement and enthusiasm that Catherine Goodman, as Artistic Director of the Royal Drawing School, and Sophy Thompson, as Thames & Hudson's publishing director, brought to the project. En route, we benefited from the good advice and support of Andrea Rose OBE CMG and The Hon. David Macmillan.

At the School's base in Shoreditch, it was a great pleasure to work with Olivia Davies, Hatty Davidson, Michelle Cioccoloni and Beck Belsham, who played pivotal roles in bringing this book together. Angela Moore and Richard Ivey, with their luminous photography of the School's activities and artwork, have hugely enhanced these pages. Over at Thames & Hudson's offices, Johanna Neurath and Amanda Vinnicombe gave us their experienced guidance; Sarah Praill her beautiful and generous design; Sam Ruston and Angelica Pirkl provided the picture research; and Poppy David the production. Most of all, in this context, we thank Kate Edwards, who, as the in-house editor for *Ways of Drawing*, has been inspiringly clear-minded, wise, patient and persuasive.

We are also truly grateful to these individuals and institutions for granting us special access to images: Leon Kossoff, Dr Sophie Bowness, Sarah Campbell, Gallery Chemould, Flowers Gallery, Marlborough Fine Art, Victoria Miro Gallery and the British Museum. We would like to make a special thanks to the Royal Collection, who so generously provided us access to their vast collection of prints and drawings, and to Desmond Shawe-Taylor, Surveyor of the Queen's Pictures.

Julian Bell, Julia Balchin & Claudia Tobin

INDEX

On the cover: Gabriela Adach, *Locomotion*, 2018,
coloured pencil on paper; © 2019 the artist.
(See pages 196–7 for full artwork.)

First published in the United Kingdom in 2019 by
Thames & Hudson Ltd in collaboration with the
Royal Drawing School

First paperback edition published in 2023

Ways of Drawing © 2019 Thames & Hudson Ltd, London

Preface and 'Drawing from Film' © 2019 Catherine Goodman
'To Start...', 'Studio Space', 'Open Space' and 'Inner Space'
introductions © 2019 Julian Bell
'Modelling' © 2019 Isley Lynn
'Nature Up Close' © 2019 Clara Drummond
'In Practice' sections © 2019 the individual authors

Artworks unless otherwise stated © 2019 the individual
artists

Interior designed by Sarah Praill

British Library Cataloguing-in-Publication Data
A catalogue record for this book is available from the
British Library

ISBN 978-0-500-29700-1

Thames & Hudson Ltd, 181A High Holborn,
London WC1V 7QX

Printed and bound in China by C&C Offset Printing Co. Ltd

MIX
Paper | Supporting
responsible forestry
FSC
www.fsc.org FSC® C008047

Additional captions
1 Michelle Cioccoloni, *Sweet and Salty*, 2013, ink on paper
2 Jessie Makinson, *Slippery Darling*, 2012, watercolour on paper
3–4 Gabriela Adach, *12.171117 (2)*, 2018, coloured pencil on paper

STUDIO SPACE

18 (clockwise, from top left)
Oona Leganovic, *Body Contact I,* 2016, pencil and gesso on tracing
paper, mounted on canvas
Rebecca Harper, sketchbook pages, 2013, graphite and coloured
pencil on paper
Sarah Anstis, *Untitled (glowing)*, 2018, soft pastel on watercolour
paper
Tara Versey, *Self-portrait*, 2010, pencil on paper
Arjuna Gunarathne, *Timath is asleep* (sketchbook), 2018, charcoal
on paper
19 (clockwise, from top left)
Richard Ayodeji Ikhide, *Ṣe Aṣaro,* 2017, oil pastel on paper
Carl Randall, *Portrait of Donald Richie*, 2006, pencil and ink on paper
Charlotte Ager, *Sunk*, 2018, ink, watercolour and pastel on paper
Rose Arbuthnott, untitled, 2010, charcoal on paper
Cheri Smith, *Chris in Bed*, 2018, pencil on paper
Lottie Stoddart, *Oliver reading Shakespeare*, 2015, etching and
aquatint

OPEN SPACE

100 (clockwise, from top left)
Elizabeth McCarten, *San Giminiano*, 2018, ink and watercolour
on paper
Julia Balchin, *Green Valley*, 2018, ink and pen on paper
Matthew Booker, *Scarborough Beach*, 2016, ink on paper
Kate Kirk, *Phoenix Gardens*, 2015, pencil on paper
Kristian Fletcher, *The Wrench*, 2013, pen, pencil and charcoal
on paper
Mark Cazalet, *Essaouira*, 2011, pencil on paper
101 (clockwise, from top left)
Cheri Smith, *Bubblebath Cloudland*, 2018, pencil and pastel on paper
Holly Froy, *Cactus*, 2016, gouache and wax crayon on paper
Gideon Summerfield, *Pathway to Villa Ephrussi* (sketchbook), 2017,
pencil on paper
Laurie Crean, *Entrance*, 2017, pen on paper
Peter Wenman, *On the late train* (sketchbook) , 2017, pen on paper
James Albon, *Swimming Lessons in Progress*, 2015, ink on paper

INNER SPACE

186 (clockwise, from top left)
Oliver McConnie, *Tribulations*, 2014, etching
Salma Ali, *My Boot*, 2014, pencil on paper
Charlotte Ager, *Orange Horse Rider*, 2018, charcoal and watercolour
on paper
James Trimmer, untitled, 2009, pencil and watercolour on paper
Christabel McGreevy, *Bathtub Shrine*, 2017, charcoal and oil pastel
on paper
187 (clockwise, from top left)
Oscar Farmer, *Ready Steady Go!*, 2016, pencil on paper
Claire Price, *Minotaur* (graphic short story, p. 3), 2013, ink and
pastel on paper
Rachel Hodgson, *Sweaty Shoes*, 2018, mixed media
Alice MacDonald, *Ladies Bathing Pond, Hampstead Heath*, 2017,
monotype with drypoint on tetra pack and copper hard ground
etching with aquatint
Naomi Workman, *Untitled II*, 2018, monoprint
Richard Ayodeji Ikhide, *Phoenix*, 2017, ink on paper
Arjuna Gunarathne, *Airbourne*, 2018, pastel on paper